Holler Rat

Holler Rat

A Memoir

Anya Liftig

ABRAMS PRESS, NEW YORK

Library of Congress Control Number: 2023935973

ISBN: 978-1-4197-6300-7
eISBN: 978-1-64700-738-6

Printed and bound in the United States
10 9 8 7 6 5 4 3 2 1

*This memoir is a work of nonfiction, drawn from my own memory. Some names and
identifying characteristics have been changed to protect the privacy of others, and some
conversations have been re-created to the best of my ability.*

Abrams books are available at special discounts when purchased in quantity for
premiums and promotions as well as fundraising or educational use. Special editions can
also be created to specification. For details, contact specialsales@abramsbooks.com or
the address below.

Abrams Press® is a registered trademark of Harry N. Abrams, Inc.

ABRAMS The Art of Books
195 Broadway, New York, NY 10007
abramsbooks.com

For my family and Marcelle Soviero

There was never a plan. There was just a series of mistakes.

—Robert Caro

PART I

CHAPTER 1

My grandfather Ed was killed one frigid March afternoon in 1964. He was helping fix a septic tank when his bulldozer flipped over and sliced him in two. His severed body tumbled into the ditch he had been digging. I imagine that the funeral home told my mother, who handled the arrangements because Mamaw was too grief-stricken, to bring only a suit jacket; he wouldn't need any pants.

Ed's home, which he built by hand with his father, was something between a shack and a rough-hewn mountaineer cabin. It was the family homeplace and the heart of life in the holler. Its three small rooms were filled with cots for the eight people who lived between its unevenly plastered walls. Every inch of space was given over to communal sleep. When Ed died, the beds were folded up and his open casket was placed in the room with the coal stove, the room where he had shared a twin bed first with his centenarian father and later his young son. He lay there for two days and nights, while family and friends from up and down the country came and paid their respects. Employees of the Division of Forestry ferried people along the holler in 4x4s as a courtesy. Over 300 people came up the winding creek.

My mom, then only fifteen, had never invited anyone other than her kin to the shack. She worried that when people actually saw her home, its lack of a living room, its drab army green surplus paint job, its rag-caulked floorboards, the taunts from her classmates would get even worse. "Holler Rat," they'd spit when she sat too close to them on the bus—the bus that she walked two miles

to get on, the bus that took another hour and a half to reach her school in the Breathitt County seat, Jackson.

<p style="text-align:center">* * *</p>

The history of my mother's family has only been offered in dribs and drabs. I've caught bits of whispers and tried to deduce answers from fading and sparse photographs. What I know now is a quilt of accumulated hand-sewn stories, and no doubt some have been told or heard wrong. When my family does tell stories, they tell them big, and my mind fills in the gaps they leave. My imagination can be a seeping thing, and where the seeping meets the sown, I cannot accurately say.

As a child, I imagined Ed's lacerations began to fester on the second day, and the undertaker reembalmed him on my mother's folding cot while she held the glass container of preservative, her pet rooster perched steadfastly on her shoulder. That night, when Ed's body was put back into his coffin, my mom slept on a mattress beside him.

This part is certain: During the home viewing, someone took pictures of Ed lying in his box, eyes shut forever. Later, pictures in hand, the photographer showed up at the shack, its walls still shivering with mourning. The man offered them to Mamaw—for a price. My mom stepped in, emptied a Mason jar of quarters and nickels, piled the coins into dollar stacks. She looked at the images glazed on the square Kodak paper, but when she closed her eyes, there her father was, clinging to the inside of her eyelids. She tried to pull him back from the glow, but he just couldn't make it.

My mom hid the pictures in the *L* volume of her *Britannica* set, which her father had paid for by installment. She turned the pages until she came to *limestone*, her favorite sedimentary rock, the one that her native state was famous for and the one her father had been moving when he took his last breath. Its high pH gave Kentucky bourbon and moonshine their distinctive, fermented flavor. There, between the translucent pages, she let her father rest in the crease of the binding. Her loss rubbed up against the accumulated knowledge of the Western world; her pain cradled by the accomplishments of mankind. She

had savored every volume of the encyclopedia as it arrived in sturdy, special delivery boxes. She held the onionskin pages up to her nose and inhaled. She knew that smell; it was the smell of faraway.

Forty years later, sometime when I'm in graduate school, I'm rummaging through my mother's dresser drawer, looking for a clean pair of underwear. I feel them before I see them, their edges like baby teeth bursting through gums. I pull the slim stack of pictures out. There he is, half a man in a box. Surrounding him are his sisters and brother, one of whom is stroking his forehead. They gaze at him like mechanics examining an engine. His body is a fact they can't comprehend.

I don't know why these photographs are hidden in this drawer with my mom's most delicate things, nor how they made it there from the encyclopedia. But I do have a memory. Sitting up late with Mamaw one night, curled up on her sofa, looking through a shoebox of old photographs. There was a picture of a man in a coffin. Not Ed, but my cousin Larry who killed himself in 1973. Mamaw said, "Now that there was right awful, the way they did."

"The way they did what?"

"Those people come around and take pictures at the funeral. Then they'd sell them to you. Right wrong I say."

Mamaw held onto the picture of Cousin Larry for a long time, worrying its edges before putting it back in the shoebox. Then she took a long drag on her Salem cigarette. "Right wrong, Anya. Right wrong," she said.

I wondered, what would I—or anyone—do with pictures of my father in a coffin? Pictures of the person you love the most on the worst day of your life? Pictures you were then blackmailed into buying? Can't throw them out. Can't put them in a photo album on your coffee table. Hiding them in your underwear drawer makes sense. Maybe there they can be kept both close and quiet.

Getting my mother to talk about her father is a largely futile task. It has been my entire life. She's like a hermit crab who has come by her shell in the most horrific way. She almost never refers to her father as my grandfather; she simply calls him Ed, like he was just some guy she once knew.

Here is almost all the personal knowledge I have accumulated about Ed over the past forty years: He smelled his food before he ate it. He played the guitar. He loved fixing machines, especially trucks. He was short. He was a redhead. He had a cleft in his chin. He was a germaphobe. As a young man he made extra money as an amateur prizefighter. He liked to carve wood. He had a bullet from a .22 embedded in his shin, and sometimes, as a party trick, he rolled it around to freak people out. He had a pair of brass knuckles. When he got mad at himself, he bit his arm until it bled.

Looking back, there really was no question. I should have put the pictures back in their glassine envelope and buried them again under my mom's Hanes. There was no question that I should have done what Mamaw would have said and made no mind. But I didn't put them back. It wasn't just that I didn't, it was that I couldn't. These pictures were evidence of the moment my mom's life was set on a course facing into the wind, against the one prescribed by class, money, time, and gender. This moment shoved her out of the holler, beyond the crush of poverty, beyond the state of Kentucky. It sent her toward my father and tony Fairfield County, Connecticut, toward leafy Westport. To me. I needed to contend with this image of my grandfather, digest it in all its brutality. All my life my mother protected me from the pain of her upbringing. I was old enough to start feeling it. To understand myself, I needed to feel it. My original sin is not that Eve ate the apple. It's that my existence is inextricably tied to Ed's death.

In my hands, I held my origin story.

So, I stole them.

In Atlanta, where I was studying for an MFA in art, I drove to the all-night copy store, slid the picture, its emulsion cracked in several places by age, under the edge of the blueprint copier. Two minutes later a massive mimeograph bled out of the rollers line by line. There, for the first time, I faced my grandfather, life-size. Had I been able to hug him, I would know exactly how my cheek met his shoulder, exactly what his arms felt like around me. Lying there in his box, he looked like my mother napping in cold Connecticut sunlight. I rolled the paper up, paid for it, and took it home.

I tacked it on the wall of my art studio. It hung there for weeks and weeks, and I often stared at it until morning, trying to penetrate it with my sadness

and curiosity. He was split in two and so was I—part hillbilly, part Jew—part Ivy League, part crusty punk—part North, part South—part kinda poor, part kinda rich, all depending on the zip code I was in.

I thought if I could concentrate hard enough, I could make a Houdini trick real, make Ed levitate, whole and alive above his casket. I could make both of us whole, stitch together the places where we were split.

More than anything, I wanted to make this trauma mean something.

CHAPTER 2

I t always starts with an idea, an inside joke with myself. Sometimes it's as simple as a gesture, or as strange as a dream on fire.

This is about glue, specifically my lifelong propensity for smearing extra Elmer's on my skin when no one is looking. I'm sitting in my childhood bedroom, under a canopy of autographed pointe shoes, suspended NASA rocket models, and plastered Bruce Springsteen posters, massaging thick layers of it into the soles of my feet. Waiting and waiting and waiting, blowing hard to make it dry faster, feeling the crust encasing my skin and the ache of anticipation. And then the breathless ritual of shedding, peeling, my pores exhaling hard and pink.

Then I held the clear sheets up to the light to see the lacework of my footprints, actual proof that I was distinct from every other human. Just like the snowflakes I studied in earth science; I was singular but fleeting.

It's been twenty-five years since those nights spent shedding layers of myself, and I'm incredulous that I'm now in the midst of what was once my future. I want to know if I've made meaning out of anything at all.

Now, I am in the back of an art gallery, vacuous as an abandoned parking garage, which it probably once was. It's a totally artist-run gallery, operated solely by the sweat of artists for other artists. The prospect of profit is subordinate to the desire for risk and experimentation. It's the last of its kind in Chelsea, and in two years it will be replaced by a redundant Trader Joe's. But on this freezing October night, it's mine to command.

In the open space, three folding tables connect in a low horizontal line with tarps as tablecloths. Studio lights blaze through white umbrellas, and a few hired men with expensive cameras position themselves around the perimeter of what everyone has assumed will be the performance space. A handful of people are waiting.

But I'm hiding in the defunct bathroom stall that serves as a dressing room, having been equipped with an inoperative clip lamp and a cracked mirror. I kick back a swig of Wild Turkey from a flask, a preperformance nod to my Kentucky roots, then chase it with rusty tap water. Taking a shot before a show is strictly superstitious these days, a holdover from college when I was riddled with stage fright. I look in the mirror, adjust my habitually lopsided lipstick, and take a deep breath. Then, another ritual: I summon my strength thinking of what I once read the dancer and choreographer Martha Graham said to her company before every show: "Start from a place of strength."

I stride naked across the vast concrete floor, moving with intention and meter, a gait I've practiced for years. Without their bra to contain them, my breasts jiggle in tandem, first to the left and then to the right. Then they lose rhythm, bouncing off beat in opposing directions, as an unintentional sliver of my limp comes back. My right leg lands just a fraction of a second too late.

Sixteen or seventeen people have come to the show, four of whom I have known for years. Nude performance art doesn't draw crowds. I make prolonged eye contact with each one, flicking my eyelids down deliberately before casting them on the next person. There is no rush. I do not cut corners.

From under the eaves of the table, I grab one of the small bottles of Elmer's glue. Then, with silent but exaggerated focus, I line up twenty of them on the front edge of the table. Using psychic energy, I try to make each one feel like a key to an unknown experience, an invitation for the audience to enter a new space.

I stare out into the dark again, and like a child coaxing a rabbit with a carrot, I offer a bottle to the audience.

No one approaches, so I gesture, theatrical and heavy this time, for them to please, come up and take.

Then I climb onto the table, naked as a freshly peeled apple.

Nothing happens.

I can sense the audience is confused, waiting for something to occur. I've done this many times, and I can read them by the little pops and scuffles they make. I can hear them look at one another.

Still, nothing happens.

They aren't doing what they are supposed to do.

I've planted a participant in the audience. My ringleted college roommate, Dawn, steps into the light. She opens the orange nub of a bottle and then pours a continuous stream of glue until it puddles on my chest and catches in my clavicle. When the whole bottle is empty, she smears the glue until my breasts are completely covered.

This does the trick. The audience has the hang of it. One by one they approach the table, and one by one they pour glue all over me: my eye sockets, my belly button, the mound of my stomach, behind my ears and between my toes. One man empties an entire bottle into my pubic hair.

When every spot is covered and every container empty, the audience sits.

They don't know what will happen next. I do.

We wait until I dry, together.

We wait at least forty-five minutes, in semi-silence.

There is coughing, sneezing, low conversations, then not-so-low conversations, cell phone calls. The photographers talk shop. People plan bars to hit once I'm done.

I'm perfectly still, though two pieces of my hair are now fused over my eyes. I bat my eyelashes to swat away the strands of hair, but instead, the glue covers my lashes and they seal completely shut.

Then, after a time, they seem to realize what they are meant to do. They come back, the audience, at first tentatively and then all at once. They peel every inch of me—the goop from under my ring, the thin layer in the hair on my upper lip. The same man who dumped the container into my pubic hair is eager to pull the glue up from my inner thighs.

They peel for two hours.

When the gallery director taps the tip of my finger, our predetermined sign that all the glue is gone, I rise from the table. Four hours have passed. Six people have stayed with me through the whole thing.

There is a smattering of applause.

This is how I survive being myself.

CHAPTER 3

M y story begins in southeastern Kentucky, Ganderbill Holler to be exact, where my mother's people have lived for almost two hundred and fifty years. Huguenots and Scotch-Irish, they arrived in the colonies as indentured servants and itinerant workers with little more than the clothing on their backs. Their rogue, clannish, roughhousing ways were not tamed by the journey across the Atlantic, and eventually their restlessness led them to the perpetual edge of the frontier, pausing for a moment in the gentle dews of rural Virginia before pushing deeper into wilderness. Of course the land was not theirs for the taking, but they followed Daniel Boone over the Blue Ridge Mountains through the Cumberland Gap and into the Appalachians. There, they burrowed in the hollows made by the crevices and gaps between the mountains, living first in caves and then in hand-hewn log cabins. It wasn't long before the word "hollow" was transformed by familiarity into "holler."

The revolution came. They served, eager to distance themselves as far from those goddamn bloody redback British bastards as possible and were rewarded with deeds to swaths of distant mountains and irregular, mostly rocky, infertile fields. One side of my family, the Fugates, an Americanization of the French name Fouquet, immediately implanted themselves in the land, then sprawled out and into East Kentucky like a long-tined fork. A few other families did the same.

Growing up, this was just one of a slew of differences between my mother's Kentucky mountaineer family and my father's Americanized Eastern European Jewish family. On my mother's side, identity was not only tied to the land,

it *was* the land. Year after year, the place where your family had settled became more and more associated with your name and your people. This tie was so strong that the land could easily be confused for your corporeal body. To leave the land was to betray it. And by betraying it, you were also betraying yourself.

And for that, you should forever live in shame.

On my father's Jewish side, identity was tied to being perpetually driven off land, to having no home of your own. You must always be ready to run. If you stay in one place too long, they will come for you. And when they do, as is inevitable, you will follow in the grand family tradition of pogroms and persecution. Any Jews who convince themselves that the land they stand on is theirs is a putz; a false sense of ownership is the precursor to betrayal.

From this riddle of a relationship my younger sister, Allyson, and I emerged.

* * *

But my mom's family implanted themselves into the land for other reasons, too.

My family loved the voluptuous morning fog and the thunder that rolled like damnation over their moist creek beds. They loved the creatures they shared their homes with: crawdads that pinched their way out of silt, chub minnows that dappled the creek, hickety frogs that grew from cream-colored masses into glistening tadpoles, salamanders they nicknamed "thundersluts" for reasons no one can remember. They took special care of toads because they ate insects that pulverized crops.

"Don't touch that toad, youngin'," Mamaw said.

"Why not?" I asked.

"You hurt a toad, you curse the cows. Turn their milk to blood."

That sounded a bit of a tall tale, but anyone who knew anything knew that Mamaw knew just about everything.

Within these hills, my kin raised hell mostly free from the rules and regulations of a nascent government. Though Kentucky became a state in 1792, my ancestors then and even now looked at the law as a suggestion—more a formality than a fundamental ethos. They were insiders, cocooned by the safety of their mountains, and everyone else were outsiders—a potential threat to their independent existence. Their area of Kentucky, legally known

as Breathitt County, became known as "Bloody Breathitt," a place ruled by a steadfast pioneer anarchy that terrified renegades and innocents alike. Here they could shoot their rifles at anything they damn well pleased, anytime they damn well pleased. They could raise their chickens and their children the way they wanted. And though the difficulties of their new home could sometimes be mistaken for exile on Elba, over time, my ancestors reveled in their seclusion, wrapping it around their families, farms, and foals. They hardened into mountaineers, proud hillbillies, whose most persistent wish was to be left the fuck alone.

Basically, my kinfolk got their wish, sometimes so much so that it seems like time—time with a capital T—slid right past them. Our little pocket of Kentucky remained largely unaware of innovations like locomotives and typewriters and assembly lines, clueless about curling irons and electric coffee pots long after they made their debuts in more industrialized places. Part of it was just that they weren't needed in the mountains. People lived the way they always had, off the land, and at least in my family, they mostly liked the way they lived. Anything else was the subject of suspicion. Other advancements took longer to take hold by necessity. Automobiles could not pass through the narrow, wooded Cherokee footpaths, so horses remained the main form of transport until the mid-twentieth century.*

It was in 1955 that, using an army surplus Jeep and a winch, Ed managed to get the first automobile up to the family homeplace, effectively cutting the first real road up the holler in the process. It was still dirt and barely passable until the county expanded and paved his cut in 2001, a belated gesture to modernization.

* * *

Growing up, most things about Ganderbill were portrayed to me as utopian. While my father told stories of intense tetherball matches at Jewish day camp, my mother told of building magical huts by hand and chiseling into rock

* When the midwife who delivered my mom arrived at the shack for her birth, it was by horse in the middle of a blizzard. Mamaw always swore "the snow was up to the horse's belly."

outcroppings to unveil the saga of geologic time. While my dad played Davy Crockett on his suburban elementary school's blacktop, my mom ran wild on five hundred acres not far from where the real Davy Crockett was born.

When I was ten, I interviewed my Jewish grandmother, Na, in West Hartford about what she remembered from the Depression.

"I was only a kid, but what I remember most was sad-looking men on long bread lines. One was close to my school. I passed it every day. And your great-grandfather had many patients who couldn't pay their medical bills, so he was paid with all sorts of things: eggs, fabric, once somebody tried to give him an accordion."

I expected that Mamaw would say the Depression was even worse in Ganderbill. To my kid eyes, everything in East Kentucky still looked like the pictures of the Depression in my history textbooks. But when I asked her, what she said was, "Why we couldn't tell no difference. Everything seemed same it always was. People didn't have nary a thing anyway, so they didn't know what they were missing."

"Really?" I didn't believe her.

"Why, we was poor to begin with."

"But did you hear people talking about it, the Depression?"

"Well, I figure we did better than most because we never stopped living off the land. We made everything ourselves, we did. We never depended on anyone. You wouldn't know there was Depression here."

This was a great point of pride for Mamaw and my great aunts and uncles of that generation. It's part of the reason why Lyndon Johnson's Great Society, with its plethora of government assistance programs and financial subsidies to "alleviate poverty," offended them so much.

"A person has to do!" Mamaw used to say. "If a person don't do, then he ain't nary much at all."

Among the more poorly kept secrets in my mother's family is the extent to which they inbred; generations interlocked in tenacious sailors' knots. It's unfair to paint consanguinity as exclusive to mountain people; if people look down on hillbillies for their supposed inbreeding, they should also look down on almost every royal family in Western Europe since at least 1500. Still, some parts of my family tree do coil around themselves with hazy boundaries.

Children were raised communally, sometimes in part because their parents were not really that much older than their children. My double-double great-aunt (a relational term as complicated and convoluted as it sounds) gave birth to a son at age twelve; her sister gave birth at fifteen. Their children were quickly absorbed into the larger mass of children in the holler. Almost every-one was related, and almost everyone started to look a lot alike.

Our inbreeding is notable in that it led to a very peculiar ailment. A distant branch of my kinfolk, known as the Blue Fugates of Troublesome Creek, are carriers of a gene that produces the disease methemoglobinemia, which gives the sufferer a blue tint to his or her skin. Which essentially means that, if you want to go there, I am descended from Smurfs, minus the mushroom houses. Unfortunately, my close branch of the family has a different suspected genetic malady. Sometime in their midforties, Fugates often just keel over and die. The heart defect is called "sudden cardiac death syndrome."

Today, I am forty-five.

Among the odder misconceptions about East Kentucky hillbillies is that they currently speak a form of actual Elizabethan English. At an artist residency in rural Virginia, I suffered silently while a dining companion gave an exegesis of "the people like the kind you would see in *Deliverance*" and how they speak like they are in "Olde England." I wasn't about to get into it with her. It would kill the artistic Zen vibe I was trying to cultivate. However, because they were so physically and philosophically isolated, my family's language, like the English of many holler families, *does* have a few vestiges of Elizabethan-era phrases and songs. Like in Shakespeare's day, my relatives say they are going "a-huntin'" and "a-fishin'." Mamaw and my mother referred to buttermilk as "bonny clabber," a term brought to the mountains by the Ulster Scots of yesteryear.

But other rural ways were alive and well almost up to my birth in the late 1970s. Before LBJ, instruments were homemade. Entertainment was home-made. Basically, everything was homemade, from the shoes on feet to the straw pallets to sleep on. Over the years, a constant flood of donated clothing made its way from more prosperous areas of the US to the humble churches of Breathitt County. Heaping piles of already worn, sometimes soiled linen were picked through and refashioned: jackets became britches, tablecloths became

16

bloomers, bedsheets became diapers. Buttons, hooks, and findings were scavenged, and zippers were stripped from crotches. Dresses were made from empty calico-patterned feed sacks. Once these wore thin, the fabric was salvaged for patchwork quilts stitched by nimble female hands. And once, in turn, these wore thin, they were cannibalized for rugs, combined with Mamaw's old, flesh-colored stockings and braided into neat circles. When these were worn thin, they were turned into rags to caulk the gaps in the floorboards. Like scrawny alley cats, every object had at least nine lives. Hillbillies are the original hipsters, OG farm-core, proud hicksters long before the term was reappropriated.

The New Deal brought the magic of civil engineering, the postal service, and social security. It brought weatherproof public-school buildings and asphalt-covered state roads. It brought radio towers and Alan Lomax. Next came the Tennessee Valley Authority and the Civilian Conservation Corps, the latter of which Ed joined in the midst of the Depression, heading out to Nevada to work in forestry conservation and wildfire prevention. Later, he courted Mamaw, aged twenty, for a few weeks before they eloped at the courthouse in Hazard, the "big city" far off in Perry County. A month later, at the age of thirty-four, he enlisted in the army and spent the next four years serving in New Guinea in World War II.

When I went to Kentucky, it was always with my parents and Allyson until after I graduated from college. On that first trip alone, I waited until the perfect moment, the post-dinner ritual eating of Little Debbie Zebra Cakes, to ask Mamaw more about Ed.

"Well, youngin'. I don't know what there is to tell."

"But what was he like, as a person. Was he funny?"

"No, not quite funny. Why in fact he used to have a pretty bad reputation, he did."

"Like he was mean?"

"No, child, I don't mean he was mean. Not that. You're gonna have to ask your mommy what I mean."

She winks and then her pruned face bursts into laughter.

"MAMAW!!!!!"

She is laughing so hard that she starts hacking up her cigarette.

"Ohhh . . . Oh Lordy! Oh Lordy."

She has to catch her breath.

"Now don't tell this."

I am transfixed.

"Oh yes, that man he had him a bad reputation—they called him a 'red-head rounder.'"*

Though he lived just one holler over from her and she knew his people—was distantly related to them as a matter of course—she had never thought of him as a prospect. Then one day, she saw him come whipping up her holler on his horse, flying like a bolt of lightning.

"I never seen something so wild. Just a red streak in the sky."

She looked at me, her eyes so wide they defied her wrinkles.

"I mean that man, that man, he was truly wild."

By the time Ed was married, he was something of a local hero, and by the time he died, he was a local legend. I'm pretty sure he was the man people called when someone died and had to be "laid out"—groomed and made presentable for a home viewing and burial in the time before funeral homes sprang up. He learned the skill while stationed in the Pacific, where I've gathered he helped prepare dead soldiers' bodies for transport back to the United States. He was also the man that folks in the holler called whenever they found a menacing nest of wild bees. Without wearing any protective gear, he would whisper to the queen and quietly rehome the colony, sometimes driving them to their new location in his pickup truck, his face swarmed with insects. He was never stung.

Mamaw also said Ed was a hillbilly wizard. He was rumored to be able to stop bleeding in any sentient creature, near or far, by merely invoking the "Blood Verse," Ezekiel 16:6, four times, an ability thought to be passed from mother to son, father to daughter, throughout the Appalachians. He was also known as a water witch, able to divine the location of groundwater, a power he passed on to my mother, who, in the midst of a historic drought in 1956, helped him locate the new well at the homeplace. In his spare time, Ed cut roads up the most secluded hollers so children could get to school and learn

* A wastrel, a drunk.

18

to read and write. He wired soot-caked shacks with electricity, installed indoor plumbing and septic tanks, and strung up telephone poles. When he died, all of Breathitt County was given half the day off to attend his memorial service in the newly built high school stadium.

* * *

Some of what I think I know has come from hazy stories told hazily.

I am pretty sure that my great-grandmother, Granny Julie, was illegitimate, a love child of her young mother and an older married man. Her mother had died in childbirth and her grandfather raised her. She was descended from the Collinsworth family, another branch of which was known up and down the country as the "Shagnasties," a slur for people whose squalor was particularly exquisite. Granny wasn't a Shagnasty. She wasn't a Tyewhoppety either, a colloquialism meaning a generally slovenly looking person. But Granny had a peculiar birth defect. She had an extra thumb, a tiny one. This appendage even had a teeny thumbnail. When I was little and I held her hand in the summer, she would wrap her little bit around my pinkie like a freshwater worm, but mostly Granny used it to pluck her banjo.

She went to school for a time. My dad, who had been obsessed with my mother's history for almost a decade before I was born, said Granny's classroom doubled as the schoolmaster's chicken coop, and that every morning she had to shovel chicken shit before she could sit down for her lessons, but he might have been joking. Granny mostly made her education outdoors regardless, becoming an expert in the local flora and fauna and a well-regarded medicine woman. She used willow bark and witch hazel, elderberry and red bud, sycamore and milkweed to tend ailments. Occasionally she used hemp to heal, and just as occasionally she dried it near the coal stove and smoked it out of her handmade corncob pipe. My father often sat out on the porch with her at night and smoked his pipe, a corncob like hers in an attempt to fit in. Sometimes a not-so-nice great-aunt of mine used to sit out with them, too. When my father would get up to go inside, she would refer to him as "that dago," which I think is just because she was confused about her ethnic slurs.

Granny was half-Melungeon* and half-Cherokee. In 1918, my great-grandfather, Old Man Gran, then aged sixty-eight, married Granny—then twenty years old.† As if that isn't problematic enough, there is this: Since Old Man Gran was born in 1850, stories about him are blurry, but what I was told when I reached a certain age was that Granny's grandfather (my great-great-great) was rumored to have sold her to Old Man Gran as a housemaid at age eighteen.‡ After his first wife was gored by a bull and died of her injuries, Old Man Gran married Granny and eventually fathered four children by her—Ed, who was their oldest, and my three great-uncles and -aunts.

Old Man Gran didn't work in the coalmines like most other men of his era. For a time, he owned a sawmill and floated logs out of the holler and up to Frankfort via the Kentucky River, then walked the two hundred miles back home. The family myth I was raised with is that at 103, he fell off the ladder while he was repairing the roof. He died a few days later, his death rattle shattering the nighttime silence of the shack.

The spot where Old Man Gran supposedly collapsed was known as the "Grandied," just as the spot where he once burned a tubercular dairy cow was known as the "Cowburn." Other tales of woe gave way to placenames: "Suzie Rock" was a cliff up on the holler where a sheep named Suzie plunged to her death. "Ram Hole Holler" was named for a ram that fell into a whirlpool, and "Cut Shin" is self-explanatory. These places, along with the ditch into which Ed's severed body tumbled, were the topography of my mother's, and later my, childhood.

Eventually the area my family lived in, Fugate's Fork, became known as Ganderbill Holler, named for the rock formation at its head that looks like a goose beak—at least that's what Mamaw said. The mouth of Ganderbill begins where several delicate creeks, known as "branches," trickle out of the hills and converge below Ram Hole Holler. At its deepest, the creek is two feet, and ten

* An Appalachian triracial group comprised of European, African, and Native American descendants, rumored to be the survivors of the lost colony of Roanoke.
† This age difference is even more stunning when I consider that my great-grandfather had been almost old enough to fight in the Civil War.
‡ My father says that one of his first memories of walking in downtown Jackson, Kentucky, in 1971, the year my parents were married, was watching a man in overalls leading a donkey down the street calling out, "I come to buy me a woman! I come to buy me a woman!"

at its widest. Ganderbill is about a mile long, twisting up past Pheasant Holler, near the cave where my ancestors spent their first frigid winter in the mid 1700s; near Mean Wolf Pen Holler, where someone tried to trap some wolves that were stealing livestock; past Deep Holler; and wrapping around itself near Little Brook, the cold creek where Old Man Gran washed his face every morning. Little Brook guards my mother's favorite wild plum tree and sits just below Peddlar's Rocks, named for a long dead coonhound. It's not far from Terrapin Station Point, a spot on the hill up behind the shack where season after season terrapins come to mate, humping and heaving on one another's hard shells.

Somewhere on the hill is where my Old Man Gran's father, apathetic about the Civil War, which Granny always called "that awful Silver War," was shot and killed by marauding Yankees while he was milking his cow. Also up there is where a Fugate cousin was hanged by his tongue by locals for talking to the enemy. Farther up the creek, Ganderbill meets an old horse path that takes you over by River Caney and past the old Cherokee burial ground to the Fugate family cemetery at Low Gap Holler, where Old Man Gran, Granny, Ed, and Mamaw are buried.

My mother knew this land by heart, and from her earliest years she knew that one day she would inherit it. She drew maps of her hills and hollers in the dirt by the coal bank, a four-foot-thick seam from which she and Mamaw hauled coal in galvanized steel buckets, rain or shine, sleet or snow.

Her first lesson in geography was the holler. She memorized its drainage chain like a nursery rhyme: Ganderbill Holler empties into Lost Creek, Lost Creek empties into Troublesome Creek, Troublesome Creek flows into the South Fork of the Kentucky River, which flows into the Kentucky River proper, which flows into the Ohio River, which flows into the Mississippi River, around the delta, and empties into the Gulf of Mexico, which empties into the Atlantic, which rushes around the great, big world.

CHAPTER 4

S ometimes I imagine what they were like before they imagined me.

Her: Even before the Peace Corps orientation meeting was called to attention at the filthy fleabag Sylvania Hotel, my mom was sitting at the long table, waiting. Her notebook was turned to a blank page, her pencil perfectly sharpened because all her pencils were always perfectly sharpened. My mom was thrilled to be at the Sylvania, thrilled to be in the big city of Philadelphia, city of Benjamin Franklin and the Liberty Bell. It was like living in her history textbook.

At twenty-one, she had flawless penmanship and an adorable gap between her front teeth. That little space insured she won spitting contests among her cousins and anyone else who dared to challenge her. In another life, she might have had orthodontics, gotten wired up with elastic bands and palate expanders, but she had never been to a dentist and had only seen a doctor a handful of times.* Her father had administered the few vaccines she had, usually at the same time he injected the cows against the pox.

Implausibly, she'd spent the past three years in upstate New York at SUNY Brockport, enrolled in a Peace Corps preparation program. How she got from East Kentucky to a stone's throw from the Canadian border is still a bit of a mystery to me. I know that to get into the Peace Corps at that point, as she

* Growing up, she often followed Granny's remedies, which included: If you have a nosebleed, place copper pennies on your eyelids. If you have a wart, pierce it with a needle and thread a string through it. If you have a sty, go to an intersection of two roads, face each direction in turn, and repeat, "Sty, sty, go away, go to the first one who passes this way."

was determined to do, she needed to attend a school with a certain preparatory program, and the one school that would take her on scholarship was SUNY Brockport, just outside of Rochester, New York. Still, the leap seems not just somewhat, but completely improbable. Who runs away to Rochester, New York?

When she arrived in Brockport, her Kentucky accent was twangy and tight. Her college friends had thought it was hilarious, especially the Jewish boys from the Bronx who introduced her to bagels and lox and taught her to say "oy gevalt." But she knew she had to lose it or people would think she was an idiot like Elly May Clampett on *The Beverly Hillbillies*.

Almost immediately, she learned to say "soda" instead of "pop," "I think" instead of "I reckon," and "over there" instead of "yonder." She had to relearn proper verb forms, like not saying "set" when she should say "sat." She had to scrub her "ain'ts" and "y'alls" and relearn which parts of words to emphasize—no more "seeee-ment" or "pooolice" or "Deeeetroit." During student teaching she knew when her accent kicked in because the kids would mimic her. Learning Spanish helped because it changed the way her mouth could move. Sometimes it was easier to learn new words in Spanish than to relearn English words without the accent. And every evening in the dorm common room, she listened to Walter Cronkite deliver the nightly news. As he spoke, she silently repeated after him, and gradually her pronunciation shifted. But the vowels stuck hard, and when she was angry or drunk, her accent came back full force.

A childhood of late nights reading by flashlight had caught up with her, and she now wore round, wire-rimmed glasses like Granny Julie, but hers were the cool John Lennon kind. The optometrist had to craft a custom bridge for her since her nose was so elfin. Its tip turned up toward the sky like a jolly turnip.

Her roommates marveled that even after a few shots of Rebel Yell, her favorite bourbon, she could recite the scientific name of every bone in her body and identify bird species from fifty yards off. Rather than going to the infirmary with their ailments, roommates came to her, and she sent them to the health food store after herbs they had never heard of. Instead of beauty cream and hand lotion, her nightstand held an arrangement of her favorite

rocks. Other people collected record albums; she collected fossils. On road trips she made her friends pull over to admire the rock striations and geologic graffiti by the side of the highway. She would run her fingers along the edges of the rocks, cooing at every glittery seam of mica, every anticline. It was easy to compare it to the striated surface of East Kentucky limestone; she carried a little rock from the Ganderbill creek bed in her purse. She rubbed it when she was homesick and remembered that human life, in geological time, is nary a thing at all.

She sewed her own clothes using Butterick patterns and discount calico. Her favorite dresses were buttoned-up prairie numbers with frilled hems. She paired them with dainty lace-up boots and ancient crocheted handbags from the Salvation Army. She matched puff-sleeved blouses with hot pants and fish nets. Hippie chic was easy for her to master; it was basically hillbilly clothes with flower crowns and leather fringe. She talked to trees, spontaneously reaching around their trunks and pulling into them for bear hugs. "You old oak. You are glorious."

Even before college, she had been working toward this moment at the Sylvania Hotel. She was fourteen back in March 1961, the day JFK founded the program, and she and her father had driven an hour and a half to the nearest town, Jackson, to watch the ceremony on a television through an appliance store window. This was the second time she had ever watched TV.*

On the long ride back home to Ganderbill that afternoon, Ed and my mom had talked about signing up as a father-daughter Peace Corps team—maybe heading to Ecuador or Ethiopia or Madagascar or Malaysia. The nights when Ed was at home and not traveling across the Southeast working for the Division of Forestry, they fantasized about distant jungles. She knew Ed expected her to leave the holler, whether for the Peace Corps directly or college first, even if it meant she never came back. His daughter was too smart to stay locked in the hills.

After Ed died, my mom stopped spinning the globe. Mamaw and Granny sobbed for months, and then Mamaw had the whole shack whitewashed,

* As a kid, I found it shocking that she had not seen a television until she was thirteen years old, and then only a few more times until she went to college. My mom said that "no TV show is as exciting as watching a thunderstorm come up the holler."

the dark green army surplus paint stripped and covered over. She ordered factory-made furniture she couldn't afford and covered the worn floorboards with wall-to-wall carpeting. She started chain-smoking Salems, taking long, sucking drags and hacking through sleepless nights. It was like she was trying to choke herself. The day he died, Ed had packed a suitcase for a business trip later that week, and after his death, Mamaw refused to unpack it, choosing to pretend that he was just away for a few days, a few weeks, a few months. They kept it right where he left it, in the cut in the sheetrock that served as a makeshift closet. More than fifty years later, I'm pretty sure the packed suitcase sits undisturbed in the back of my mother's closet.

When Ed died, the family lost a father, a husband, a brother, a son, and perhaps most importantly, its leader and its sponsor: the man who handled it all. He looked out for his elderly parents, watched over his younger siblings and their young children, and financially supported most of them. So *someone* had to take charge, which meant that that *someone* didn't get even a moment to grieve. All of fifteen years old, my mom dealt with the funeral home, the sheriff, the coroner. She wrote the obituary and provided the newspaper with photos. She called the preacher, Red Coombs, and asked him to speak at the funeral. She received Ed's watch and wedding ring from the undertaker. She went up near River Caney where he was killed and retrieved his pickup. The bulldozer still sat there, tipped on its side, wholly unapologetic.

Thinking she had successfully hidden her grief over her father's death, she developed daily, blinding migraines and passed out in chemistry, English, and Latin classes. Because she did not worship at the altar of high school football, she was deeply uncool everywhere but in her sanctuary, the library. Her best friend in the big, brand-new county school was Mrs. Childers, the librarian. Sometimes she saw her father floating in the aura of a migraine just before she blacked out, but she repressed her pain into perfect grades and voracious reading of nineteenth-century novels—*Pride and Prejudice, Middlemarch, Great Expectations*. To stave off her nerves, she chewed every pencil she owned down to the nub. On pitch-black nights, as she listened to Mamaw and Granny sob, she imagined the smell of anything faraway.

When Mamaw cooked, she cried into the pots and pans. My mom couldn't bring herself to eat her mother's tears, so she stopped eating and no

one reminded her. She found that she liked feeling emptied out because there was less for her sadness to permeate. It wasn't long before she discovered that if she took up less space, just about everything lessened. Occasionally, she ate cold cornbread mixed with buttermilk, but she still lost so much weight that she stopped getting her period and her arms became covered with downy fur.

Mamaw insisted she go to the local doctor, and he prescribed her amphetamines for her headaches. She told Mamaw she hated the pills and that the doctor was a fraud. Mamaw told her not to doubt the doctor, he had proper training. She lost more weight, and he prescribed her more amphetamines. She lost even more weight, so she threw out the pills and started eating Ritz Crackers by the boxful. Despite how fragile she must have been, she was class valedictorian. Mamaw sobbed the entire ceremony.

My mom read about Sarah Lawrence College in Bronxville, New York, in a free ACT brochure she found in the library. She asked Mrs. Childers if she had ever heard of the college. Mrs. Childers said it was famous, one of the top colleges for women, and that to get in she would need to fill out an application and maybe attend an interview. My mom asked her high school career counselor what she needed to do to go to Sarah Lawrence. He told her he'd never heard of the place and asked why she would want to leave Kentucky anyway. Besides, places like that were expensive and not for holler folk. He had a brochure for a secretarial school; maybe she would like that instead.

"I don't want to be a secretary. I want to be a scientist or an astronaut."

The counselor threw his hands in the air and begrudgingly went to a filing cabinet. He dug around for a while, finally producing an application for the nearest state college.

"Here," he said, "College."

But Mamaw didn't want her even that far, just a few hours up the road. As the oldest child, my mom was expected to stay close and take care of her mother as she moved into old age, especially because Mamaw was now a widow. What's more, the massive, extended family of double and triple cousins that Ed had kept together had begun to collapse, engendering stereotypical Hatfield and McCoy–style feuds. Petty squabbles over who owned what turned into escalating threats. Fights broke out over food and coal and cars. Babies

gave birth to babies. One cousin shot himself in the head; another most likely killed a man and fled the state.

Then a letter from the state college arrived, and my mom's resolve to get out strengthened. She couldn't live in the shack with her father's memory just hanging there. If she stuck around, she'd be expected to get married and pregnant over and over again like her cousins. It wasn't that she wanted to abandon them, it wasn't that she wanted to be disloyal, it was just that the thought of being stuck up at the head of a holler, hauling buckets of coal, spending her life scrubbing a washboard, made her want to run.

There was another factor in her desire to leave: Lyndon Johnson's War on Poverty. As part of his Great Society program, LBJ promised to address income inequality in the country by creating created a slew of government welfare programs and other support services designed to lift people above the poverty line. After his declaration of "unconditional war" in January 1964, right before Ed died, television crews had started flooding into the hollers, producing wildly biased documentaries about hillbillies and their supposedly anachronistic ways of life. On the national news, images of deprived children apparently so poor they ate dirt were juxtaposed with images of body bags shipped home from Vietnam. Child brides held rickety, malnourished children in their arms. Toothless miners sat, dusty and forlorn, in crooked coal company houses. Charles Kuralt toured shacks, reporting on the squalor lurking in America's backyard.

Television also poked fun at my kinfolk with characters like Gomer Pyle and shows like *Hee Haw* and *The Beverly Hillbillies*, all presenting them as foolish, dirty, and backward. Even my mom's favorite flavor of pop, Mountain Dew, featured a cartoon of a barefoot hillbilly shooting at an "outsider" on its aluminum can. Not so ironically, this label echoed a real incident from the war on poverty. Down in Letcher County, Canadian cameraman Hugh O'Connor trespassed on Hobart Ison's land while shooting footage of poor miners. Ison shot him dead. Any of the Fugate clan would have done the same.

My mom knew she was poor, but she had no idea exactly how poor until those stories and images came raging into the spotlight. Finding out that the rest of America thought her world pitiful, a national embarrassment, really took the wind out of the sails of youth. Ed had always made sure that her

family had everything they needed and more. She had never gone hungry a day in her life. They might be poor, but they were proud, self-respecting people who cared for others and for the land they lived on.

When the cameras and politicians came in, my mom realized that she was the butt of the joke, as she had been when her classmates had called her "holler rat" every day on the bus years before. She was determined to prove them wrong. Leaving the holler was no longer a choice but a question of proving that she was worthy of existing.

After a year at the mediocre state college, my mom finally managed to find a career counselor who expedited her application to the Peace Corps. Up to that time, her only other experiences outside the holler had been a trip to Warner Robins Air Force Base in Georgia (all she could remember was eating eggs at Waffle House) and a senior graduation trip to Washington, DC. The Peace Corps was sending her to SUNY Brockport's preparatory program, and then on to West Cameroon—both of which sounded a hell of a long way from Lost Creek, Kentucky.

Mamaw refused to say goodbye the morning she left the holler with her two cardboard suitcases. She stayed inside the shack, howling that Jesus took Ed away and now he was taking away her baby girl. Though she was crying, too, my mom walked off the porch and didn't look back.

It was three hours by car to Lexington, a flight to Pittsburgh, a connection to Kennedy, a taxi to LaGuardia in New York City, a plane to Rochester, and a bus to Brockport where the state college teetered on the edge of Lake Ontario.

By the time she landed in Rochester, her suitcases had melted into clumps of paper pulp after her jar of Granny's best moonshine shattered and soaked everything. She smelled like 'shine for days.

CHAPTER 5

And then, him:
He stumbled in late to the meeting, his pale skin tomato red from too much time in too hot a climate. He was nursing a hangover late in the day, wearing the kind of ribbed turtleneck that only a Marcel Marceau imitator could find appealing. His daily duds were Nehrus and leather vests. His style had once veered toward prepster folknik, but ever since Bob Dylan plugged in an electric guitar at the Newport Folk Festival, he'd adopted a more existentialist style—more Kafka and less Kingston Trio. His teeth were perfectly straight, fortified by a childhood of fluoridated water and Ovaltine. As a ruddy kindergartener, his grandmother had brought him into New York to sit in the peanut gallery on *The Howdy Doody Show*.

My father had already spent six months with the Peace Corps in Puerto Rico and the Virgin Islands, was already cynical about its mission and completely over the inane orientation at this Philadelphia craphole, the Sylvania. He knew the drill: indoctrination into the mission of the Peace Corps (in short, modern day white man's burden mashed with the Roosevelt Corollary), use bullshit scare tactics about native insurrections, and attempt to debunk cannibal myths.

Earlier that year, my father had graduated from the University of Maryland with one strong conviction: the Vietnam War was a shitshow. The US had no business invading the small South Asian country and mercilessly dropping bombs on civilians. The war was nothing but a meat grinder for the guys of

his generation. So he'd rallied and marched and sang. He played the requisite acoustic guitar. He wrote vitriolic protest poetry and drew cartoons for the underground Students for a Democratic Society newspaper, *Grok*. He held his cigarette lighter up at all the appropriate moments.

During one demonstration, after speeches from Norman Mailer and Dr. Spock and the obligatory Peter, Paul and Mary performance, he helped encircle the Pentagon in a human chain of love and compassion. Together with fifty thousand other protesters, he chanted ancient Aramaic exorcism rites, determined to levitate the whole Department of Defense, turn it orange, and make it vibrate until all its evils were evacuated. He wanted to see Robert McNamara quake in his Brooks Brothers loafers.

The child of a member of the Army Dental Corps, my father had little support in his upper-middle-class Jewish home for his blistering hatred of the war. My grandfather called him a coward, a yellow belly, a goldbrick, a wimp, a pansy. My dad retaliated at dinner, shouting all his favorite protest slogans at his parents.

Fight the VD, not the VC!

Hey, hey, LBJ, how many kids did you kill today?

One, two, three, four, we don't want your fucking war! Five, six, piss on Nix!

Instead of being incited to rage at the military industrial complex, his mother begged him to take a shower, turn down his Joe Cocker records, and remember to put the seat down after he peed. His baby brother begged him to stop festooning himself with feathers and twigs and instead come toss a football in the backyard. His father just rolled his eyes.

However, after an incalculable number of fights and exploratory trips across the border to Canada, my grandfather, Pop, slowly began to come around to the idea that his beloved army just wasn't making the kind of wise decisions it used to back in good ol' WWII. He watched the flood of body bags on *CBS Evening News*, read Mailer's *The Armies of the Night*, saw the riots in Chicago, and witnessed police beat the crap out of shaggy-haired kids who looked like his son. And as time rolled closer and closer to the draft lottery, he decided it might be right to pull a few strings in the close-knit Jewish community of Hartford, Connecticut. In the final hour, it was a patient, Abe Ribicoff, Connecticut's Jewish senator, who came through with

a slot in the Peace Corps.* It was either that or whack his son's knee with a hammer.

Instead of being shipped to basic training, my father was sent to Peace Corps boot camp in rural Puerto Rico for a program called *Agricultural Extension*. He packed a copy of Rimbaud's poetry, the soundtrack to *Hair*, and a shortwave transistor radio. There were eighty-seven trainees vying for seventeen spots. If you didn't make the cut, you went straight back into the draft. Every aspect of daily life had to be conducted in French to prepare for their Francophone destination of Upper Volta, no matter how complicated or far beyond my dad's level of comprehension it was. He spent his evenings studying verb forms and sweating.

His days were more varied and more interesting. According to a report by the USDA, castrating bulls made them less aggressive and their flesh more marbled and tender. The Peace Corps administrators believed that doing this would give them a good chance of stopping starvation in Upper Volta, so for practice, the training camp had procured a lone bull, nicknamed Ferdinand. For weeks, the team practiced by piercing Ferdinand's nose and ears. When the day came to practice castration, it took twenty volunteers to hold him down by his hooves, and it was my father who ducked under his raging body to cut the spermatic cord with a pair of dull clippers.

At the moment of mutilation, the bull bellowed, and the men dropped their ropes and ran, abandoning my father in the dusty corral. He scrambled up a denuded palm tree, all those rope courses at summer camp finally coming in handy. A villager managed to distract Ferdinand long enough for my father to climb down. But it was god-awful, the blood, the squealing, the gore. He hadn't gone to college for this. He hadn't memorized Poe and Thoreau to rip the balls out of bulls. That night he listened to reports from Woodstock on his shortwave. It sounded like a real groovy scene. He wished he was on Yasgur's farm instead of sweltering in the Caribbean.

After the Ferdinand incident, in an effort to make amends with the animal kingdom, he adopted a baby goat that he named Goat. On his afternoons off, he would drink lukewarm Heinekens and sing to Goat from the *Hair*

* Pop had recently done his root canal.

soundtrack. One afternoon, my father skipped out of the village to meet up with his aunt and uncle, in from Brentwood to vacation at Club Med. After a pu pu platter and a few too many mai tais, he made it back to the village just in time to see Goat's throat slit. Some Peace Corps higher-ups from Washington were flying in, and the management wanted to impress them with a local delicacy. They went out of their way to serve my father Goat on a paper plate. He screamed that they were nothing but a den of spies.

He was called into a meeting, berated for thinking that he had any say in how to "dispose of government property." Did he hate the government? "No, I love my country," he said. Would he be similarly hostile to the government in Upper Volta? "Of course not," he said. Didn't he know that there were only seventeen places in the program? Didn't he know that he had already failed the bull castration test? Yes, he was fully aware. How could he forget? Didn't he know that they were keeping a permanent file on him? Didn't he know that this type of insubordination would not be tolerated? Didn't he know that the FBI also had a file on him? Didn't he know that they had made an exception for him, with all this subversive behavior in his past? Wasn't he grateful?

Yes, he was grateful.

They reminded him that if he didn't shut up, if he didn't comply, didn't do everything right, there was a plane waiting to airlift his ass to Saigon, regardless of how much sway Senator Ribicoff might have.

And yet, eventually, the powers that be relented. Impressed with his ability to learn French in six weeks, they gave him one of the coveted seventeen spots, contingent on his good behavior.

Abe Ribicoff might or might not have had something to do with it.*

My father was headed to Africa. Castrating raging bulls or even eating his pet was still better than being shot at by Viet Cong or shooting Viet Cong or having anything to do with the goddamn mess of the Vietnam War. He knew he was lucky. Really lucky.

Now it was the first day of the new session. All the Peace Corps volunteers who had headed to Africa in January 1970 were gathered here at the Sylvania. He looked across the conference table and saw my mom.

* Pop gave *really* good root canals.

My dad says it was love at first sight. My mom isn't so decisive. When subjected to close questioning, she usually says *meh*. What is certain is that that night they walked around Rittenhouse Square together and visited a psychic.

Her words of wisdom were: "Sometimes you will be happy, sometimes you will be sad. Sometimes you will be rich, sometimes you will be poor."

"That's it?" my father asked.

"Why don't you come back later without the girl and we can have a little fun."

The psychic placed her hand on my father's thigh and winked.

"Um, I'm on a date," he said, rising to leave.

My mom and dad shared a pack of Camels.

CHAPTER 6

I was five, splashing naked in a plastic Smurf pool with my two-year-old sister, Allyson. We were called inside for lunch. My mother had made my favorite sandwich: pepperoni and mayonnaise on Wonder Bread with the crusts cut off. As she was drying me off, she noticed a lump on the left side of my abdomen, the part she called my groin—a strange-sounding word. It was hard and round, like a large marble. She poked at it, and I yelped.

My mother brought me to a local pediatric surgeon, Dr. X, in the next town over. Upon entering the examination room, he bent down to my height and offered his hand. I shook it like I had been taught.

Dr. X explained that the bump was a hernia, and the repair procedure was simple. All he had to do was make a small incision over the bump, pop it back into my intestinal wall and finish it off with a few stitches. Afterward there would be candy, maybe a stuffed animal, and a few days sitting at home watching my favorite game show, *Press Your Luck*.

The operation would leave a two-inch scar that would be easily covered by a bathing suit. Dr. X said that when I got older and grew curly hair down there like my mom, the scar would be hidden forever. Yes, it was surgery, and yes, I would have to go to the hospital, but there was nothing to worry about. He had done this procedure so many times, he could do it in his sleep. I would be running around again in a matter of days, if not hours.

I had been taught to respect doctors. Pop had a whole wall of medical degrees, and so did my uncle. My father was also a doctor, though having failed organic chemistry three times and having accidentally splashed nitric

acid on his professor's arm, his specialty was English literature. Doctors were experts.

The morning of the procedure, my sixth birthday, my parents lifted me up on a gurney and sent me off with a flurry of kisses. I wasn't scared. Having an operation made me feel special. The only thing I was sad about was this was outpatient surgery, so I wouldn't stay overnight in the children's ward like they did in the Berenstain Bears book. It was a place rumored to offer endless bowls of raspberry sherbet.

Under bright light in a white-tiled room, I fiddled with my plastic ID bracelet, spinning it around my wrist. I looked at my name printed underneath the plastic and thought, *I am an Anya. Today is my birthday. Six years ago, I became me.*

Dr. X entered the OR and glanced down at me. The light made his scalp shine. I smiled at him, but he didn't notice. He kept rubbing his nose. A nurse asked him if he was all right. Dr. X nodded.

"You sure?"

"Let's just get this over with."

A man holding a green mask that was attached to a vacuum hose approached the table. He placed a ring of plastic over my mouth and told me to breathe. The air smelled like hot toilet bowl cleaner and rotting Christmas trees. He told me to count backward from ten. The room wobbled at nine, melted at eight, and collapsed by seven.

I woke in the dark. Not the kind of dark that accompanied Dr. Seuss stories and monsters under the bed. This dark burrowed under my toenails. I was buried alive, locked in a kid-sized coffin, contemplating solitary evermore. For the first time, I was completely alone, just a brain floating in a puny body, fully independent of parents, sister, dog, and cat.

Then, pain.

Pummeling.

Not in my abdomen, as the doctor had told me to expect, but in, from, and about my right leg. Maybe I had been carved up like a Thanksgiving turkey on that operation table. Maybe some greasy adult, hungry for a child limb, had pulled my leg out of my socket. Maybe they were munching on it in the corner now.

People were eating me.

As the pain became sharper, so did my vision. I could now discern the tacky pattern of the tile on the walls, feel the starched sheet under my chin, and see a sliver of fluorescent light seeping in from under what I slowly concluded must be a door. Against all evidence to the contrary, apparently I was still alive.

I screamed and nurses came running. They sat me up and gave me apple juice in a minty-green-colored cup. I had no words, only shrieks. Eventually, my parents lifted me into the backseat of our gold Chrysler K-car. I shrieked the whole way home. I shrieked when they lifted me into my bed. I shrieked in my sleep.

Or I think I shrieked.

Inside I was shrieking, though it's possible I might not have made any sound at all.

Inside I am still shrieking.

My parents seemed paralyzed by my complaints, and I couldn't figure out why they were just sitting there on our sofa with worried looks on their faces. Why hadn't anyone told me about this? Did they think I wasn't old enough to know if this was supposed to happen? And why was everyone whispering on the telephone? Couldn't somebody just explain what had happened in that operating room? Did I do something wrong?

Though I had an impressive vocabulary for a six-year-old, I struggled to find the words to explain how I felt, and after a while, I gave up. My parents were right in front of me, and no matter how hard I cried, they seemed unable (or was it just unwilling?) to hear me. Actually, they seemed a little afraid of me, like I had just turned into a monster right smack in their living room. Allyson heard me though. She crawled into my bed and held my hand.

"You can have my Cabbage Patch," she said, offering her baby doll, Clarissa Joya. I snuggled Allyson close and imagined my pain was a thick chocolate milkshake. I tried to slurp it as fast as I could, willing to accept all the ice cream headaches in the world as the price of reprieve. It didn't come.

Five days later, when it was time to go back to school, my dad picked me up off the couch and set me on my good leg. I fell down. He had me try again. This time, I managed to teeter for a few moments.

"See, you just have to stop being afraid. You just need to try."

I was trying. I was always trying. If there is one thing I can say about myself with certainty, it is that I have always tried.

I overheard my dad on the phone to Na, my Jewish grandmother.

"She seems to be getting worse. She's walking a little now, but still says she is in pain. Ma, I don't know what to do."

A week later, my mother took me back to the Dr. X's office to have my stitches removed. I limped into the examination room. I told him that my leg felt like someone pulled it off.

Dr. X's nostrils flared.

"Don't be melodramatic. Don't make up stories. This isn't a movie."

"But she seems to be in a great deal of pain. My husband has to carry her up the stairs and she's limping. She never limped before."

The doctor said he saw it all the time. A child gets attention for having surgery and is indulged for a few days. They don't want to give up being the patient, watching cartoons, and missing school. So they exaggerate, make up ailments that don't exist. In short, they manipulate and prey on parents' emotions and guilt.

I wasn't sure what "manipulate" or "prey" meant, but I picked up that I was in trouble. I *had* felt special going into the OR. Dr. X must be right. I did something wrong and now my leg was my punishment. I'd never been punished before.

My mom conceded that I did have a flair for the dramatic. "But," she said, "she is not a child who lies." Her voice was clearer, louder this time.

"My advice is to stop letting Anya make a fool out of you. She's pulling a grade A swindle, manipulating you. Tell her she'll never get a Happy Meal again; tell her no more Barbies. Punish her for lying, especially for lying to me."

Dr. X told me to pull off my panties. He placed his hand on my groin, grabbed a pair of tweezers and plucked out the thatch of stitches. I looked down. A blistered line stretched from my hip to the middle of what I would one day call my bikini line. He pressed his forefinger down on the cut and looked me straight in the eye. "Good girls don't lie."

I nodded yes and sucked on my imaginary milkshake.

Over the next three months, my leg felt tethered to a runaway train, its sinews and tendons perpetually pulling away from my body. I tried to ride the bicycle I got for my sixth birthday, but I couldn't get my leg over the crossbar. I struck out in gym class so I wouldn't have to haul myself around the bases. I couldn't climb up to the monkey bars and I couldn't pump my legs on the swings anymore, so I sat alone at a picnic table at recess.

Honestly, I was already uncomfortable in school. I was weird. My T-shirts identified me as a fan of Antietam National Battlefield, the periodic table, and Mr. Wizard. I carried a PBS tote bag. Kids rooted for the Yankees over the Red Sox, the Rangers over the Bruins; I rooted for WNET over WGBH. I wrote with pencils my mom gave out in her classroom, which were imprinted with goofy science jokes like: *What did the proton say to the electron?* I mismatched Velcro Zips sneakers in cheetah- and leopard-print patterns that we got from the clearance rack at Marshalls with triple-tiered peasant skirts hand stitched by my mom. Occasionally, I topped my outfits off with my personalized Mickey Mouse–ears hat. My fashion inspiration was a little *Punky Brewster*, a little *Murder, She Wrote*, with a dash of *Dynasty* for shimmer.

As winter was closing in on Southern Connecticut, my mom discovered another bump in almost the exact same place the other one had appeared. My parents took me to a new pediatrician, who took one look at me limping into the examination room and told my parents they had a serious problem on their hands. Sudden unexplained muscle loss was a medical emergency, forget the hernia.

I had been right; I *had* been right. But what was it about my voice, the only one I had, that kept them from hearing me? Why did my parents believe this new doctor but not me? Was it because he was an expert? I had already learned that these experts couldn't be trusted, and most devastating, I was now learning that my parents might not be trustworthy either. I'd become so used to keeping my pain hidden that now almost everything didn't feel like anything. I was numb, everywhere. I was Han Solo frozen in carbonite.

Though cancer was initially suspected, my blood tests were all negative and my scans clean. Meanwhile, my leg got worse. I had no reflex at my knee or under my foot. My muscles had atrophied severely, and eventually the muscles in my right leg were just two-thirds the size of my left. Doctors stuck needles

into my leg and used electronic current to try to stimulate it. I felt nothing. More ultrasounds, CT scans, x-rays, sonograms. When I wanted to walk, I had to repeat to myself, *Move, leg, move. Move, leg, move*, and slowly the maimed limb would toddle behind me.

It took the brilliant minds at Yale New Haven Children's Hospital to uncover that the incision from the first operation was a full two inches below the actual hernia, which had not even been repaired. Dr X had mysteriously mistaken my femoral nerve for the tissue around my hernia, and his sutures, meant to bring together his incisions, had been instead sewn through the nerve, slicing almost completely through it. The doctors estimated that I had only a few weeks before I would permanently lose most of the use of my leg. I needed another surgery, which would be much more complex and risky this time.

Sitting alone in my hospital bed the night before the operation, I took Crayola markers and drew instructions for my doctors on my right thigh. I couldn't feel the markers as they slid across my skin, but I marked my body like a map, circling my hernia in red and adding arrows and exclamation marks. I drew connecting lines to my leg in orange and green. I drew lopsided purple stars along my groin. I wanted there to be no doubt about where and what the doctors should fix. Those markers were defensive weapons. This time, I was the expert.*

A different man holding a green mask asked me to breathe in hot toilet-bowl-cleaner air, and eight hours later, the operation was deemed a success.†

For the next two years, my mother carted me back and forth to Yale for physical therapy. As a special treat for enduring the appointments, we ate chicken nuggets with double BBQ sauce at the West Haven Wendy's just off I-95. Eventually, my office visits decreased to once a month, as long as I exercised rigorously every day. I chose ballet, simply because my other option was

* This discovery of marking my body, of using my body as my voice, would become integral to my life as an artist in the years to come.
† The surgery was also historic. It was one of the first nerve reconstruction cases of its type in the world and was written up in pediatric neurology textbooks and journals. It had a secondary, and in my view more important, takeaway: When considering pediatric cases, listen to young patients. Though they may not be able to fully express what they are feeling, their complaints should be carefully considered and explored.

playing on the super competitive town travel soccer team. Since those girls had been so mean to me when I couldn't walk properly, it wasn't an option.

And I danced and I danced and I danced. At first, I did it only because the doctors told me that unless I wanted to walk with a cane for the rest of my life, I had to move my body daily, no matter how much it hurt. Then I did it because ballet class was one of the few places where I wasn't bullied for being smart or for wearing strange clothes or for not being able to afford to take fancy vacations. Then I did it because it because of George Balanchine, cofounder of the New York City Ballet. Though he had died in 1983, I was taught by two of his dancers, Carol Sumner and Edwina Fontaine, and I became obsessed with his technique and choreography. While other kids my age were at home playing Nintendo, every afternoon Carol and Edwina taught me that real, true artists had a higher calling—to turn our bodies into the most finely tuned instruments in the world. Childhood was for children, they said, but ballet, *real* ballet—not "dolly dingle strip mall ballet"—was for aspiring immortals. Balanchine gave me the opportunity to subvert the inexplicable violence that had occurred to my body, a chance to be transformed.

Because of the constant, intense training, my right leg eventually regained its strength and reflexes, but I never regained any feeling in my thigh, and my limp took longer to disappear. There was a malpractice lawsuit and a settlement. Dr. X had (allegedly) been snorting lines of cocaine before my surgery, but it was hard to feel vindicated when I saw how guilty my parents felt. They had only done what they thought was best. I didn't confront my anger; I buried it in my milkshake.

But milkshakes melt, and when they do, they make messy puddles. For so long, I forced myself to believe that what had happened was really for the best because it led me to dance and art and performance. It taught me that I can overcome any challenge placed in front of me! That all I must do is believe in myself! That hard work leads to great things! That perseverance is everything! All of that may or may not be accurate, but it's certainly true that I could have found it out without having to have my leg mangled in the process.

Although, of course, it's also possible that I appreciated the language of dance, the voice in the silence, more than others because I came so close to losing so much of my mobility. Dance was a language that loved me back

because it fully honored all my experiences. The scars and the weakness that still lived in my body's kinetic archive became the seeds of developing my own aesthetic systems and iconography. Which is just a lot of blah blah to say that it's taken me a long time to realize that the way I made meaning out of all of this nastiness was by becoming an artist.

It was a survival strategy.

Dr. X tried to silence my voice, but through ballet, it grew back.

CHAPTER 7

I am nine, and I am convinced I was Clara Barton, Civil War nurse, in a previous life. Though I dislike hiking and blister when left in the sun for too long, I am certain I have an innate talent for wilderness medicine, just like Clara. When I play in the woods behind my house, I collect mullein leaves, which I read in *Encyclopedia Britannica* were used as bandages in the Civil War. I keep them ready to go in a Fig Newtons box in case I am called to duty.

I go to ballet class almost every day after school and write long, melancholy poems about the greenhouse effect. My heroes are Bruce Springsteen, George Balanchine, and Chuck Yeager, in that order. At my birthday party this year, I had a cake decorated with an image of The Boss's denim-covered butt cheeks. I ate his right one.

My best friend is Allyson, and my favorite TV show is *Miami Vice*, in part because Sonny and Tubbs go after sweaty cocaine dealers, and because of my screwed-up leg and Dr. X, I know all about how bad cocaine is. At my tenth birthday party, I want to have a cake decorated with Sonny Crockett. I plan to wear pastel blue loafers without socks and a light-pink sports coat. I also like anything having to do with the Revolutionary War and have committed all fourteen stanzas of Longfellow's poem "Paul Revere's Ride" to memory, for fun. My favorite highway is the Massachusetts Turnpike because its symbol is a pilgrim hat and it takes me to my favorite place: the dollhouse rooms at the Boston Children's Museum. I purchased my second-favorite toy of all time there, a miniature roll of toilet paper the size of a thumbnail. My first-all-time-favorite toy is still my Cabbage Patch Kid, Zena Melina. My grandmother Na

stood in line overnight at the West Hartford Toys "R" Us to get her in time for Christmas, which we always celebrate like good bad Jews. Zena is pretty sure that in a past life she was Florence Nightingale, so we have a lot to talk about. She is only a few years old, but I've loved her so much that her arms have fallen off and my mom has had stitch her back together. Zena is a bit dirty, but I refuse to have her washed. I don't want her to lose her history.

Na is a real artist. She has a real studio and real paints that you cannot dip your fingers in because if you do, it won't come off. Na and I like to look at the stacks of books she has in her studio. My favorite artist right now is Winslow Homer because I didn't know that waves could have feelings, but I also didn't know that Kenny Loggins sings he's "yearning, burning" for somebody and not, "You're yearning, burning for coleslaw" in "Footloose" until about five minutes ago. For my birthday, Na gave me a very serious book about one of her favorite artists, Toulouse-Lautrec. She asked me what I thought of one of his paintings of women. I told her that I liked the way he made things ugly but also pretty at the same time. She told me that meant I was a real artist, because I could hold a contradiction in my head.

I am very proud of this.

I love wearing my beige Members Only jacket covered with my collection of NASA mission patches. Every time I go to my second favorite place, the Smithsonian National Air and Space Museum, to see Yeager's Bell X-1 plane, *Glamorous Glennis*, hanging from the ceiling, I get new patches and sew them onto my jacket myself. I also like to wear XXL hooded college sweatshirts as dresses with my favorite pair of shoes, black loafers with big silver pilgrim buckles. My favorite song is a tie between Elton John's "I Guess That's Why They Call It the Blues" and The Boss's "Darlington County." Both make my stomach flutter, and I am not sure why. My least favorite song is "Hotel California" because checking in and never leaving is just scary. Also, the guy that sings that is the same guy who sings about dead head stickers on his Cadillac. Who wants a car with a dead head on it?

I sleep over at homes with custom in-ground swimming pools and multiple big-screen TVs. One girl has a bowling alley in her basement and another girl has an elevator. One girl puts all her friends in limousines and takes them to Serendipity in New York City to have hot fudge sundaes for dinner. One

girl has a heated patio just for her pet turtles. One girl's entire house is canti-levered over a duck pond. Another has a movie theater in her basement. One girl has a real British phone booth in her bedroom, with her own phone line. And one girl's dad is in charge of a big corporation that makes hair dryers and curling irons and toasters, and when we play in her basement, we can use any appliance we want.

I live in one of the smallest houses in Westport, which is an upper-class town, my friend's dad says, but then he also says your parents are public school teachers, so they are middle class. I don't understand why who is in what class. I know am in a class called "Special Workshop." Dean Levy, who still trips me in gym class even though I am not as easy to trip now that I have had physical therapy and I don't limp so much, says that Special Workshop class for nerd losers. When I ask my dad why I am in Special Workshop class and he is in middle class, he says I am in Special Workshop class because I am smarter than Dean Levy and that our family is not in middle class. We are upper-middle class.

I'm confused.

My parents moved here so Allyson and I could attend Westport's excellent schools. The girl who was in the movie *The Exorcist*, which I am too young to see but know what the word means, went to the middle school I will go to. My parents added a second floor to our house so we could each have our own bedrooms, which my dad says is something that people in the upper-middle class do. Still, we don't have: a guest room, a garage, a basement, a wet bar, a dry bar, a deep freezer, a trash compactor, a laundry chute, a laundry room, a lazy Susan, a bonus room, a swing set, a swimming pool, a mud room, a gazebo, a greenhouse, a tree house, a tennis court, or even a trampoline. Did you hear that? We don't even have a trampoline! We also don't have a cleaning lady or a guy who comes and scoops dog poop out of the backyard. My dad does that with an old shovel he used when he worked on the highway sanitation crew.

Even though we technically have two bathrooms, we share just one shower because the downstairs bathtub is filled with my father's Jewish genealogy books and my mother's collection of rescued houseplants. The bathroom also has a bookcase packed with books about psychiatric disorders, Atlantic Canadian history, and the Yiddish theater of the Lower East Side. My father says

they are very calming when he is on the toilet. We don't have Beemers or Mercedes. My father says those are Nazi cars. We drive Dodges.

At overnight birthday parties, when my friends tell spooky stories, I cry in my sleeping bag, which isn't one of those puffy "mummy bags" from L.L.Bean. It's an ugly beige thing my father had at summer camp, and it smells like meaty dog farts. I don't like playing "light as a feather, stiff as a board," and I don't like watching rated-R movies, because I am afraid I will see something that I can't unsee. My favorite movie is *SpaceCamp*, and even though there is some swearing when the students are accidentally launched into actual outer space, it's still rated PG.

When my mom picked me up at school to go to *Nutcracker* rehearsal last week, I couldn't stop crying and I couldn't tell her why. Christine Pudcell said she asked her mother why I was so pale (they call me "Casper the Friendly Ghost"), and her mom said it was because my parents were schoolteachers and were very middle class, and they couldn't afford to take us on vacation to any place good and warm. That they had to work all the time to afford food for us to eat and that she should feel bad for us. That people in the middle class have to work a lot. Christine Pudcell said she wanted me to know that she felt really bad for my entire family and that if I wanted her to, she would save me some of the beads from her Jamaican braids next time her family went.

My mother teaches middle school earth science, and my father teaches high school English. He is also an adjunct professor at two colleges, writes free verse poetry, organizes amateur archeology digs, and plays the bagpipes. In fact, he is the only Jewish bagpiper on the Eastern Seaboard. He says he likes to play to honor my mother's Scotch-Irish forbearers. That it's a tribute to them. He claims the only instrument the Jews really ever gave anyone was the shofar and no one likes listening to the shofar for more than two minutes. The bagpipes are much more interesting. When he practices in our backyard, the neighbors call the police; he's that good. Dad says his talent is just misunderstood, that his "midlife crisis" could have occurred in a lot of ways, like a hot new squeeze or a snazzy convertible, but he chose the bagpipes and for that we should all be grateful.

Meanwhile, in her spare time, when she isn't making yogurt or collecting igneous rocks, my mom shoots rockets off our back deck. Other mothers

fantasize about minks and diamonds, but my mom fantasizes about fighter jets. She is not afraid of heights, and she is not afraid of going fast. She applied to be the first teacher in space and made it past several cuts. When we watched Christa McAuliffe and the rest of the *Challenger* crew fall from the sky, we both cried for so many reasons.

She is convinced that the squirrels and chipmunks are engaged in some sort of woodland soap opera in the backyard. Every morning when she wakes up, she greets the critters individually. "Hello, Mr. Brown-Headed Cowbird! Hello, Mr. Prairie Chicken!" She always points out the pileated woodpeckers with their funky red mohawks. Other mothers are concerned about keeping the lawn pitch-perfect green and having a landscape design team. My mom tosses the toughest of the toughest seeds, Kentucky strip-mine mix, over the whole backyard so the bees and birds have plants to roam in. She says she wants to turn the front yard into a farm. I beg her not to. Other mothers squeal in terror when their cats deliver dead mice to the doorstep, but she picks them up and dissects them on the kitchen counter so we can see what's inside.

"Now that, girls, is a very cute little stomach!"

She has a stash of Harlequin Romance books under her bed that she thinks she is keeping secret and at least fifteen brand-new and unworn pairs of shoes in her closet. She says she needs to keep them in case she needs them. My mom says this about lots of things in our closets, like new sets of sheets, very pretty and unchipped plates, and fluffy new towels. She says they are being kept for "later," for "company," or until "the others wear out." My dad says just use the towels; that is what they are there for. Instead, she stitches up the holes in the old ones, turns the chipped plates into dog food bowls and plant pots. She won't let things go. Even if you put something in the trash can, she will find it and clean it up and put it back where it was. But if she hears that somebody we know is in need, she will give everything in the house to them.

She is obsessed with flashlights of all sizes and their menagerie of attendant batteries, especially size C Duracells. Allyson and I are not allowed to go to sleepovers unless we bring a flashlight and promise to keep it right by our side. She says that when you grow up without electricity, you learn not to trust it too much. Perhaps her favorite moment ever was the time the power went out during a matinee of *Back to the Future Part II* at the Fine Arts Cinema in

downtown Westport. She led the entire audience out the exit doors with one of the three flashlights in her purse.

When we go to the Westport Fourth of July fireworks, she shouts the name of every chemical reaction blasting in the sky. "Lithium! Calcium! Sodium! Wow, look at that barium! You go, barium!" The other mothers just stare at her over their platters of deviled eggs. While some girls' moms take them for mother-daughter mani-pedis and perms, my mom orders a cow eyeball for Allyson and me to dissect. Instead of baking cookies for the bake sale, she whips up homemade slime out of cornstarch, green food coloring, and water. She keeps a jar of moonshine high up in the cabinet over the fridge. When she has menstrual cramps, she mixes it into ginger tea like Granny did.

Every summer, my dad brings a thick file of documents with us down to Kentucky. When he isn't digging up arrowheads or driving the neighborhood dogs out of their minds with his bagpipes, he conducts genealogical research about my mom's family. He says that he has almost no ancestors that anyone really knows about, that Hitler destroyed almost everyone and everything, and that he loves history because he doesn't know much about his own other than that everywhere they went, people hated them. So, on the long car ride to Mamaw's shack, he tells us his latest findings.

"Girls, you are almost definitely related to none other than Joan of Arc! The Maid of Orleans! Isn't that marvelous?"

"Yes, Dad. That's great. She was a real heroine for France," I say before shoving the family cooler hard into Allyson, who has just tried to steal the yellow Sports Walkman we are supposed to share. She waits till I fall asleep with the headphones on, and then she turns the volume up really fast to freak me out. Allyson loves practical jokes, so when I go looking through the cooler for food—egg salad sandwiches (crusts removed, more whites than yolks), a jar of peanut butter (Jif), and boxes of crackers (Stoned Wheat Thins)—I'll probably find a spider trapped in a fake ice cube. If she offers me a stick of gum, it might shock my finger. When I come back from the bathroom in the gas station, my seat might be covered with a splat of plastic vomit.* Everyone

* Thankfully she has cooled it on the whoopee cushion since she was caught terrorizing our eighty-something-year-old babysitter with it. The nice lady kept excusing herself and going to the bathroom. Then Allyson would blow it up again, put it back in the chair, and wait.

thinks she is so shy and quiet, but she is more like a mischievous cat who waits till everything is just right and then pounces.

Allyson and I long ago gave up lobbying to go on normal family vacations and resigned ourselves to becoming connoisseurs of the historical reenactment films that greet us at every national park visitor center. We think the films at places like Mount Vernon and Monticello are far too conventional. We each specialize in subgenres. I am fond of taxidermy displays, fake food, and wax museums, while she gravitates toward electronic maps. I am in awe of the people who work at Colonial Williamsburg and Old Sturbridge Village. When I lie in bed, I imagine churning butter for retired couples and disgruntled schoolchildren.

But it's Stonewall Jackson's beloved horse, Little Sorrel, moldering away in the basement of the Virginia Military Institute in Lexington who I love most. He's so sad in his dark corner, left there with a fake hay bed and some rickety plastic fencing. Though there are signs everywhere warning us not to, Allyson and I take turns nuzzling his threadbare nose year after year. So does my dad. "Attaboy, Little Sorrel!" he shouts, the way other dads yell, "Let's go Mets!

My father loves stopping at national parks for impromptu picnics. At Gettysburg, he points out the location of Pickett's Charge while we munch lukewarm egg salad.

"See girls, that's where Robert E. Lee really screwed the pooch."

My mom laughs.

They are two peas in a pod, a very odd pod, but a pod nonetheless. Sometimes I wonder if my mom is OK with her father's death, even just sometimes, because it led her to my father and Allyson and me. Without the Peace Corps, without Ed's death, and without the Vietnam War, they probably would never have met.

I'm always trying to find a way to explain why everything is the way it is. I'm trying to make good come out of the bad, but I'm finding that that doesn't mean I can erase the bad. In some ways, trying to focus on making things good just makes me think about the bad more. I'm not sure why this is. I can't figure out if things happen because of random things or because of what the Greeks called fate.

In the summer, we can often be found together at some forgotten Southern battlefield at dusk, listening to my father's rapid-fire play-by-play of the Blue versus the Gray. My father narrates and my mother acts out his incantations.

"And then Sherman's men rose up from behind the crest. Lee's troops could taste their fear."

My mother salutes and marches across the field or the parking lot— whatever has become of the battle site. She gallops on an invisible horse. Allyson is stabbed with an imaginary bayonet. My mother becomes a drummer boy and then a supply-strapped medic. I have no choice but to assume the role of my past-life heroine, Clara Barton.

And while the other Westport kids go to cotillion and sail off the coasts of Ogunquit and Quogue, I go to East Kentucky, to spindly garden cucumbers and cottonmouth snakes, to broken-down pickup trucks and dried creek beds, to the shack where my mother was born.

To Mamaw.

CHAPTER 8

Mamaw slides her hand under our pillow to get the gun, opening the screen door and firing into the black night. The sound arches above the vegetable garden and then slings low, ricocheting up and back down the mouth of the holler. It slams against the sandstone crags, playing the ridges like a sadistic harp. "That oughta get 'em," she says, wiping her palm on her muslin nightgown.

My parents rush in from the upper room, my dad holding Allyson by the hand. "Vesty! What are you shooting at?" my dad says, breathless.

"Varmints! Just them varmints. Don't make no mind, Bob. I live alone up this holler for a long time. I ain't afraid."

Without turning the light on, Mamaw reloads her pistol. Then she pulls back the thin cotton bedsheet, pilled from years of her meticulous washing and ironing, and crawls back into the creaky bed we share, the bed under which she stores squash and pumpkins for the winter. Mamaw slips the gun back under our pillow and puts her calloused feet on top of mine, rubbing up and down for warmth. I start to whimper.

"Hush up, Anya. Your Mamaw keep you safe." She snuggles her arms around me, squeezing me extra tight. Her long fingers wrap around my back. Mamaw's hugs are magic. Even though I am almost eleven, I have nightmares about Dr. X hovering over my pelvis, rearranging my organs. I see my leg encased in gray concrete. I sledgehammer myself, but concrete keeps pouring over me.

Sometimes I wake up in the middle of the night, fretting and sweaty. Mamaw can't sleep either. She sits in the rocking chair in the corner, up by the old stove. I watch the red cherry of her cigarette sweep and arc, sweep and arc, sweep and arc. It sort of comforts me and it sort of scares me, because everything in East Kentucky seems covered by the weight of a damp wound.

Though Mamaw more than qualifies for almost every type of government welfare program, she refuses to draw anything other than her Social Security check. She hates asking for help, for anything—lifting boxes, hauling coal, chopping wood. Asking for help is admitting weakness, admitting dependence. Hillbillies of her age are not dependent.

"You've got to be able to do for yourself, 'specially a woman. Nobody do for you." She sighs.

We have to read her mind to find out what she needs help with. If we wait too long, she will have already finished the chore and then she will not so subtly remind us of how unhelpful we were.

"No, youngin', I already done *done* that." She'll sigh again.

When Mamaw isn't out in the garden or husking corn or slicing sausage, she holds court in her beige Barcalounger. Embedded in the armrest is an ashtray dotted with the stubs of Salems. They are long, skinny lady cigarettes, the kind lean women smoke in *Family Circle* magazine. Those ladies keep their cigarettes in the pockets of their bellbottoms, but Mamaw keeps hers in a maroon leather pouch. She taps the bottom of the pack to release her next smoke. She flicks the wheel of her lighter with her long, yellow thumbnail, the same way she pries open cans of grape pop. Her right thumbnail is her sharpest tool, more versatile than a Swiss Army knife. She wraps her wrinkled lips around the filter and sucks hard. Mamaw doesn't like to put in her teeth.

Above the Barcalounger is a framed picture of Jesus walking on water. It has some kind of metallic sheen that makes it glimmer. Jesus looks like a surfer with wings, gliding on a killer wave into shore. Honestly, I don't know much about Jesus except that he is supposed to keep people from behaving badly and that Mamaw really likes him.

Once, when Allyson stubbed her toe on the big rock by the plum tree and shouted, "Jesus H. Christ!" Mamaw exploded.

"This child! Wash its mouth out with soap!"

Then Mom dove in, too.

"Allyson! What language! You know better than to curse like that. You're in big trouble!"

Allyson and I just looked at each other, shrugged our shoulders. Big trouble? We were never in trouble. And my mom said Jesus H. Christ all the time. Like seven or eight times a day. What was the big deal? Should Allyson have said "goddamn it"?

I try to help Mamaw with the wash, but she is pretty hard to please and impatient about teaching me. She takes great pride in the way she hangs her clothes up on the line, all even and color coordinated. Every time we drive her out of the holler to town, she comments on the clotheslines. She says it makes you look right poor if you don't care how you hang your clothes.

"Lordy, what an almighty disgrace, how they hang their drawers upside down." *Drawers* is a pretty funny word that Mamaw uses. So is *britches*, as in "pull up your britches." Allyson likes to say, "Pull up your bitches," and then pretend she didn't swear in front of Mamaw.

Mamaw is equally critical of ironing skills. She is fanatical about how the clothes are placed on the board. Leg seams have to be perfectly matched and held while they are ironed so they show a nice sharp crease down the front. Shirts have to have the collar ironed first, then one of the front panels, then the back, and around again.

"Just 'cause a feller is poor doesn't mean he has to disrespect himself, doesn't mean he was to show it up and down the country."

And it's true. When I look out on Mamaw's perfectly neat rows of potatoes in the garden and painstakingly pruned flower gardens, I am also proud. We are not Shagnasties.

In Connecticut, Na's world explodes with color. Her clothes look like Rothko and her jewelry like Kandinsky. Even the shag rug in her living room looks like a box of crayons at a disco party. In Kentucky, everything is black and white and muddy except for the green grass and the stinging yellow of the black-eyed Susans. But I know it just means I have to look harder, wash the mud off the rocks, rinse the crawdads and the terrapins. I can't be afraid of things that look different than what I am used to.

I also know there is something strange behind the locked white door in Mamaw's room, though no one ever fully acknowledges it. I know that the room used to be Ed's office and that Mamaw had it locked up after he died.

I always ask my mom about it. "What's behind the white door?"

"My father's office."

"Can I go in it?"

"No."

"Why not?"

"You just can't."

"But why not?"

"I told you. Don't ask me again. Probably copperheads in there."

It makes no sense. The shack is so small, and we are all crammed in here to begin with, so why wouldn't she use an entire extra room? Especially one already attached to the house.

Every summer I come home I hope it will be open. It never is.

It's an unspoken rule that I should never ask Mamaw about it. But when my mom says there are copperheads back there, I let it go. She knows I'll do almost anything to avoid getting snakebit, to avoid even seeing a snake. It's bad enough watching Mamaw kill them with her hoe. Even after she lops off their heads, they flop and flail for fifteen minutes. When we walk in the garden, Mamaw carries her big snake stick. When she sees one, she mashes it over the head, then finishes it off with the hoe.

Once it was just my mom and me sitting on the porch. Everyone else had gone, and out of nowhere she said, "You want to know what is behind the white door?" She said that when Ed was working for the Army Corps of Engineers, he needed a place to sort out his paperwork. He was in charge of requisitioning and repurposing pieces of machinery from military bases throughout the Southeast and bringing them to various government agencies all over Kentucky. He decided to make an office, which he built not so much as a proper addition but more as a lean-to—three walls balancing up against the back of the shack, fitted with a raised plank floor and a single window. Inside this new office, he kept the trunk he brought back from his years stationed in New Guinea during World War II.

When she was studying World War II in school, Ed opened it for my mom. He showed her his helmet, his canteen, his binoculars, his uniform. He showed her the empty suicide pill the army gave him in case the enemy held him captive. He showed her a defunct grenade, a bird he whittled out of New Guinea rosewood. He unfolded a blood-spattered Japanese flag he found over the heart of a Japanese solider. The bullet had gone right through the red silk, dead center.

Ed showed her the mosquito net that failed to protect him from malarial mosquitos. At least once every summer he broke out in a cold sweat. He showed her a stack of letters Mamaw sent him during the war, each one marked S.W.A.K.* She wrote every day. He wrote once a week. Ed showed my mom the wad of receipts for the money he sent home from the front. Between prize fighting and carving war souvenirs for his fellow soldiers, he had managed to stash away a hillbilly fortune, which is to say, enough money to get through winter.

Two years after Ed built his office, he was killed. They didn't lock it up right away. My mom moved her cot into the white room. She did her homework on his desk, balancing chemistry equations by the light of the bare bulb. Her pet rooster, Radcliffe, named after what she knew was a famous women's college, would watch her while she diagrammed sentences and sketched out charts on homemade graph paper. Later, after her cousin fried him in bacon fat, my mother stared at the spot where Radcliffe used to sleep.

Sometimes, when Mamaw was out in the field, my mom took out Ed's uniform and smelled it. Sometimes she strummed his old guitar. Once, Mamaw heard her playing, grabbed it by the neck, and punched a hole right through the wood. Mamaw never stopped raging at a world that took Ed away. Every flick of her cigarette, every scouring scrub was ringed with fury.

After my mom left for college and the Peace Corps, Mamaw had the white door shut with a padlock. Ed's ghost was in there, and she wasn't letting him out.

She also locked up his 1964 Studebaker, just two months old at the time of his death. He had been teaching Mamaw to drive so she could get out of

* Sealed with a kiss.

the holler more than once or twice a month. Ed tried to get her to go to the new community college up at Jackson, the Breathitt County seat, but she refused, saying she had her hands full at the homeplace. After he was killed, Mamaw really lost the will to go anywhere. The car was left in the middle of the tater field.

It deteriorated. The seats became infested with copperheads. Mamaw said if they bit you, you would laugh until you died. But she didn't let go of the car. So my cousins carefully mowed the grass around it week after week, year after year, decade after decade. Occasionally someone offered Mamaw cash for the body. She met all offers with silence.

Mamaw is such a light sleeper that the slightest shift of weight, the gentlest sigh of springs immediately wakes her. When my mother was a child, she slept in the bed I now share with Mamaw, alongside Mamaw and Granny. They shared a single pillow. When I complain that I want my own pillow because I like to flip it over onto the cold side in the middle of the night, Mamaw reminds me that I have it easy. In Connecticut, I have a room to myself and a bed of my own. In fact, I have a pair of beds, an antique pine spindle set with matching rainbow sheets and cascades of stuffed animals. I have bins of toys and shelves full of books. My dance bag is full of leotards of different colors. I do no chores. My parents say my responsibilities are being a good big sister* and doing well in school. My biggest worry is making sure I am at the bookstore the second a new Baby-Sitters Club book comes out. I rule a Barbie empire. I am clearly the most spoiled kid in the holler. But it's also the holler that makes me think about how you can have so many things and still feel deprived. When I collect things, and I collect a lot of things—Barbie shoes, Weeble Wobbles, Bruce Springsteen pins, Strawberry Shortcake figurines, earrings with cats on them, earrings with dolphins on them, tiny televisions, erasers that smell like Bubble Yum—I still feel like I have a big hole inside that I can't fill, no matter how much stuff I find.

Mamaw reminds me that when she was a kid, she spent her days picking pinworms out of her feet and hauling buckets of water up from a distant well.

* In the name of being a good big sister, I have convinced Allyson that the white creamy centers of Oreos are bad for her. When we eat cookies, she should hand them to me. In exchange, I give her back the dry cookie discs.

Her mother and father beat her until she was as blue-black as the cover of their only book, the Bible. She didn't have any paper to write on. They were so poor they didn't even have a dime-store thermometer, so they couldn't even tell how cold it was outside. Her only doll was made out of dried corn pith, its face painted on with crushed elderberry juice. If she was lucky, she got a single orange for Christmas and maybe a new pair of shoes.

"All my mommy ever did was have her youngins, nine of them. Then she died, bless her heart," Mamaw says.

This immediately shuts me up. I can't fight truth. I go sit in a rocking chair on the porch, listen to the wind chimes, and pout. It's not my fault that I live in Westport. It's not my fault that I don't know what it's like to be poor. I've started to figure out that when people in Westport call my family middle class, they think we are sort of poor, but I know I've never been actually poor, not Kentucky poor. I didn't ask for this. I'm always just trying to do my best to figure out what everyone wants of me, and then I do it.

I wonder a lot about what Mamaw is thinking. Not if she is thinking if the cucumbers are ripe or if the road is going to wash out, but what she really thinks. I wonder if she dreams about the baby, the dead one. His name was James Edward, and he was born in the middle of a brutal February. The shack was heated with the coal Mamaw collected along the creek bank every morning, but cold still blew in between the floorboards.

Two weeks after he was born, Mamaw went to nurse James Edward and found him frozen, his skin stuck to his handmade cradle. The fire had gone out in the night. Mamaw's milk ducts grew hard as rocks, swollen with unsuckled milk. She spiked a fever. Her body was still recovering from the trauma of the three-day birth, when the placenta, stuck high up inside her, had to be pulled out with a stove fork. The way she tells it, Ed said she almost died.

They buried James Edward up on the hill, where the family has been burying dead since the eighteenth century. There, small grave markers rise from the ground like goosebumps. They put him next to Nora Bea, Ed's baby sister, who died when she fell off a ladder-back chair and hit her head on the hearthstone, the same place I sit on when we listen to the Grand Ole Opry on the radio. She was three. After they put her in the ground, Old Man Gran hacked the chair to bits and burned it.

Once I walked up to the cemetery with Mamaw, just the two of us, past the chicken coops and the dog pens and the place where they burned the tubercular cow. I picked some Queen Anne's lace and set it on top of Ed's grave. Mamaw was quiet. I asked her if she wanted to be buried there. She said she thought she did, but that there was no space next to Ed. My double-great-aunt was buried next to him in what should have been Mamaw's place. No one had consulted her in that decision, they just did it, and so even in death, they would still be split up again. Then she sighed and said she guessed one over was close enough, that it didn't matter because dead was dead was dead.

I asked her about James Edward.

She said dead was dead was dead.

Some nights I lie awake and picture digging down under his tombstone, trying to give James Edward CPR like I learned at Girl Scout camp. I pound his tiny chest up and under the sternum like they showed us on the plastic dummy torso. I blow hard into his mouth. I listen for his breath. I pound his chest again. He throws up a little and coughs then gasps for air.

My mom was born in the middle of a blizzard, even colder than the day that James Edward arrived. The freezing wind whistled through the doorjambs. After two days of labor, my mom plopped out bloody and screaming, and Granny Isabelle pulled the placenta out of Mamaw with the stove fork again. Granny Isabelle didn't know her letters, so she marked the birth certificate with an X. Mamaw was up hauling coal the next day. For three years, she packed my mom on her hip while she worked in the house and in the field. Mamaw started to stand crooked, always jutting her hip out to carry her baby girl. When she milked the cow, she held my mom with her left arm and squeezed udders with her right.

Sometimes late at night I think that if James Edward didn't die, my mom, his replacement, probably would not have been born the following February. Then I wouldn't be lying on this too-soft bed, with my face on this too-warm pillow, listening to warty toads go "jug-a-rum." I wouldn't be anywhere. I wouldn't be me. I might be a blackbird or a praying mantis or maybe just nothing at all. I think about how I have come so close to being nothing. I have to try to be something and not nothing. I want to make things mean things.

Other nights I just lie awake and stare at the mantelpiece. It's not really a mantel; it's just a couple of boards banged together to look like something you'd find in the living room of a real house. Hanging up above the mantel is a framed photograph of Mamaw's parents, my great-grandparents. Actually, it's two separate photographs that were printed on the same page, like the only time the two of them were actually ever together was under the red light of the darkroom.

Their faces look like gristle.

* * *

Mamaw shouts in her sleep.

"Oh Lordy, Lordy, Lordy!" Then she hacks her smoker's cough.

My mom, panicked, rushes into our room.

"Mimmy, are you alright?" she says, waking Mamaw up.

"I got to be alright living up here at the head of this holler alone."

My mom is silenced by guilt. I am silenced by guilt. When Allyson is old enough, she will be silenced by guilt. We are the women, the ones who should feel her pain, who have abandoned her. Mamaw goes back to sleep and cries, "Oh, Lordy," again and again.

When the sound of Mamaw suffering subsides and I think she is asleep, I slide my body off the bed and crawl onto the oily shag carpet in the room with the dim nightlight and the Barcalounger. The ceramic Persian cat who lives on the floor glares at me. I climb into the recliner and find the sweet spot where Mamaw's bony butt has etched the cushion. I stare at the unfortunately uphol-stered sofa, covered in vomit-colored tweed. I watch the insects swirl near the ceiling and dodge their long shadows. I wonder how the hell my mom got out of here. But as much as the holler scares me, if it was truly my home, if it was all I had ever known, I don't know if I could leave it like she did.

I keep a transistor radio hidden by the foot of the Barcalounger, right in the pocket made for pork rinds and remote controls. It doesn't have proper headphones, just one earbud, like in the Secret Service. I curl into a ball and hitch onto the voices riding the sky. I listen to tinny gospel from Arkansas and irate Bible-bangers from Alabama. I pick up beltway traffic alerts from

Washington, DC, and surf reports from the Outer Banks. Art Bell discusses the benefits of peyote and Bernie Wagenblast tells me how long it will take to get through the Holland Tunnel. Deep in the Kentucky night, I am part of a confederation of insomniacs, all of us waiting for the first rays of sunlight, the glow that tells us we have survived, that we have not succumbed to our nightmares. But I am not just surviving the night. I am surviving being here, this place that sharpens my shame like a whetstone.

In the morning, Mamaw finds me asleep on the rug, having tumbled out of the Barcalounger sometime just after dawn. She lights a Salem and starts making the biscuits and gravy.

In Kentucky, even though I'm already eleven and can smell stinky, I don't bathe every day. I might bathe once a week, in the same lukewarm water as my parents. In between, I run out into the wild thunderstorms that growl around the mountains, squeeze dish soap on my hair and rub as fast as I can. Storms are celebrations in the holler. When they come, we watch them roll up between the hills, headed right for us. Sometimes I run out and tombé pas be bourrée, glissade, and grand jeté in the rain, to see what it feels like to dance in falling water. Sometimes I make my feet muddy with creek dirt to watch my footprints wash off in the grass.

Sometimes I ride an ATV down and out of our holler, onto the state highway, and then up another holler to my double second cousin Tim's trailer, which has a shower. I have sixty-two double second cousins. No one can name them all. As many times as it has been explained to me what a double second cousin is, I barely get it; it's like multiplying fractions. He hands me a towel and a bottle of Pert Plus. In the warm, sulfurous water, I peel off layers of dirt and then twirl in clouds of Shower to Shower.

When I am pink and dry, we watch *The Price Is Right* from the satellite and eat Little Debbie Creme Pies from the day-old bakery. We shout at the TV when the person doesn't know the price of Brillo pads, or when the little mountain climber guy falls off the cliff. When the Showcase Showdown comes, we always root for the lady to win the trip to Acapulco. Bob Barker always reminds us to spay and neuter our pets, but most of the dogs and cats anyone keeps here get snakebit or eaten by wildcats. Some get hit on the road by coal trucks. Others just "wander off."

One of my cousins has about sixty cats and kittens living in his backyard.

"'Bout time to round 'em up and toss them off the bridge," he sometimes says.

The first time I heard him say this, I burst out in tears.

"Mom, we have to stop him. How do we stop him? That's not right!"

"Anya, don't say anything."

"But why?!?! He is going to *drown* the cats! They are *living creatures*."

"You don't understand. This isn't Westport. Animals don't mean the same thing here. You can't act like you would at home. Things are different here."

Mamaw is always a little upset when I come back from using my cousin's shower. I think she thinks I am trying to insult her old bathtub. Like I'm saying she isn't clean because she takes baths and not showers. Or that her house isn't good enough. Mamaw acts tough, but she is actually the most sensitive person I know.

Once, when we were in Kentucky, my mom left the screen door open and my dad looked at her and said, "Hey, were you raised in a barn? Shut the door so the mosquitos don't get in!"

My mom shut the door, but Mamaw got real quiet, a hard silence that spelled trouble.

After a pause, she raised her voice and said, "No, Bob, she weren't raised in no barn. We didn't have much but what we did have we kept clean. After her daddy died, it was hard, but we always did get by on what little we had, not like you fellers up there in New York. No, we weren't no bigwigs like up there in the big city, Bob. We're just poor country people."

My dad sputtered and tried to defend himself, "Oh, that's just a New England expression for leaving a door open. I didn't mean anything by it, Vesta."

Mamaw sighed.

"Bob, this ain't New England. We might not have had much, but we did what we could. We did what we could."

What Mamaw never says is that she knows that my father was my mother's ticket out of the holler, and for that she is titanically resentful. She wanted her daughter to do well, to be educated, but she didn't want her to leave. She knew that when people leave the holler, they never come back for good unless they

go belly up or need to hide from the law. Marrying my father solidified my mother's escape from poverty. Allyson and I were her anchor babies into the middle class, and our education and welfare were ostensibly the reasons my mother would never live up in the holler full time again. As much as Mamaw loves us, I am old enough to tell that she also resents us. I am pretty sure that nobody else knows and I have to protect them from finding out, especially Allyson. I don't want her to see Mamaw's bitterness and I don't want my dad to feel guilty and most of all I don't want my mom to feel bad for leaving. Because I worry that if my mom feels bad about leaving the holler, then I'll worry she also feels bad about having had us, adrift in the space between two worlds that seem to have never touched each other before me.

* * *

Mamaw's toilet is only occasionally flushed because it sends sewage into the creek if the tiny septic isn't almost totally empty. So Mamaw doesn't use the toilet, she just pees in an old Maxwell House coffee can and tosses it up on the hill. I don't know what she does when she has to poop, because as far as I know, Mamaw doesn't poop; most adult women I know don't poop. I poop. In the toilet. My mom says that when she was a kid, they all pooped up on the hill, up past the corncrib that was home to a six-foot black snake. They dug a little hole with their foot or a stick and wiped with squares of paper cut from Sears, Roebuck catalogs.

Allyson and I have to ask permission to flush Mamaw's toilet, and we often wait all day for the go ahead. Sometimes the summer days pass so slowly, the humid air so still and the hills so quiet, that flushing our accumulated waste is like watching *Dick Clark's Rockin' New Year's Eve*, waiting for the ball to drop in Times Square.

Mamaw has a habit of using a product until it's just a hairbreadth away from being totally gone. Then she places it high on a homemade shelf over the water heater. She has a fortress up there: almost-empty Nair bottles, hollow Queen Helene lotion containers, dried-out Ban deodorant. She saves slivers of her single indulgence, Dove soap, and then mashes them together to form an almost new bar. She forages for extra ketchup packets at Long John Silver's,

saves her pennies in a Bible-shaped piggy bank to send to Jimmy Swaggart, and stockpiles cans of Vienna wieners.

My mom explains to me that Mamaw holds onto things so that she knows she has things. She also keeps: empty Mason jars, old lottery tickets, fake nails, construction nails, thimbles, greeting cards, the envelopes the greeting cards came in, blush brushes, rubber bands, twine, plastic bags, twist ties, old shirts, the buttons off other shirts, canceled stamps, straight pins, safety pins, bobby pins, dull razor blades, old light bulbs, cracked mirrors, frayed underwear, empty lip balm tins, ballpoint pen caps, bits of chalk, wire hair curlers, old keys, matches, incomplete decks of cards, soda can tabs, a hair dryer that my mother used in 1968, perfume bottles in the shape of cowboy boots, perfume bottles in the shape of clowns.

At Mamaw's, the perishable becomes everlasting. Objects attempt to fill the void of all the leaving—Ed, James Edward, my mom, her two exiled granddaughters, even her antsy Jewish son-in-law. Maybe for Mamaw they are mortar holding the stone wall of our lives together; maybe they are mental caulking against the sin of poverty. They are definitely homemade shrapnel, a physical retaliation to the humiliation of class oppression. But the truth is Mamaw's home is a museum of gimcrack.

Mamaw also saves the cardboard cartons her cigarettes come in. She tears these up and writes on the inside of them in looping, textbook cursive. She keeps precise track of what she calls "the clicking times": phone calls when she knows the line is being tapped. Every time she hears a crackle or a click, Mamaw takes one of the ballpoints they give out at the bank and notes the time, the type of sound—crackle or click—and the name of the person on the other end of the line. It's never exactly clear why her phone would be tapped, just that it is and that it needs to be recorded, in case.

Other pieces of cardboard are transformed into paper fans. Mamaw sits out on the porch and sighs, "Lordy, it's a hot one. I just about burn up if I didn't have this fan." She lights another Salem, crosses her legs, and flicks the heel of her house slipper up and down.

Mamaw and I sit in humid silence on the porch. We listen to the wind blow through the chimes. Sometimes, when it gets quiet like this and the only thing that fills the air is the buzz of the katydids, I think about asking her about

Ed and about what is behind the white door and why she won't sell the car in the potato field and why she pees in a coffee can. But then I think I should make no make no mind about these things, this place. Soon, I'll be back in Connecticut on field trips to Broadway shows and cubist art exhibitions. I'll be back with *The Witch of Blackbird Pond* and *Swan Lake* and far away from this majestic, broken palace that sometimes makes me proud and sometimes makes me very, very confused.

CHAPTER 9

I didn't need sixth-grade health class to tell me what a period was. I knew I was going to get one because I was a girl and I knew that boys didn't get them. Boys got something called "morning wood," which sounded pretty rustic, and their penises popped up in the middle of class for no reason, making their pants look like little camping tents. They also reportedly had "nocturnal emissions," which seemed like a safety violation at a nuclear power plant. Boys were turning out to be disgusting.

I knew that when I got my period it meant I could become pregnant like some of my teenage cousins in Kentucky. Last summer I saw one packing a baby in the hair-dye aisle at Walmart. I asked her whose baby she was holding.

"Mine," she said.

I knew about abortions because one of my double second cousins had to drive to Missouri to get one when she was in high school. I heard Mamaw whispering about it to my mom while we ate corn on the cob on the porch. How Kaylee had gotten drunk at a party and been "taken advantage of." I wasn't sure what "taken advantage of" meant but everyone was shaking their heads. "What a waste," Mamaw said. "She was right smart, she could have been a doctor." Why did having an abortion mean Kaylee couldn't be a doctor?

At sleepovers, I watched *Dirty Dancing* and *Fast Times at Ridgemont High*; the first made the pregnant girl a victim of desire, the second showed her taking care of the situation like an annoying chore. Maybe it was both? I knew that having my period meant that there was something potentially dangerous about what my body could do and about what others might do to it. I did know

that boys were starting to look at me differently and so were grown men, like they were waiting for me to answer a silent question they constantly asked with their eyes.

I wanted to say, "Why are you staring at me?"

It wasn't just Dr. X who could invade my body. It seemed like all men, even those I'd known all my life, suddenly wanted to do the same. The more my body grew, outward and barely upward, the longer the stares became.

One afternoon in Westport, Allyson and I headed out to the far end of Compo Beach to the tide pools. I was wearing my psychedelic-print flip-flops that looked like a backdrop from *Laugh-In*, and she was carrying a plastic pail. At twelve, I was a little old to play in the tide pools, but it was something we did every summer, and I wasn't ready to admit I was getting older. As was traditional, my job was to flip over the rocks, and her job was to shout, "Crab!" We only wanted the tiniest crabs because they were the cutest. We used to serve them to our Barbie dolls in the elaborate restaurants we made out of sand, but since I knew I was too old to be seen playing with dolls in public, now we just collected and admired them.

I balanced on a slim piece of shale and flipped a rock. It was a big one. We had to act fast.

"Crab! Crab!" Allyson shouted.

"Where? Where?"

"There! He's running under that shell! Oh no! He's gonna go under the shell. Get him! He's soooo cute!"

I scooped the crab up with both hands and tripped on my flip-flop, slicing the bottom of my foot on a swath of barnacles. Blood filled the tide pool. Allyson screamed and dropped the pail, letting all of our tiny creatures loose, and bolted home.

In the first-aid cabin, a young blond lifeguard washed my foot. A flap of skin from my sole drifted back and forth in the basin. Blood continued to leak out of my heel, dancing in rivulets.

"I don't think you'll need stitches," he said.

"Thank you, sir," I said.

Stitches would mean going back to the local hospital, where Dr. X had chopped my leg.

That night the dream started with one dot lodged deep into my forehead. I chiseled my skin with my fingernails to try to scrape it off. As soon as I scratched it off, two more took its place. Calcified and hard, they erupted into ten, then twenty, then a hundred, and soon my entire forehead was covered with barnacles—small sacs filled with worms pulsing to the berserk beat of their multiplication. They huddled in my eyebrows, bounced toward my eyes, and then slurped my eyeballs out like noodle soup. Dr. X sprinkled my stomach with cocaine from a McDonald's saltshaker, the ones that looked like famous modern architecture. Dr. X took a green anesthesia hose and shot four hundred million barnacles up into my uterus. They congealed into a barnacle baby, its right leg kicking to the beat of the worms. The baby crawled out of my chopped-up torso, splashed into the creek, and headed up the holler.

I awoke to the sound of my own screams, hurtled back into the conscious world. My eyes were sealed shut with blood and mucus. I managed to pull my eyelids apart, unzipping the fluid. My hands felt for my forehead, which turned out not to be covered with barnacles but with deep scratches, like I had tried to dig out my brain. I moved my hands into my pajama pants and felt for my vagina, afraid the entire organ was crusted over with barnacles. It was soft and smooth as usual.

After that, my body felt like it belonged to Dr. X, like I was his plaything. The dream recurred at least once a week. At night, I tried to fight him back, sometimes writing journal entries before bed about plans of attack. But as time passed, the line between dream and reality began to get hazy. The fear I felt at night crept into everything. To protect myself, I developed a set of rituals. They helped me feel in control again, and if I was subtle, then no one noticed me doing them.

I became obsessed with the idea that every scab, every piece of peeling skin was the beginning of a barnacle-baby infestation. Soon every morning began with a through scraping of my body—starting with the bottoms of my feet and ending with a thorough investigation of my scalp. Any bump or scab was picked. It went like this: examine the soles of the feet, scrape, rip off toenails, poke tonsils, bite my fingernails, dig into the way back of my nostrils, rip out an eyebrow hair, search the surface of my scalp for scabs, pluck them off, and rub the center of my chest until I almost bled.

CHAPTER 10

O
ne Saturday afternoon during my sophomore year in high school, my parents took Allyson into the city for a matinee of *The Will Rogers Follies*. My father's teachers' union could get discount tickets to Broadway shows that were past their prime, and he jumped at the chance to take in some of the Great White Way's least popular offerings. He also insisted that Betty Comden, one of the lyricists of the show and half of the famous songwriting duo Comden and Green, was a relative by marriage on his side of the family. In fact, we were so closely related to Betty Comden that my father once shared a corned beef sandwich with her at the Carnegie Deli in between rehearsals for *Singin' in the Rain*.

I begged my way out of the trip. I was beginning to think about life beyond high school. An obvious path was being a senator, or at least an influential lawyer. Maybe a public intellectual, State Department official, or National Security Council member. I remained torn about pursuing a career in professional dance. I still traveled into the city to dance, but I had switched from studying ballet to studying modern dance at the Martha Graham School. Modern dance seemed more forgiving of my burgeoning hips and breasts. My standards for success were ridiculously high. I was spoiled by having worked with some of the world's best teachers. If given the opportunity to be a dancer in a major company with a major choreographer's work to perform, I might have been willing to postpone college. Even if that were to happen, though, I didn't know if I could let myself become *just* an artist. Dance and art and writing were all things I pursued in the time when I wasn't studying.

I never thought of them as hobbies exactly, but it was obvious I didn't have any inherited wealth coming my way, and everyone I knew in the dance world was totally impoverished. So it seemed like it just wasn't a possibility if I wanted to continue eating.

When I told my parents that I might be interested in going into public service like them, my father rolled his eyes and begged, "Couldn't someone in this family try to *make* money?" I told them I might like to work at the UN doing something about human rights. Of course, these lofty aspirations meant I couldn't possibly take time off to go see *The Will Rogers Follies*, no matter how disrespectful it was to my third cousin by marriage Betty Comden. I had to work extra hard in my AP US History class. We were in the midst of studying muckraking.

Up until then, I had been pretty bad at parental subterfuge. My house wasn't an easy one to sneak out of unless I wanted to swan dive from the second floor. Besides, my father was an insomniac like I was and sat up watching reruns of *Taxi* and rereading all the historical works of Will and Ariel Durant. Even if I could have snuck out, I didn't have anywhere to go. Most of my friends were as preoccupied with schoolwork as I was, and it never occurred to us to steal our parents' booze and party behind the Lutheran church the way I heard other Westport kids did (though some rebel nerds did steal library books and pirate computer programs). But that February afternoon was the first time I deliberately did something I knew would send my parents into orbit.

The previous year I had fallen psychotically in love with a senior named Will when I watched him sitting alone in the cafeteria eating french fries with a tiny wooden fork. I had never seen anything as beautiful as the moment he dipped his fry into his paper cup of ketchup. I was so sure I had been felled by Cupid's arrow that I searched my body for the exit wound. I was shivering with something I would learn to call desire.

A Martha Graham legend says that once the great lady was asked her opinion of the work of another solo female choreographer. She replied with obvious disgust, "She doesn't dance with her vagina." For me this was one of the main differences between studying the Balanchine technique and the Graham technique. Graham accounted for female desire in all its complexity.

After the french fry, I danced in a new way, with my vagina.

I had noticed Will in the hallways before but hadn't been even mildly attracted to him, a fact that made the thunk on my head all the more baffling. He was eighteen, but his preferred wardrobe was that of an affluent older man, the kind you might find shopping for Earl Grey tea and Cat Chow in an Upper West Side Gristedes or sitting on a park bench admiring a rare bird, all swaddled in corduroy. Instead of wearing canvas Converse like everyone else in high school, Will wore full-grain leather Top-Siders and carried a suede Ralph Lauren backpack. A lot of high school kids wanted to look like Joey Ramone and dressed in thrashed black jeans and motorcycle jackets. Will wanted to look like Art Garfunkel. Everything about him looked soft: his cashmere sweater, his plump lower lip, his almost undetectable lisp, his blond hair that couldn't make up its mind about whether it was curly or kinky. I sometimes saw him leaving campus in a boxy Volvo sedan, driving fifteen miles an hour, tapping the steering wheel with his thumbs. I imagined he was rocking out to James Taylor.

I began stalking him. I spent my afternoons before dance class going to meetings of clubs I thought he might be in: Law Club, Debate Club, AV Club, and WWPT, the school radio station. I tried to find out if Will had a girlfriend, who his friends were, what classes he was in, what kind of music he liked, where he hung out. One morning he passed me in the hallway in the science building, and I followed him back to his physics class, hiding in the lab closet to watch him stare at the blackboard. This became a daily habit. I looked up his address and phone number in the school directory and called just to hear his voice, then frantically hung up. I dusted off my too-small Barbie bike and rode by his house, peeking into the void of his empty mailbox.

In the great pantheon of high school characters, Will was not a likely target of infatuation. Most girls in my class favored the football and soccer captains. A few went in for the school's honorary Buddhist, a hunk who mediated every morning at Compo Beach on the hood of his BMW and offered some of his macrobiotic lunch to unspecified gods. Then there were the baby goths, who worshiped their goth prince, a junior with malachite lipstick and hair the color of blackberries.

I joined the cast of *Fiddler on the Roof* as village girl number twelve. Will was playing Motel, the nebbish tailor. I watched every rehearsal from the wings and repeatedly cried jealous tears when Will shared a stage kiss with Tzeitel, Tevye's eldest daughter. I spent entire weeks in a love-drunk daze, scribbling what I was sure would be my full married name, Anya Elizabeth Liftig Albert, in number two pencil in every binder, every notebook. I sobbed myself to sleep after hearing a rumor that Will had been caught in the green room with his hand up Audrey Zabelini's shirt.

I heard through the grapevine that Will liked the Beatles, so I went to the library, checked out every album, and memorized every song. I also heard Will thought Bob Dylan was cool, so I dusted off my parents' records and learned all the lyrics to everything up through and including *Blood on the Tracks*. Some of the vocabulary was a little beyond me, words like "forsake," "reprobate," "vagabond," and "proletariat," so as I listened, I looked up them up in *Webster's* and memorized them. Needless to say, I had little time left over for my actual schoolwork. But how could I care about the narrative arc of *A Tale of Two Cities* when someone's big sister heard from her best friend that Will smoked Benson & Hedges? I acquired one and tested it out.

I heard Will loved *Star Trek* like my father. In fact, one of my dad's patchwork of adjunct teaching gigs was a course on science fiction writing. I always thought the late-night reruns of the show were hilariously bad, the entire set looking as though it were held up with cellophane tape. But overnight, I became a Trekkie. Each rerun on channel eleven was treated with the utmost solemnity. And miracle of miracles, a short time later, I uncovered a nugget of gold: my uncle had been college roommates with a writer for the *Star Trek* comic book series.

Armed with this precious piece of information, I marched into rehearsal and assumed my usual spying perch, off stage right. Like the new kittens Allyson and I had just adopted (which I insisted we name Kirk, Spock, and McCoy to prove allegiance to Starfleet Command), I waited for my chance to pounce. Sometime during the break between "Matchmaker, Matchmaker" and "Sunrise, Sunset" I sprang into action and oh so casually bumped into Will.

"Hey," he said with that sexy lisp.

"Hey," I said, sputtering. "So I heard you like *Star Trek*. I'm super close family friends with one of the writers. In fact, he even named a character after my family." I was sweating all the way down to my Doc Martens. While this was undoubtedly an exaggeration, it was not ungrounded in truth. DC *Star Trek* issue 204 had featured a brief encounter between Captain Kirk and a character named Male Nurse Liftig, who was killed off by the bottom of the next page. I insisted that my dad have the pages enlarged and framed. The spread was currently looming over our downstairs toilet.

"Cool." Will said. "Have you ever been to a convention?"

"Oh, totally," I lied. "I go all the time because, you know, there is a character named after me." This was a complete fabrication, and months later, after I lured Will over to my house to watch a VHS of said family friend discussing his work on *Star Trek*, after I causally dropped the needle on *Magical Mystery Tour*, after I kissed him on my bubble gum–pink bean bag chair, I did in fact find myself at a *Star Trek* convention.

Will was a fantastic boyfriend. He was calm and adoring, always introducing me to great music and great books. We liked to read to each other, and he gently corrected my pronunciation when I stumbled on a difficult vocabulary word. Will was serious about his schoolwork, and because I was serious about anything involving Will, I became even more serious about my schoolwork.

On Sunday afternoons, we would take his mother's boxy Volvo and drive to the comic bookstore in Norwalk. I didn't care about comic books at all, but Will did, so I started collecting them. When Superman died, we both donned the black armband included in the foil-sealed commemorative issue.

One icy afternoon, as we were walking back to the Volvo, Will said, "I love ya."

I almost peed myself with excitement. But I had to play it cool. "You mean like Paul McCartney, 'she loves me, yeah, yeah, yeah'?"

"Yes, I luuuurrrrrrve her, yeah, yeah, yeah."

But pretty soon we start saying it for real, not just in our Beatles voices.

So a year and a half later, on that February afternoon, while Allyson and my parents were being regaled by the genius of Comden and Green at the Palace Theatre, I invited Will, by that point a freshman at Cornell, over to

have sex on my carpet using a bright-green condom. Though the bed would have been way more comfortable, I didn't want to be stared at by my stuffed animals while I lost my virginity, and besides, if we did it on the carpet, it kind of made it less official. Maybe?

I have always been afraid of roller coasters, and those brief moments when Will rocked back and forth on top of me, testing out how hard he could push before I made him stop, felt like flying unbuckled on an upside-down loop-the-loop. Something was expanding inside of me, undiscovered countries on a multiplying map of the world. I figured I wouldn't bleed because my hymen was likely all stretched out from sitting in splits in dance class, but my hips were still resting on an old *Simpsons* T-shirt in case it happened.

As my stomach dropped into my knees, bestial knowledge crept into its void. This squirming back and forth, this push and pull, this desperate desire to be filled was the thing everyone said I had to protect, the thing that drove men to attack you in the still of the night, the thing that could kill or create life or commit some version of both.

I had sex with Will though I full well knew I was way too anxious to be sexually active with anyone, even just with myself. When I'd start to think about sex, I'd pour some Elmer's glue on the bottom of my feet and wait for it to dry so I could peel it off. I'd do this a couple times every night, rubbing off the little balls of glue while I did my homework. The thing was, once I'd really started looking and listening, it seemed that all artists, all real artists, made work about love and sex. If I didn't know what sex was, then how could I make real art? Wasn't this research?

And though I knew I was doing the same thing as my teenage cousins in Kentucky, though I knew that sex was sex was sex regardless of whether it was with a future poet laureate or a truck driver, I was still sure that it was the poverty-stricken girls like my Kentucky cousins who became pregnant and dropped out of school, not middle-class (upper-middle-class?) kids with college savings accounts like me. Or, at least, if I did become pregnant, someone would make sure I did something about it, someone would pay for it, quickly and quietly—and maybe I would have mono and be out of school for a week. I wouldn't be expected to actually have a baby when I was a teenager.

My life was already planned: high school, college, job, husband, house, babies, in that order.

The fact that I lost my virginity that February afternoon was also due to a fluke of sorts. A few weeks earlier, hanging out with my friends from the Model United Nations Club, which I'd joined because Will had been the president in his senior year, I came in close contact with my first condom.

Our gatherings were usually hanging at someone's house, eating Flamin' Hot Cheetos, shouting jokes we thought were funny as fifteen-year-olds in 1993, usually about "funny-sounding" African nations.* We would watch Monty Python, order some pizza, and argue about innuendo-laden aspects of AP US History, like whether Teddy Roosevelt actually carried a big stick.†

One such evening, the most talented scientist in tenth grade, Gabby Skatuer, pulled a witty gag. She had purchased a box of rainbow-colored condoms at Utopia, the local head shop, and in the middle of another evening of reenacting scenes from *Holy Grail*, she tossed the entire box over our heads. Colorful plastic squares littered the carpet. Everyone laughed. As the "Lumberjack Song" started up again, I grabbed the nearest condom, a Gumby-green one, and tucked it into my jeans pocket.

Later that night, despairing of finding a hiding place safe from my mother's constant straightening of my room, I had to think fast. Though I had started to give my bedroom more of an angry, teenage vibe with posters of the Pixies, I hadn't had the heart to put away my collection of Care Bears, Popples, and Pound Puppies.

I surveyed my kitsch kingdom and then, just like in the short story "The Lottery," I randomly selected my victim: a plush California Raisin doll with dark felt sunglasses. I took a pair of scissors and cut along the side seam of the raisin's back. I burrowed into the stuffing, slid the condom inside, and sewed it up with black thread. Then, I placed it back with the other stuffed animals.

But almost immediately after losing my virginity, I thought I was pregnant. I was paranoid that some disgruntled condom-factory worker might have

* Would you like to touch my Burkina Faso? (I'm sorry.)
† Wink wink, nudge nudge, say no more, say no more.

poked a hole in the rubber, just to stick it to the man, or rather the woman. There was nothing to do but wait and tell myself it would be fine. But three weeks later, when my monthly gift was supposed to rear its ugly red head, my panties remained clean.

And the next day.

And the next day.

When I was two weeks late, I drove to the pay phone behind the Grand Union grocery store and placed an anonymous call to Planned Parenthood. "It's probably all the stress of thinking that you are pregnant that is delaying your period," the counselor said.

"But what if it's not? What if it actually is being pregnant that's causing it to stop?"

"If that's the case, then Planned Parenthood is here to tell you that you have options. You don't have to have a baby now if that's not what you want." All I heard was that my life was completely over.

I kept waiting, another week, then two, then four. I tried to get up the nerve to take a pregnancy test, but I was paralyzed.

Will and I speculated about what we might have to do over cheese fries at the Sherwood Diner. "You know, if *Star Trek* was actually real, we could just beam ourselves to another time and place, and then we wouldn't have to worry," he said.

"I love you, but that is unhelpful."

He yanked a cheese fry loose.

"I once saw this movie about a girl in Ireland who tossed herself down the stairs over and over again until she had a miscarriage," I said.

Will said that with a little wrangling, I could probably live in his dorm room at Cornell while the news blew over. But I didn't want to be a mother yet, and I was afraid of how I would survive the guilt of having an abortion, of keeping it from my parents if I actually had to walk through Planned Parenthood's doors. I didn't want to share his stinky room with his angry electrical engineering roommate. I wanted to go to the prom and dance around bonfires and spray Easy Cheese all over the cafeteria on prank day.

That night, I came home five minutes past curfew. I wasn't too worried; everyone was usually asleep when I got home. But not tonight.

"Anya, I want to talk to you." My mom was waiting at the top of the stairs. "Are you aware that you are out past your curfew?"

"I'm only five minutes late. My Swatch is busted."

"I don't want to hear it. What were you doing?"

"I was at the diner with Will; I lost track of time. I'm sorry."

"Are you having sex?"

This was not the gentle question of a supportive adult. This was a rhetorical accusation worthy of 1690s Salem, Massachusetts. Had she been tuning into my terrified frequency every night? Picking up my pregnancy worries on the local mothers' intuition radio station, WWYou'reInBigTroubleRadio? Had she been surveilling the trash can, waiting for my soiled tampons to appear? Was she just trying to scare me straight? Or was this her screwed-up way of asking if I needed help?

"No," I lied. I had barely even kissed Will since the green condom, but still, the present did not obviate the past. Did having sex once count as "having sex"? That made it sound like it was something regular, habitual even. The thought of doing something so terrifying on a regular basis was, simply, terrifying to me.

"I just want to let you know that if you are, and if you get pregnant, don't walk through my front door again. I didn't fight my way out of the holler for my daughter to get knocked up like all of my godforsaken cousins. I didn't bust my ass so you could whore around. Do you understand me?"

Her hair was standing up like a rooster's coxcomb.

Moby Dick was about to blow.

I nodded.

"Good night," I said.

I crawled into bed and surrounded myself with my gang of dirty Smurfs, crying into their blue fur. I poured Elmer's up and down my shins, all over my feet, and between my toes. I chewed the insides of my cheeks, swallowing the little pieces of flesh. I dug my fingernails into my scalp and scratched. I knew that if my parents started asking questions about all these little tics, the way I was chipping at myself, I'd come up with something to tell them. We'd all acknowledged I was weird. As long as I came up with a creative motivation, I was certain I could keep people from fully noticing what I was actually feeling.

Being artistic meant that people gave me leeway. "She's just expressive," they'd say. "She just sees the world differently," they'd say. Actually, I think I saw the world the same way. It just hurt more.

That night I had the barnacle baby dream. Instead of Dr. X, Will was filling my womb with four hundred million barnacle sperm.

I was infested.

In the morning, I woke in a pool of blood.

CHAPTER 11

I'm standing in Grand Central, trying to call my mom to tell her that I'm on my way home from dance class. No one answers. I punch in the calling card again. Allyson picks up. She says mom is in the hospital. Something about her heart, indecipherable.

"I'm on my way," I say. Terror sets in. "I can drive us to the emergency room."

"No you can't! You know you aren't allowed on the highway yet! You'll get in so much trouble. Anya, I'm really scared."

When I get home she flings the door open. I have to make her rewind to explain from the beginning. "Mom felt really dizzy so she went to Dr. Baubaum, and he said it was probably hormonal, because she is doing the change, but he asked her to wear a heart monitor in case."

"In case of what?"

"I'm not sure. If she felt dizzy, she had to punch a button in the middle of the machine. A place in Florida would see a report." Dr. Baubaum knew that a big chunk of my mom's medical history was hazy. In Kentucky, doctors were few and far between, and she had mostly relied on Granny's home cures, herbs, and tinctures. She couldn't medically account for her early years, other than to say she survived.

After the appointment, Allyson and my mother had gone to the pet store to buy a bag of crickets for Allyson's lizard, Scaly. He was scrawny but he ate four times his weight in insects. They were standing in the fish-food aisle when my mom was hit with a wave of dizziness. She pressed the button on the monitor.

When they got home, there were four messages on the machine. The monitoring company had caught her dizzy spell on its system. Apparently, her heart had completely stopped, then restarted on its own. She needed to go to the emergency room. Our parents are now at Yale New Haven Hospital, my old stomping grounds.

While Allyson is telling me all of this, my father calls.

"Girls, Mom's heart stopped in the emergency room and didn't start again. They used a defibrillator. Now she's conscious and she's in the best place possible. Yale has a terrific cardiology department."

"What's that?" Allyson asks.

"What's what?"

"A defribbleator?"

"Those paddles they use in TV shows, those things. The shock things," he says. "They said her heart might not start back up on its own anymore. That she was so lucky she saw Dr. Baubaum today and that she got to the hospital in time."

"But what do they do to fix it?" I shout. "Dad, they can fix it right?"

"We just have to wait and see. Girls, someone needs to call Mamaw."

This means I need to call Mamaw.

I take the cordless into my bedroom. I have to look up Mamaw's full number. Near the holler, the phone system is so old and there are so few people that you only dial the last four digits. I dig up the other six.

The phone rings.

"Mamaw, it's Anya. Mom is in the hospital. Her heart stopped. But they got it working again, and well, she's OK for now, but we just have to wait and see."

"Why poor little Inez, I done told her that working so hard and doing all she does to take care of you girls an' Bob was gonna catch up with her one day. Bless its heart. Must have worn her plum out. I never did see someone work as hard as she does. Bless its heart."

I usually do a pretty good job of blaming myself for things, but until I talk to Mamaw, it hasn't occurred to me that it might be my fault.

"Why maybe she's got that Fugate gene. Uncle Fred and all them just pass around age forty-five. None ever knew why. Just a Fugate thing."

"Mamaw, do you want me to tell her anything from you? If I get to see her? When Dad calls back?"

"Why no, you just tell her I hope she gets right better, and I sure hope she can come home this summer."

"That's it?"

"It sure is, Anya."

"Do you want to know her phone number at the hospital?"

"Why no, I don't reckon I need it. I'll just call you if I need. You tell her to get right better. You tell her that her Mamaw loves her. Tell her that her Mamaw misses her."

For the first three or four days, I phone Mamaw every afternoon to give her an update until it occurs to me that I might be annoying her. All she keeps saying is that Uncle Fred and all of them just pass about the age of forty-five.

Visiting my mom at the hospital in New Haven reminds me of the winter I spent there as a six-year-old getting ready for my leg surgery. Walking through the rotating doors on York Street, past the security desk and the gift shop, it all comes back: the antiseptic smell, the fluorescent lights, the interminable waiting, fidgeting with magazines, scribbling with crayons, cardboardy cheese-burgers, and fear. But I know this is not about me. I could handle it (mostly) when it was about me. This is much worse.

When Allyson and I finally get in to see my mom, she is burrowed in a nest of wires. Despite the constant hiss-whirr-bing of the machines, she is sleeping, her jaw grinding back and forth. She looks shrunken. Her hair is matted on her pillow. It occurs to me that this might be her deathbed. If not here, then some other time, in another place, there will be a deathbed. I'm a year older than she was when Ed was killed, when her whole world fell apart. It could happen to me, right here, overlooking the puny New Haven skyline.

But she wakes slowly. She is happy to see us though it's hard to embrace through the wires. She insists we eat some of the cream of chicken soup the nurses have brought. The smell of it reminds me of my operation, but I manage to swallow a spoonful. We smile and giggle together even though there is nothing funny at all.

"Have you called Mamaw?"

"Yes, I have."

"Did you tell her I was here?"

"Yes, I did."

"What did she say?"

Should I tell her that Mamaw isn't interested in talking to her, keeps mentioning how people in the family just keel over at her age, and how Allyson, Dad, and I probably are driving her into her early grave?

I make an executive decision.

I lie.

"Mamaw says she wants to get on the next plane up."

"No, no, no." My mother shakes her head violently. "Don't make her leave the holler. You know how she hates leaving the holler."

"OK, I'll tell her everything is OK."

"Yes, make sure she knows everything is OK. You have to promise me."

Has my mom not noticed that everything is clearly not OK?

"Don't worry her," she says.

"I won't."

The doctors try to figure out what is wrong with my mom for several weeks. They don't know why her seemingly healthy heart randomly speeds up then screeches to a halt. They suspect it's genetic, because it's true, there is a tendency for people on the Fugate side to keel over at forty-five. No one knows why, though. In Kentucky, things just happen to people: car wrecks, ODs, the sugar, TB. No one really spends too much time figuring out the details. Dead is dead is dead.

Eventually, my mom's doctors think her condition might be a "deleterious effect of consanguinity"—an erudite euphemism for birth defects caused by inbreeding. Standing around her hospital bed, they say the words gently, as if it hasn't already crossed our minds, as if we don't all remember Granny with her extra little thumb. I think of the fact that nearly everyone in Breathitt County looks exactly like one another. The doctors offer a less embarrassing but still plausible explanation, that this might be the result of untreated childhood scarlet fever. Any way you cut it, it's a hillbilly shitstorm coming back to bite my mother in the ass.

Over her umpteenth cup of orange Jell-O, my mom says, "You can take the girl out of the holler, but you sure can't take the holler out of the girl." I'm glad

she is laughing about it. Of course, she's not really laughing about it. Though my mom physically left the holler, I don't think she ever emotionally left the holler. None of us have. It clings.

Small fleets of doctors come and go. My mom is a rare medical bird. Most people suffering from sudden cardiac death syndrome (what they eventually diagnose her with) do exactly what the name says: die suddenly. There is the usual posse of medical students lingering in the hallway outside her room. They poke and prod at my mother, scribble down notes, and nod reassuringly. She's an anomaly, and they are fascinated.

When I see the doctors surround her bed, I disassociate on behalf of both of us. I swallow my memories. I smile. I crack jokes. I take notes. I distract her. I eat her pudding. I focus on who needs to be called. Who needs to talk to the insurance? Also on petty teenage things: Will I have time to buy a junior prom dress? Should it be strapless?

But sometimes I feel so entwined with my mom that I have trouble differentiating myself, my thoughts, from hers. Sometimes when we hug, I hold her too tight because I'm afraid she is going to fall off the edge of the world. She almost did. I'm also afraid I might to fall off the edge of the world, but I've learned that if I clench everything tight, the spinning stops. My secret rituals keep us safe. I can differentiate good vibes from bad vibes. I can protect us.

The doctors decide to implant a device in her body, a stainless-steel box as big as a deck of cards. This machine will be her personal pacemaker/defibrillator. If her heart stops, the machine will shock her. Those EMS paddles and wires will be implanted in her heart walls.

The surgery is lengthy and complex. To install the device, they stop her heart long enough to implant a set of wire leads. They cut into her chest, shoulder, and stomach and plunge the wires directly into her heart wall. They test the machine; when it discharges, she flops like a flounder.

It will take some getting used to and not just for her. If we listen to her stomach carefully, we hear a faint beeping sound under the skin, emitted by her device. My mother, always petite, will have to get used to the large contraption in her body. She has to gain at least ten more pounds to create a physical barrier to pad the device from being jostled. If the device is jostled,

there is a chance it might randomly start discharging electricity into her heart, electrocuting her.

As soon as we come to rest in the rocking chairs on the porch in Ganderbill that summer, Mamaw will make mention of this.

"I'm glad I've lived long enough to see my daughter look right fat and happy." She'll laugh as she takes a long drag of her Salem.

My mom will look at my dad, panicked. Her hair is doing that rooster coxcomb thing. He will try to intervene.

"Well, Vesta, Inez had a very serious surgery, and she has a very complicated device implanted in her heart and her stomach wall. They required that she gain weight in order to—"

"I understand, I'm just happy to see her fat and jolly, that's all I mean to say, Bob." This is not nice. This is not nice at all. What about the fact that her daughter is lucky to be alive? What about the fact that her daughter is most certainly not happy, having just spent weeks in the hospital and emerged with a diagnosis that includes the words *sudden* and *death* in it? What about making her a bowl of chicken soup? Fluffing her pillow? Reading her a book and letting her cuddle up by your side, Mamaw?

But this hasn't happened yet. We're still in Connecticut. My mom learns that she can't go through the metal detectors at the airport, and for the rest of her life will be taken aside and felt up by a female security officer. Her device is powered by lithium batteries that have to be physically replaced every three years. In order to do this, they will have to stop her heart and the device with a large magnet, then operate on the heart wall again. This will mean heart surgery every three to six years for, if she is lucky, the next forty or so years.

The doctors have rarely seen someone so young with this condition. They offer no prognosis. The prospect of repeated heart surgery is ominous, and no one really knows what its effect could be. There is only limited space in the human heart to implant wire leads. The doctors tell us that the future, always unknown, is indeed unknown.

Sagacious.

Somewhere in there I take my AP exams. I take my SATs. I take my SAT IIs. I buy the lizard crickets, I feed the cats and dog, I make the arrangements. We

try to keep my dad calm. He heats up lasagna from a box; he packs lunch. I make sure we have milk and bread and some kind of green vegetable, because I know one must always have some kind of green vegetable. I perform. I rehearse. I talk to Will on the phone. I get myself to dance class in the city and back. I write my junior year research paper. I write scholarship essays for a national award I later win. Allyson helps me get ready for the prom. She swabs my eyelids with blue powder. We hold down the fort.

No one from Kentucky sends a card. No one sends flowers or balloons.

When she gets home from the hospital, my mom is relieved to hear Mamaw's voice.

"Yes, Mimmy," she says. "Yes, I'm sorry to hear that Terry pulled his back mowing the yard. Yes, I hope he gets right better. No, I didn't hear that Howley has arthritis. That sounds right painful."

Mamaw explains how everyone up and down the country is in worse shape than my mother is. The implication is that she should stop complaining, buck up, and get on with it. It has been evident all my life that my mother is an outcast, but only now do I start to see that there may be a little malice mixed in there. When I have seen glimpses of it in the past, I have explained it to myself as my misunderstanding of holler culture, as my oversensitivity or just my eccentricity. I have followed my mother's lead in dismissing the neglect and foul treatment because it has always been easier than confronting it. But now, watching my mom, I am ready to roar.

I allow myself to remember that a certain form of cruelty has always been latent up the holler. My cousins delighted in roughhousing with me, even after the problems with my leg. They tossed me on the backs of ATVs and rode hard and fast up the side of the mountain. They strapped me, a hyperventilating and trembling eight-year-old, onto jet skis, then drove the motorboat so recklessly I was thankful when I fell into the lake, despite the cottonmouths. They coerced me into climbing to the top of the pool slide and, when I had worked up a terrified sob, shoved me down. This was all considered to be in good fun, good to toughen up my whining, Northeastern ass. It probably looked harmless from the outside, but I was a child with towering strength in some places and bottomless fear in others. When I complained that they were scaring me or hurting me, they told me that they were just showing their love. Apparently,

love was supposed to hurt, and so just like the pain in my leg, I drank in my milkshake and accepted it as a matter of course.

Everyone liked to tell the story of Maylie and the bucket. When my great aunt Maylie was a child, Granny had a terrible time getting her to mind, until she came up with a solution. She went out to the clothing line, took a bucket, and flipped it over. She made Maylie stand on it while she tied a rope around her neck. She left her there. For eight hours. Maylie's only option was to stay still or hang herself.

CHAPTER 12

O n a swamp-butt-damp evening in late June, two days before my official high school graduation, the principal brought all three of us Key Award nominees up to the podium. As she read off my accolades and achievements, I stared over everyone's heads into the darkness of the theater. The girl she was describing, with all her prizes and achievements, was a mystery. I felt as empty as a tin can.

I wasn't valedictorian like my mother, but I did win a generous college scholarship from Discover Card for "overcoming the adversity" of my leg injury and eventually dancing professionally. I won honors in English, history, visual art, and theater, and now I was one of three nominees chosen by our teachers for this award, the highest academic and leadership award given by the school system, voted on by the entire senior class. It was announced tonight, on Awards Night, with the drama of a glitzy, televised beauty contest that happened to be held in an unairconditioned high school auditorium. The winner would receive an engraved 14-karat-gold key charm and a handsome wooden plaque, and would have their name inscribed on a trophy forever displayed in the school foyer.

To my right was the affable daughter of a respected administrator in our school system. She had been deeply involved with her church group and a variety of animal welfare organizations. She was headed to the University of North Carolina on a full ride and was nice and smart. I had no beef with her. But to my left was my all-time archrival nemesis, foe of foes, calumniator of calumniators, Meredith Golden. From the moment we first made eye contact

during a jazz dance audition in third grade, we had been smiling condescendingly at each other, barely disguising our mutual jealousy. Every diorama, every class presentation, every exam was a battleground for unconditional dominance, a possible strategic move in our game of sycophantic scholastic chess. By the time we were in high school, our parts were cast; she was popular, as saccharine as a candy apple, her bubbly handwriting adorning her every notebook page. I was an artiste with a vocabulary and mood disorder able to devour developing nations. My cool was uncool, which I convinced myself was doubly cool to me. I was so cool that I didn't even *need* to be cool, because I was already so cool.

Of course, I had many motivations for doing well in high school. For years I dreamt I would follow Will to Cornell, and we would get married after I graduated. I also wanted my parents, especially my mother, to feel like leaving the holler had been worth it if it meant her daughter could rise to the top. Most simply, though, I loved school. I loved devouring books and putting words together. I relished rip-roaring debates in class, particularly arguing about nefarious elements of US history that I thought I was the first person to uncover.

But I am now old enough to finally admit that some small part of my motivation for getting good grades and being the president of everything was because I kind of wanted to be a thorn in Meredith Golden's zit-free existence. If she was an editor of the school yearbook, I would be the editor of a newer, wittier rival newspaper, a *Spy* to her *Vanity Fair*. If she was in charge of the school literary magazine, I would be in charge of the Young Democrats, which during my tenure might put out a literary magazine, just because. If she was the head of the publicity office for the school theater group, I would be vice president of the school theater group, charged with managing said head of the publicity office. If she won the Smith Book Prize, I would win the Vassar Book Prize and privately gloat that Elizabeth Bishop was cooler than Margaret Mitchell any day of the week, and I would do it all with a gracious smile that belied my jealousy over every extracurricular crumb.

In general, Meredith Golden always won our battles, or it seemed to me she always did. The fact was, she was extremely smart and hardworking.

She was going to Dartmouth like her father had; she had been wearing Dartmouth sweatpants since third grade.

What's more, Meredith Golden was chair of the senior award committee, which meant she was also partially in charge of manning the polling for the Key Award in the cafeteria. At lunch, she sat at a folding table and passed out the ballots with all three of our names on them. She smiled at every voter, offering some chummy inside joke as she gathered the white election slips. Clearly, this shit was rigged.

I watched her and seethed. Though I knew I was on to bigger pastures next year—I had been admitted to Yale early partly on the strength of an essay about my time at its children's hospital—I was still mired in the cutthroat and, in retrospect, completely naïve ecosystem of high school.

It was with more than an air of resignation that I mounted the auditorium stairs that sweaty evening. I looked out at the audience, steeling myself for the oncoming humiliation. As the principal pulled out the award plaque from under the dais, I focused on the nearest light fixture like I was bracing for a typhoid shot.

The principal asked for a drumroll.

Seriously?

A drumroll?

"And the winner is Anya Liftig. Congratulations, Anya! Well-deserved!"

I was still looking at the light fixture, my vision a little trippy from staring too hard. The principal had to force the plaque into my hands. My eyes bulged at the sight of my name.

A camera shutter clicked.

The crowd applauded.

"Huh?" I asked the air.

Meredith Golden turned and faced me. Through the clenched teeth of her frozen smile she said, "You won, Anya. You won."

Then we air hugged like we always did.

The next day the front page of the town newspaper featured a picture of me the moment the prize was announced. I look like I've been shocked by my mother's defibrillator.

"SURPRISE! Staples High 1995 grad Anya Liftig is shocked to receive the school's Key Award," read the caption.

My mom called Mamaw to tell her the news.

"Ain't that nice. Now, Bub won a big trophy up at Panbowl Lake. They give Anya a trophy?" Mamaw said.

"She got a plaque."

"Well, this is a big trophy, the kind you put up so everyone can see."

Two days later I officially graduated. As gifts, I got three copies of *Letters to a Young Poet* and two copies of *The Collected Poems of Allen Ginsberg*. I got a Modern Library edition of *To the Lighthouse*, a copy of Alice Walker's *Her Blue Body Now*, and *The Collected Stories of Dorothy Parker*. My parents gave me a Pentax K1000 35mm camera, which I had heard was the first camera of all the best photographers. Allyson gave me a Barbie for President doll and spiked the chair at my graduation party with a whoopee cushion.

I watched the mailbox and waited by the phone to see if there was any word from Kentucky. Cards came from all over: San Francisco, Stockholm, and Sudbury. They came from Scarsdale and Brentwood, but none ever came from Ganderbill.

I was obviously getting above my raisin'.

CHAPTER 13

The summer before Yale, after we make our way through the steep switch-backs of Pound Gap; after we fight wheezing, speeding coal trucks and head deeper up and into the Appalachians; after we drive past signs for places like Vicco, Fisty, Happy, Rowdy, and Shoulderblade; after we go by the rickety go-cart track, the forlorn "Coal" bowling alley, the bustling discount cigarette outlet, the bizarre Mother Goose House in Hazard;* after we drive by the US post office in Bonnyman that has a habit of hanging its American flag upside down; after we pass the flea market where you can buy fighting cocks, semi-automatic rifles, and bootleg Metallica cassettes; after we pass through Bad Branch, Defeated Creek, Scuddy, and Sassafras; after three hours of driving away from big box stores and interstates, we come to an unmarked gravel road, the homeplace, Ganderbill.

My dad drives slowly as we pass each shack and trailer up along the creek. Everyone in the holler is kin, kin on top of kin, kin squared. We wave and honk and cousins come running, all wanting to know how long we're in for. We stop in at every house, repeating the same stories of our year over and over again. We are collectively known as *Inez's people*, down for the summer from big ol' New York City, city of pornographers and swindlers. In between houses, I ask my mom exactly how we were related to everyone again. It's easy to lose track.

* Yes, there really is a place named Hazard, and yes, there really is a house there shaped like a goose—a green goose with automobile headlights for eyes.

"That's Wayne's brother. You remember the blind man who always sat in front of the old log cabin? Where Old Man Gran's mill was at? The man in the overalls? That's his cousin."

As we slink up the holler, my mother's accent trickles back. Hearing its initial permeation into her learned Connecticut speech still frightens me a little, even at seventeen. It's like she's looking for some ancient stroke of graffiti she scrawled on a wall as a teenager, testing to see if those trenchant sounds are still hiding in her somewhere.

"Why looky there!" she'll say, pointing at a towering field of corn.

She only talks like this when we are up Ganderbill and on Sunday mornings when she calls Mamaw. It's a family ritual: We lie on my parents' bed, eat bagels and lox, tear apart the Sunday *Times*, and take turns talking to her. My father grabs the crossword, I grab Arts & Leisure, my mom grabs the coupons, and Allyson complains that a newspaper without comics is another in a long list of American atrocities.

When I first hear my mother's accent drift back, it always sounds fake, like she is doing a bad impression of herself. Then it sinks in that it's her Connecticut accent that's the falsehood, that she had to practice for years to achieve the harsh nasal inflections; the strange, elongated endings; the confusion between "picture" and "pitcher" that characterize my Southeastern New England accent. When she speaks with her twang, I remember that though I made my first home inside her and my second in her arms, I am not her. She is of this worn world outside our car windows; I am not, except when I am, which is always.

We round the last bend of the holler and Mamaw's shack emerges from the mist, Ed's Studebaker forever parked in the potato field. Up on the porch, Mamaw is waiting, rocking back and forth, waving one of her cigarette-carton fans. A passel of cousins is sitting up with her, drinking pop and smoking Camels. Mamaw hears our car coming long before she sees us. She knows the sound of almost every motor that makes it this far up the holler. When she doesn't know the sound, she waits for the vehicle to come around the bend. If she doesn't recognize it by sight, she readies her pistol.

As soon as we see her, my dad honks the horn, announcing our friendly intentions. By the time we get up the holler, Mamaw's phone has already

been ringing. Our car, with its royal blue Constitution State license plate, has been tracked by watching eyes all the way from the county line, spotted first down by the dairy bar and second over by the gas pumps at Vic's, where we stopped to buy Mamaw a sheaf of scratch-off lottery tickets and a few cartons of Salem 100s.

My mother frantically checks her look in the mirror.

"Ugh! So many wrinkles. It's awful. When did this happen?"

"I don't see any wrinkles, Mom." Allyson says.

"And my rosacea—I look like a drunk hobo!"

"No, you don't," I say.

Before we open the car doors and open our little family to the assessments of everyone else, I give the scabs on my scalp one last swipe. I know that as soon as I enter Mamaw's world, she will be watching me, tracking my chewed fingernails and pointing out my tiny bald spots. Since I graduated from high school a few weeks ago, my tendency to pick has subsided, but it's still like an itch travels around my body. When I know people are watching, I sublimate my need by making intricate doodles or shredding paper into teeny bits. When I have no pen or paper, I fold my fingers in on one another and squeeze. I have finally learned how to keep people from noticing, but Mamaw always knows.

She makes her way from the high front porch down the rough stone steps, a little creakier every year, treading carefully through her curated maze of lawn ornaments—clusters of ceramic ducklings, gnomes engaged in landscaping chores, patriotic pinwheels—to stand at the head of the driveway.

"Oh, Mimmy," my mom says, "Mimmy, Mimmy, Mimmy."

Mamaw's tick-ridden dogs circle us, waiting for a final sign that we are not strangers. They swoop in and smell us. They are an assortment of maladies, sore from fights or mossy green from being doused in kerosene to kill their mange. They don't look too good, but they are tough. The same goes for the myriad cousins who gather around, pulling us in tight. Their bodies are busted from labor and lifestyle, but they are as tough as old hickory.

I want to hug Mamaw before anyone else.

"Looky you. Ain't you a big thing now? Just like your mommy," she says, setting aside her Salem to let me bury my head in her bosom. I fold into her arms. We are home.

My uncles rock back and forth on the porch in wooden chairs. We stand there, bedraggled kin from the sleazy city, and subject ourselves to their judgment. It's an annual ritual to go up in front of this squad of mountain men and listen to them take the piss out of you.

Every year it's basically the same:

To my mother: "Inez, you ol' fart blossom! Those gray hairs gotcha. You look as old as Ol' Granny."

To my father: "Why, Bob, you bald as a judge. You got nary a hair up there at all, do you? Still playing those bagpipes? Never did see no one else play them pipes. You bring those skirts back home, too?"

To me: "You ol' sourpuss. Always got that grouchy face on. Why you as busty as Granny and she was just about to fall over on herself. But you still a little butterball. Still got those butterball cheeks. Hey, butterball! You ever heard of a razor? You got enough leg hair for a varmint to swing from."*

To my sister: "Why poor little Allyson, she don't say nary a thing do she? Just right quiet and pretty. Yes, it ain't so easy to be the little one, what with her sister taking up all the attention. Now that's called showing off. Poor little Allyson needs that Anya get out of the way and let her come on through. They never let the little ones do, do they? Ain't that right, Ally?"

Then, like making a peace offering to a potentially hostile tribe, we pass out gifts from the northern hinterlands: Stella D'oro biscuits, sticks of cured pepperoni, a twelve pack of Samuel Adams, a Yankees cap, a Harley-Davidson Zippo. Up in the kitchen, thin steaks seasoned with garlic salt, crisp potatoes fried in grease, soup beans boiled with ham hocks, and cucumbers fresh from the garden are waiting. We serve ourselves on Styrofoam plates and dig cans of Royal Crown Cola out of the Frigidaire Ed bought in the '50s.

I'm already planning who and what I'll photograph with my new camera. Sometimes I wear it with the strap slung diagonally around my body and just stare at myself in the mirror. I have to admit, I look pretty cool, official. I'm serious about capturing the decisive moment like Henri Cartier-Bresson talked about. My ambitions are lofty; my abilities are not. I'm just getting used

* I have given up shaving to make some sort of vague feminist statement. When Mamaw notices my armpit hair peeking out of my shirt, she says, "That nest's so big you have to pay some dog tax."

to how the mechanisms of my camera work, and I'm making a lot of mistakes, especially with the light meter. Everything is turning out either too light or too dark.

The in-between place is hard for me to find.

But that's what I'm starting to love about taking pictures. I get to be an insider and an outsider at the same time. It's pretentious, but I like to think that my camera is a metaphor for me. A tool for figuring out how to navigate the fissures I face and something to put in front of my face. The camera frames another contradiction about me that is starting to emerge. Sometimes I want to be the star, I want all eyes on me, but other times, I want to shove those eyes aside. Hard.

Sometimes, I want to do both at the same time.

* * *

My cousins from up on Shucky Bean come calling. Jeannie is with them. She was born in '77 and, like me, was excited to have graduated high school that June, the first in her branch of the family.

As the night gets darker, Jeannie and I whisper to each other, huddling on the far end of the porch. I tell her that I want to be a famous lawyer, maybe a senator. She says that she hopes to go to nursing school but she probably can't. Her father won't let her.

Her father, a blind preacher, raises his daughters in a strict, evangelical Christian home, and their only exposure to the outer world is listening to religious songs on the radio for an hour each Sunday. Jeannie's entire life revolves around church; she and her retinue of sisters wear dowdy ankle-length skirts and baggy blouses. They wear their waist-length hair in teased half-ponytails that rise from their foreheads like peacock plumes. To my jaded Northern eyes, they resemble a country music Manson Family. And though Jeannie's father allowed her to complete high school, he is now insisting that she stay home and prepare for marriage and babies. She's had too much school already. She thinks she knows more than the good book itself, he says.

That night, marinating together in the heat, I encourage her to pursue her interest in biology and medicine. Actually, it's more accurate to say that I

vehemently, obstinately, unrelentingly try to coerce her to pursue her interest in biology. Jeannie says that paying for school is the problem and that in her family, her education is by far the lowest priority. They can barely keep food on the table, much less pay for a girl to go to school. I realize that it's only by chance that I am not Jeannie. We are almost exactly the same age, with genes that repeatedly overlap, generation upon generation. It's only by chance that my father is a wacky Jewish bagpiper and her father is a blind Kentucky preacher. Unintentionally, but probably not unconsciously, evoking the quixotic spirit of LBJ's Great Society, I launch into a monologue about FAFSA forms, Pell Grants, scholarships, and student loans. I offer to fill them out for her, to take her to Hazard to see the community college, edit her essays, or even do the whole application for her. If Jeannie wants to go to college, I will drag her out of her holler kicking and screaming.

I am so involved in browbeating Jeannie into higher education that I tune out the conversation brewing at the other end of the porch. Then I hear my name several times in a row. My uncle is telling my mom how much cheaper it would be to send me to the University of Kentucky in Lexington.

My mom is quiet. I can tell she wants to step lightly. Though she hasn't said anything directly to me about it, I know that she felt as hurt by the absence of fanfare about my graduation as I did. It was one thing for her family to ignore her accomplishments; it's something different for them to ignore her daughter's. In some way, it seems to have hurt her more. So she equivocates, "Well, yes, it would be, but Anya got a big scholarship from Discover Card and some other places, and, well, Yale is, well, Yale it's a . . . a . . . a . . ."

Silence.

"It's a good school," she finishes lamely.

Everyone is waiting for Mamaw to weigh in. She taps another cigarette out of her leather pouch and spins her lighter with her long yellow thumbnail. She shakes her head hard.

"Why, hon, so is University of Kentucky. You see their basketball team? Best in the whole country. Everyone wants to be a Wildcat. They got scholarships at UK, too. She is right smart. She could get one; then she can home to her Mamaw on the weekends. Not fool with any of them parties they have up

there. That's the way a body gets in trouble. With boys I mean. Yale ain't for nobody from here. They live real high off the hog there, that old dirty George Bush and his people. It ain't our place."

"Mimmy, of course UK is a good school. It's just that . . . I think she's attached to Yale because . . . I don't know, it's very hard to get into . . . and . . . she has some friends that are already there and . . ."

She is sputtering. Why can't she just say it's Yale, duh. You don't turn down Yale. You just don't. Cause it's Yale, that's why. It's the Ivy League, goddamn it. Why can't that be enough? What else do I have to do to impress them, to make them brag on me the way they brag about Bub's touchdowns and homecoming dates? Actually, I don't really care if they are proud of me, but I do care that they are proud of my mom. That's really what I care about most. I am protective of her here. She seems so vulnerable—such a peculiar bird. Everyone seems to want to take her down a notch—or twenty. No one will ever forgive her for moving away, and now, no one will forgive me.

Then, the kicker.

My aunt shouts across the porch to my father. "Hey, Bob . . . how much you reckon Yale costs?"

My father takes a moment and calculates.

"I guess about, um, maybe about twenty thousand bucks a year?"

It actually costs about forty thousand dollars a year, before books and beer. Most of it will be paid for by the lawsuit settlement over my leg, the difference made up in scholarships and loans and work study. But still, anyway you cut it, it's a fuckton of money.

The porch stops buzzing.

Everyone looks at me.

I am an asshole. Twenty thousand dollars is enough to send Jeannie to nursing school here over and over. It's an unfathomable amount of money to spend on something that seems to be just a stupid brand, an obnoxious name to be slapped on T-shirts and beer koozies, easily interchangeable with a less expensive and perhaps equivalent product. Education is just education. A decent one could be had up the road in Lexington for a lot less. Who was I that I would let my parents pay such an exorbitant sum for something so unnecessary? And who were my parents that they would encourage me?

For the past seventeen years, I've done a fairly good job of keeping my worlds separate. I've been careful. I've figured out when to order Mountain Dew and when to ask for Dr. Brown's Cream Soda. I've learned how to mumble Kaddish at temple and almost sort of check the motor oil in a pickup. I've been the best Jewbilly I can be. But now, it is becoming clear that the problem isn't keeping my two worlds separate, it's the chasm that exists between them. It's the way they regard each other.

For his part, my dad doesn't flinch.

Later, when I protest that he shouldn't have blurted such obnoxious information out across the porch, he says, "What are you so ashamed of?"

I look at the coal-stained walls. I look at the greasy carpet and Mamaw's coffee can and shrug. Maybe this? I think to myself.

Yes, this. This broken place with its satchels of drowned puppies, headless snakes, and blocks of government cheese—everything in this worn-down world.

I try to love it, but it does not love me.

It whispers, "Who are you?"

PART II

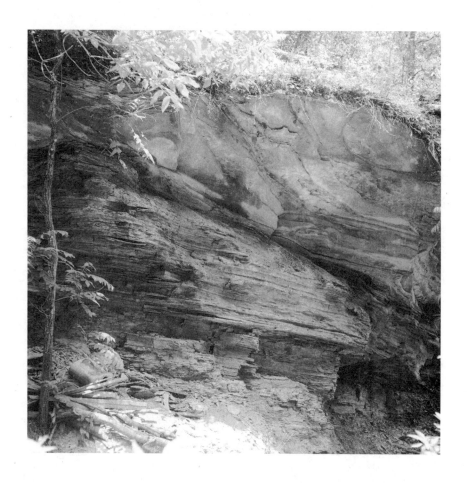

CHAPTER 14

The first time I met Philby Whitman, I was wearing a full-body bear costume, dancing to bad techno. It was a rehearsal for a Yale theatrical called *The Clown Show*, a piece that included a skit in which an affable golden retriever borrowed from the Branford College master's house licked a wad of peanut butter off an actor's teeth, followed by a mini make-out session between the actor and the dog. There were numerous jokes about baguettes doubling as crusty penises and a running sexy-dancing-bear gag. I played one of the sexy dancing bears and also helped to wrangle the engorged golden retriever on and off the stage. We were performing in a defunct underground squash court that had been jerry-rigged into a black box theater; we thought we were the greatest comic minds of our generation.

Philby was the producer of our circus, charged with selling tickets and provisioning us with peanut butter, baguettes, and bear suits. Though I didn't know him personally, he was what I had imagined a Yale man would be. He was a dead ringer for dreamy Neil Perry from *Dead Poets Society*, but he also looked like a young FDR, with the same arrogant, albeit oddly alluring habit of tossing his head back and looking down his nose when he talked.

Philby flitted around campus in a gauzy little cloud of pot smoke. Everywhere he went, he instigated highbrow banter that was meant to double as social commentary. He was clearly going places after graduation, maybe the State Department, maybe the *Paris Review*. I was learning that everything seemed to be easy and prestigious for the upper-crust kids at Yale.

Philby lived in graciously appointed Jonathan Edwards College, not in Morse College like me—its ugly beige concrete walls making it known throughout the university as a postmodern architectural fuckup. Our rooms were famously built with no right angles, a conceptual strategy that was supposed to encourage creative thinking. The most common creative thought Morse College students had? Living without right angles sucks.

Philby and his friends, all educated at elite boarding and private schools with not a whiff of Jew or hillbilly, threw raucous parties and pulled benign pranks on the Yale administration. They hosted some of Yale's infamous invite-only "naked parties" in conjunction with the Pundits, the secret society of campus nudists; his crowd had a sincere penchant for blue-blooded douchebaggery.

At the end of a tech rehearsal for our so-called play, I was backstage, wiping peanut butter off the toothbrush used for the dog scene. I had tried to introduce myself to Philby earlier, during a fitting for my costume, but he seemed to look through me. It wasn't unusual to feel like people at Yale were looking through me, so the fact that Philby had didn't surprise me. But suddenly, he wanted to talk to me.

"Hey, are you an English major?"

Last year I'd finally admitted to myself that I actually hated studying the subject I had planned on devoting my life to, political science. I had drifted into the English department, hoping to be good at something again.

"Oh, me? I guess."

"I'm thinking about becoming an English major, too. Originally, I went in for American history, but I'm currently smitten with Milton."

"Can't help you there. I hate Milton."

"But *Areopagitica* is a masterpiece."

I dug my copy of Milton out of the vintage, blue-pleather Samsonite suitcase I used as my schoolbag and showed him how I had graffitied the front cover. A mustached, devil-horned Milton looked out from the Penguin Classics cover, his mouth wrapped around a hairy cock.

"Wow. I guess you really do hate Milton."

"It's the only way I can get through class."

"How can you hate Milton so much if you're in the Lizzie?"

The Elizabethan Club, colloquially known as the Lizzie, was a private club dedicated to all things old, white, Anglo-Saxon, and male. It was something of an honor society for English department students, though my only honor was falling asleep on cue in my 9:00 a.m. Industrial British Literature seminar. I had been inducted because I'd won a prize for antiquarian book collecting. My winning submission was fifty-nine books and assorted ephemera titled "George Balanchine and the Advent of an American Ballet Idiom."*

At the Lizzie, you could sip Darjeeling tea from a monogrammed porcelain cup and read back issues of the *London Review of Books*. Other English majors liked to wear twinsets and strands of freshwater pearls when they took afternoon tea, but I stuck to the gigantic overalls Mamaw sent me from the feedstore in Jackson. I usually encountered disapproving stares when I stuffed extra gingerbread into my front pocket before I took off to the sculpture studio. Upstairs there were buttery leather chairs and a working Victorian pull-chain toilet. On Fridays, Lizzie members could don a pair of lint-free cotton gloves and flip through the pages of a Shakespeare first folio like it was the *National Enquirer* at a grocery store checkout.

Philby tilted his head back, his hair framing Gatsby-green eyes.

"Can you get me in?"

"Into what?"

"Can you get me into the Lizzie?"

I thought people like Philby just walked into anything they wanted. At Yale, there seemed to be different rules for the upper class than my fellow middle-class comrades. Or at least that was the impression I had. Philby was making the kind of request I would never make because I would be terrified that I was being rude or presumptuous or out of line. But of course I was going to try to get Philby in. I was a nice person and when people asked me to do them a favor, I almost automatically said yes. In order to nominate him, I knew I

* I'd started collecting anything I could find about the New York City Ballet at age nine, and it hadn't been long before my collection grew beyond stacks of old programs, ticket stubs, and signed pointe shoes to first-edition memoirs and biographies of dancers as well as company histories and dance surveys.

would have to write a letter of recommendation. I asked him if he wanted to grab a cup of coffee so I could figure out what to say.

A week later, Philby and I wandered up to Xando, the hip new coffee shop on Broadway back by the Chinese food place, Main Garden, which we often referred to as "Main Garbage," and Yankee Doodle, the lilliputian greasy spoon on campus.

"I love that place." Philby pointed to the Yankee Doodle.

"Oh, me too. I love the fried glazed donuts. They're insanely bad for you."

We set in to talk. Philby told me that as a kid he had had some complex operations on his right leg. Both of us had withstood years of painful physical therapy, it turned out, and both of us had long scars and permanent damage in the same part of our body.

"I've never met anyone who knew even a little bit what it was like to go through that. I guess in some ways I'm still going through it, actually. It's just that my injury is invisible now," I said.

"Maybe, but everything we went through, all of that is still visible, right? Just in the people we've become because if it."

"I have this vivid memory of being in my fourth-grade class. We had to write stories about facing fears and I wrote a little essay about the first time I went on stage to perform by myself, how I was afraid I might fall down the way I used to, just crumple onto the floor. Anyway, I wrote this story and I read it out loud in class and Carolyn Watson, who was already horrible, raised her hand and said 'Ms. Danielson, she writes about this every year. Can you tell her to stop? It's boring.'"

"What a bitch."

"Yeah, I hated her."

"The important thing is that we got through it. And that we *keep* getting through it. You know?"

I added him to my dog-eared catalog of crushes, and I went home and wrote the letter of recommendation. Maybe one day we might have tea together if he got in.

A few months later, after passing the admissions committee, he was inducted. I would see him there occasionally, snacking on crustless sandwiches, reading Jonathan Swift. We always nodded politely to each other,

but I was disappointed that he never mentioned that I had written his letter of recommendation or said thank you or really said much of anything to me at all.

Even with all that happened later, I never asked him why.

It was easy to guess: I had stopped being useful.

CHAPTER 15

I begin, as usual, by staring out at the audience. This time I am in Bushwick, Brooklyn, a place that has only just started to gentrify, looking out into a former automotive garage that has been turned into what is, depending on who you talk to, a squat or an anarchist collective or both. My fellow performance artists and friends, Jake and Jamie, call their makeshift space "Surreal Estate."

I am sitting behind a long folding table draped with a rainbow of plastic tablecloths from the dollar store. I am wearing three clear plastic garment bags, my head popping out through the holes for the hangers. I am naked underneath, and my long brown hair is tied in a low ponytail. From under the table, I pull out a small container of silver body paint. I look seductively at an audience member while I smear it up and down the length of my arms, making sure to fully cover my hands. I pull out a tube of cheap red lipstick and train my gaze on someone else as I encase my lips in a thick coat of glop. I stare some more.

I step away from the table, crouching to pull out a long silver object encased in yet another garment bag. I toss the heavy package onto the table. It lands with a thunk and shakes the table. The audience doesn't know what it is. I unzip the bag and slowly place my nose at one end of the thing inside. I sniff the length of it, then, raising my head so the audience can see, nod my head enthusiastically. A few people in the crowd titter.

I gently lift the head of the silver object, now revealed to be a shimmering, fourteen-pound raw salmon. I coo softly to her and fully reveal her long body to the audience. I run my silver hands and forearms all over her. Again, I sniff

the length of her body; I caress her silver scales and begin to lift her. As I raise her high over my head, the clear garment bags I am wearing reveal my breasts and pubic hair.

A famous opening beat starts. It's David Bowie's "Let's Dance." The audience laughs out loud as I proceed to sexy dance with my fish friend. I pull the red lipstick out again and smear it all over her mouth, then French kiss her, long and deep. When I told the fishmonger I ordered her from what I planned to do with her, he was completely unfazed but warned me about cutting my lips on her teeth. As I stick my tongue in her mouth, I remember his words of caution.

I make out with her, then I rub her all over my body. My garment bags are getting slick with scales. I play her like an electric guitar, sticking my fingers into her sliced pink belly and air riffing with Bowie. I sing along with the song, pretending her ribs are strings. The audience sings along with the song. The fish sings along with the song.

I take her body and wear her like a hat. I rock back and forth, and she slides and smears my hair. I become a dancing fish-head lady. She is a thing to me. I dance into the audience while the music plays louder and louder. I climb up onto the table and dance in red high-heeled shoes. When Bowie gets to the part about putting on red shoes, I kick up my red heels and fling them at the audience. As if on cue, the table collapses under the weight of my fish and me. Without missing a beat, I keep wailing on her. She is now my fish guitar. I use her any way I want to. I split her belly open and let everyone see inside. The audience is hysterical now.

The song ends. I am out of breath, very out of breath. I toss the fish on the floor then hurl it back on the table. I stare at the audience, longer this time. I look at them accusingly. Something is shifting but they don't know what.

I take a long, super sharp knife out from under the table. I stare at the audience and someone gasps. I start to whack the fish. Pieces of her go everywhere. Fish is flying all over the stage. A bit of fish lands on the soundboard, another comes close to wiping out the video camera. Frustrated with the limitations of my knife, I begin to tear her flesh with my bare hands. I rip the pink inside, pulling the sides back like the lips of my vagina. I tear her violently, her muscles breaking into string in my hands. I put my arms and my back into

shredding her. I call her bad fish names. Someone in the audience lets out an anguished sigh.

I take a blender out from under the table, first placing the motorized bottom on the surface, then slowly revealing the glass carafe. Hesitant laughter returns. No one knows what is happening. I tear her more and more, then throw her flesh into the blender. I turn the blender on high and let it mash and froth the salmon. I stop to check her, make sure she is unrecognizable. She is dry, so I spit into the glass carafe, hoping to add a little liquid. I pour her, now just a smoothie, into a large pint glass, lift it toward the audience, make a toast, and drink her.

CHAPTER 16

"See here, this is where it says that your ancestor was an illegitimate son of none other than Bonnie Prince Charlie, the Young Chevalier! Isn't that marvelous? I had to access the British Library in London for this one. Took a little doing but here it is." My father produced a creased xerox from one of his folders.

My uncle could care less. He responded by bragging on my cousin, Bub, whose football team won the Honey Bowl that year.

"That sure *is* something. Why you keep it up, Bub, you might even get a scholarship to UK," my dad said with the dopey twang he sometimes adopted at the homeplace.

"Not everyone has to go to college, Bob. Not everyone *wants* to go to college either. You see, down here you get you a good paying job without it if you do right."

My uncle looked down the porch at me, then lit another Camel and rocked his chair back and forth.

In Westport, Yale was a big deal. Not long after I started school, my father bought four identical Yale T-shirts so that we could all wear them at once like the Beatles in *A Hard Day's Night*. In the holler, it felt more like a burden—just more proof that I was, once and for all, an outsider, an interloper, a fraud. Maybe they thought I was becoming one of those "bigwigs" Mamaw hated so much. The people who were always committing what she called "some made-up piece of business." In my mom's gigantic family, the collegiate hurdle

had only been jumped by her, the first to graduate; my cousin Kaylee; and hopefully, me.

My father kept going.

"And this paper, which I dug up at the New England Historic Genealogical Society shows that you are related to, get ready, *both* Cotton *and* Increase Mather, the Puritan witch-trial leaders! Isn't that incredible? These were some of the most important people in the entire Massachusetts Bay Colony. Far better than being part of a *Mayflower* family, in my humble opinion."

My uncle deflected this news about his esteemed witch-hunting heritage and mentioned that Dwayne shot a six-pointer up on Boonehorn and that Dawn won the state noodling competition on Lake Barkley, pulling a forty-pound catfish out of the lake with his bare hands.

My dad tried so hard to fit in there, collecting bluegrass records and attempting to unravel the gnarled family tree. He pretended to know a lot about fishing, but I knew the only thing he ever caught were oily, PCB-riddled Long Island Sound bluefish, the junk of the sea. I knew he tried so hard because he loved my mom, because he loved Allyson and me, and because he genuinely wanted to be liked, but god it was awkward sometimes.

We were both uncomfortable with silence in conversation. It made us feel obliged to entertain, often to the point of annoyance. When he ran out of things to say, he grabbed his bagpipes from the back of our car, then tuned up and played the longest rendition of "Amazing Grace" in the history of mankind. He marched back and forth in between Mamaw's lawn ornaments, lifting his knees so high that things fell out of his pockets, pieces of snotty paper towels and empty Nicorette wrappers. He played so loudly that no one could hear anything else. All you could do was applaud every time he seemed to be ending. Then he'd stop to catch his breath and say, "Again?"

He wouldn't stop until my mom came down from the kitchen and shouted, "Enough, Bob!" over the drone of the pipes. He let the air wheeze out of the bag and returned to his spot on the porch, satisfied he did his bit to pass the time.

When I felt sorry for my dad, I felt a little sorry for myself, too. I did the same thing, trying to convince Mamaw that I knew how to shell peas and hoe the garden. I always tried to please, but inevitably, I fell short. I couldn't even make the bed the way she wanted. My corners were never taut enough.

"Don't do like that!" she said, pushing past me to redo my shoddy work, loud so my mom could hear. "This youngin' doesn't know how to keep things neat. And she didn't keep her fingernails neat neither. Look at them all chawed and ragged—nasty hangnails. And maybe it's time you start you wearing you a little lipstick. A little lipstick hurt nary a soul." My mom turned and glared at me. My deficiencies were her deficiencies. Sloppy housework and sloppy grooming were personal affronts to Mamaw, and personal affronts to her as well.

Both of them were never satisfied unless something was completely spotless. Like eagles, both of them could identify an offending wrinkle, leftover crumb, or speck of dirt from any perch. They wandered the rooms of the shack, Mamaw running her finger over every surface, checking for dust. When she found a suspicious spot, she frantically scrubbed. Meanwhile, when my mom cleaned, she sometimes glared at me for making more dust by obliviously reading dusty old novels on the sofa.

"It must be nice to have a maid."

"What?" I said.

Unlike Allyson, who apparently smelled as bonny as a gourmet marshmallow, I took after my dad and existed in a miasma of mess. My dad never tucked in his shirt; I looked as though I thought hairbrushes were fascist. I guess you could say we were lazy, but it's more like we were just totally out of it. But my mom and Mamaw took our carelessness as a lack love and respect for them, and it caused them great pain.

It took me a long time to understand that their compulsion was about not looking poor. At Mamaw's house, your belongings had to be above reproach, shining with care. Even if you had some bona fide hoarding tendencies, like Mamaw probably did, like my mom probably did, like I probably, OK, really do, you kept all your treasures impeccably clean. Mamaw had a collection of dolls in the upper room, and she fluffed each one multiple times a day. "All my little pretties, all my little pretties," she murmured. To her, being poor was nothing to be embarrassed about. But being poor and dirty, that meant you had no self-respect, no inner dignity. It meant you did not love yourself the way you should as one of G-d's creations. That was an utter disgrace.

CHAPTER 17

E verett, a dreamy lightweight rower from Charleston, looked like the dollar picture of Jesus that Mamaw had tacked above her Barcalounger, his hair hanging in beatific ringlets. I loved cheering him on at regattas like the Head of the Charles in Cambridge and Gales Ferry in Groton. I loved saying the word "regatta" over and over again in my head. And I loved having a boyfriend again. Will and I had taken the better part of a year to break up, neither of us fully able to let go at the same time. In the end, I knew there was a wildness growing in me that felt corralled by our relationship. Sometimes I'd found myself wanting to run unbridled.

And sometimes I borrowed my father's ailing Dodge Shadow and followed Everett's boat around New England. I watched his team slide along the water, usually pulling ahead of the pack as it neared the finish line. Crew was an elite subculture, and in some small way, though I never had the desire to row myself, through Everett, I felt part of this world.

When his boat won a race, it was traditional for the losers to give the victors the literal shirts off their backs. Over the season, he collected shirts from Cornell, Harvard, Brown, Dartmouth, and Princeton. He let me sleep in them in the skinny twin XL bed we shared in the basement of Lawrance Hall.

Everett dumped me one scorching afternoon at the New Carrollton Metro stop in Maryland. He waited until I was on my way home from a weekend together to tell me he didn't want to be with me anymore. Yalies were expected to spend most of every summer working, researching, or somehow building their resumes, and I had gotten a lobbying internship in DC at Amnesty

International so I could be near Everett. Truth be told, I was a little vague on what Amnesty International actually did, but the Yale name had opened the door easily. I quit with no explanation and went back to Westport. My heartbreak was bigger than fighting for universal human rights.

It was my policy to burn bridges completely at the conclusion of romances, no matter how short-lived. It felt more dramatic that way. And because it was more dramatic, more meaningful.

I never spoke to Everett again.

The Yale-Harvard football game, breezily referred to as "The Game" as if it's the only one in the world, is always held the Saturday before Thanksgiving in either New Haven or Cambridge, alternating locations every year. For the festivities, alumni and undergraduate legacies don raccoon-fur coats and wave triangular Yale pennants, just like Snoopy. One year, my roommate Dawn and I saw Teddy Kennedy eating a canapé out of the trunk of a Jaguar. Dawn, the daughter of a schoolteacher and a police officer, was a middle-class kid like me. Together, we tried to deduce the unspoken protocols of Yale culture. Not savvy enough to know that we shouldn't make a big deal out of these things, I quietly tapped Senator Kennedy on the shoulder and asked if he would take a picture with us. Fortunately, he was game. "I always take pictures with the girls," he said. We giggled as he wrapped his arms around our shoulders, drawing us in tight. The camera flashed, concrete evidence of our arrival in an upper echelon.

Mamaw got a copy. That Sunday she told my mom, "Seems poor little Anya is meeting them bigwigs. Pretty soon she won't be coming home no more."

I dated a guy who grew up on Park Avenue. He gave me a tour of his home. In the long hallway that led to a formal sitting room, he tugged on a tiny gold ring embedded in the wall. A hidden door was revealed, and inside there was a small fountain—an anthropomorphic sun, spewing water from its shimmering lips.

His library was lined with identical leather-bound books. He saw me admiring them and said, "Do you want to know a secret?" He pulled a book out from the wall; it was completely hollow inside except for a piece of fresh Styrofoam. Buying old leather books by the yard and stuffing them like taxidermy was apparently a common practice in the truly grand apartments of the Upper East Side. It had all the prestige of book-lined walls without having

to deal with the annoyance of text or paper or that incorrigible pest, symbolism. And they were so much easier to clean. On second thought, it did seem a little suspicious that someone would actually want to read so many volumes of Alfred, Lord Tennyson. Forever after, no matter where I have been in the world, when I see a room full of leather-bound books, I wonder if they are hollow inside.

* * *

Later in the summer of Everett, I become obsessed with twentieth-century Jewish writers. It is a good distraction from my long-echoing heartbreak. I bring a thick stack of paperbacks to Mamaw's. There, my parents still sleep in the large bed and Allyson now sleeps with Mamaw beside the still-unyielding white door. Mamaw says Allyson is a better sleeper than I am, that she doesn't kick and mutter all night long. I sleep on the couch that looks like it threw up on itself, where, armed with my mother's mandatory flashlight, I read under my thin, pilled bedsheet, one hand holding my book and the other swatting the ravenous mosquitos that stream toward the light. Occasionally, Mamaw hacks her smoker's cough. She cries out, "Lordy, Lordy," then gets up to go pee in her coffee can. Other than the slow tinkle of her urine, the air is completely still. In one week, I read Saul Bellow, Primo Levi, and Bernard Malamud by the light of my Duracell.

Then, in the middle of one night, I decide I want to keep kosher.

Mamaw goes to serve me my usual sausage biscuit the next morning, but I stop her to pronounce to my assembled family that I am becoming kosher. My mother glares at me, but I am adamant: no pork, no shellfish, no meat and dairy together.

Mamaw says that is fine, but don't I want some bacon? She made it extra crispy, the way I like.

"Bacon is pork."

"Why are you making mind about pork, Anya?"

"I can't really explain. It's a Jewish thing—not to eat pork because it's disrespectful to G-d." The truth is that I'm not exactly sure why Jews keep kosher, but I figure I have to start somewhere, even with just rampant speculation.

"Not even a slice of hickory ham? Jean's Ol' Sid cut his hog up for y'all. Smoked it, too."

"Ham is pork, Mamaw."

"What about some bologna? I got me a new package down at Winn-Dixie the other day."

"Bologna is pork, too."

Mamaw pauses, taps the long ash of her cigarette on the rim of her empty RC can, tilts her head, and looks at me.

"Every morning I wake up, I'm lucky to eat bacon. Youngin', you don' know what it's like to wake up hungry, just some beans and cornbread to eat. No, you don't know. Poor little Inez works hard to put meat on your plate just so you can say you don' want it. It's right shameful if you ask me." Her lower lip starts to quiver.

Shit.

I am rocking the boat. I am not the child who rocks the boat. I am the child who nods yes and smiles. I am the child whose default mode is to make everyone proud. I am the child who makes my mom think that leaving the holler was worth it so her daughter could go to a school like Yale. I am the result of her sacrifice. I am the silver lining to Ed's death. And now I am being bad.

But keeping kosher would mean that I'm really Jewish, that I've solved the sketchy equation my parents had assigned to me for homework.

Allyson eyes me devilishly and places two strips of bacon into her mouth. "I love pork, Mamaw. I never want to stop eating it. Yum, yum."

G-d she can be a pain in the ass. Since I left for college, she has dug through my bedroom, stolen my clothes, and despite the fact that we don't really resemble each other, started a side hustle using my old driver's license to buy half the kids at Staples High Parliament Lights and lord knows what else. And more annoyingly, she is completely unrepentant about it.

"Of course, Sugar. You eat up all you want. Don't make no mind about Anya. Maybe up there you can be high and mighty but not here. Not in Mamaw's house."

I'm so tired of taking shit because I go to Yale. Can't someone around here give me any credit? My whole life here has just been a pig pile of "You're hogging attention," "You're trying to show off," "Why don't you smile?" "Why

113

are you so serious?" No wonder my mom wanted to get the hell out of here. The things they must have said to her. I thought most families were proud of their kids for reaching such an achievement instead of needling them for it at every turn. My father's side, the Jewish side, is almost pathologically obsessed with advancement and education. When they refer to me, the second thing out of their mouths is that I am a sophomore at Yale. They remind me of the onetime Jewish quotas on admittance and how some of the societies I am part of not long ago banned Jews, either by decree or practice. They are so proud I am getting above my raisin'. That's what we have been trying to do for centuries.

I leave breakfast hungry but righteous and go back to reading Sholem Aleichem.

My father asks me to take a walk, something we regularly do together during our summers in the holler. When living on top of one another at Mamaw's gets the best of us, we drive into town and walk around the concrete track next to the Little Red Schoolhouse, the one-room building where my mother went to school from kindergarten through eighth grade.

We get out of the car and start walking in silence.

My dad dives in. "You have to eat the bacon, Anya. You have to keep the peace."

"But it's dirty, and I don't like it."

"Don't do this."

"Do what?"

"Decide to do this Jew thing now. Just wait until you go back to New Haven. Please. Seriously, I don't want to deal with a shitstorm from your mother. You know how much she wants to make Mamaw happy, how important it is to her to show that she raised her kids properly. You know how much it means to her."

"Wanting to keep kosher doesn't mean that I was raised improperly. In fact, it could be interpreted as being raised with a reverence for a higher power. There is a lot of evidence that Jesus Christ was kosher when he was younger. Mamaw would like that."

"But can't you just wait like a couple weeks? You've been eating cheeseburgers and shrimp—sometimes together, might I remind you—for your entire life. Another few weeks will not upset G-d."

"But this is part of my journey, like something I really need to experience. And that can't wait. It's part of my path. You don't want me to wait to go on my life journey, do you?"

My father rolls his eyes.

"Anya, screw your path, just eat the goddamn bacon. Listen, I rarely tell you what to do because usually you do the right thing. When you are back at school, you can join the kosher kitchen, bury your dishes in the backyard, go live on a kibbutz and have fifteen kids, I don't care. Take whatever life journey you want. Just please, not right now. OK? Not now."

"Fine. It's not like you would really even know what it's all about. You just eat bagels and lox and talk too loud like Seinfeld. That's the kind of Jew you are."

He is nonplussed. "Yeah, well, you are, too."

We walk two laps in silence, huffing and puffing in the humidity. I can't sustain being mad at my father for long.

"Bacon is pretty hard to give up anyway," I say.

"That's my kid."

And the storm passes.

CHAPTER 18

S ophomore spring, the trash can outside the Morse College gate becomes an oracle. Depending on which way I pass by it, to the left or to the right, it can predict every aspect of my life. But I have to tune in to its transmissions with my secret antennas. This takes both time and skill. At first, the messages come in loud and clear, and I can easily decipher what is being broadcast into my brain. But as the semester goes on, the signals start to get more convoluted, and a foreboding static begins. Even when I concentrate hard, repeat my rituals—pull a few hairs, scratch my scalp—and practice ahead of time in my room, I have to stand in front of the trash can longer and longer in order to receive the messages. I start to be late for classes because I am stuck in front of the trash can, trying to discern which direction gives off better vibes. I also have to do maintenance on my secret antennas, which means testing them out in other places to make sure that they are finely tuned. All around campus, I casually pause in front of parking meters and fire hydrants. Sometimes I circle them a few times. Sometimes more than a few times. Sometimes lots of times.

Things get worse. When I do successfully make it to class, I sometimes have to run out of the room thirty minutes later because I realize I made the wrong decision when I walked by the step in front of Toad's Place or the parking meter by Ashley's Ice Cream or the phone booth by Wawa. When I am in class, I sometimes fixate on the image of the trash can, which floats above our discussion table. The scariest part of living with the Morse College

gate trash can is that to get out of the cloister of my dormitory quad, I always have to contend with it.

Soon all the decisions that were once so small they were basically involuntary have begun to feel fateful, final, and epic, like which spoon to pull out of the cutlery bin in the dining hall, or which side of the double door to push to get out of the library. Picking a pencil becomes agony, and getting dressed for class is exhausting.

Then I give up.

I refuse to leave my dorm. Days start to go by. I do go to the dining hall to eat because I can get there without leaving the quad, and I do shower, once. It is very freeing to concede all of my mental matches to the trash can. It gets me really pumped up. I don't have to worry about it anymore. I'm a loser, my ass kicked by a fucking trash can. It's a pretty funny way to go down, actually. I feel better than I have in months.

Best of all, I never have to step foot outside of the courtyard again. The ugly beige concrete walls here are all I need. If anyone needs me, I'll be right here, but I'm digging in. I'm going to live here forever, grow older and crazier in my room with no right angles. Right here in entryway C, fourth floor, first room on the right.

I'm so excited that I stay awake for forty-eight hours working in the darkroom in the basement, listening to Radiohead's *The Bends* on repeat. I eat an entire Costco-size box of pretzel rods. I eat a barrel of cheese puffs. I eat a couple cups of dry ramen noodles. I cut my hair with paper scissors. It's lopsided, so I even it out. It gets more lopsided. I've lost track of what something unlopsided would look like, and I couldn't give a shit. I keep cutting until I realize I have to clean up the mess. That ruins everything.

I fall asleep so long and so hard that when I wake up, I am uncertain of where I am. I've crashed back down on Earth. Everything in my room is trashed. I turn on my computer and discover I have missed four days of classes, skipped an exam, and failed to hand in one major paper. Then I crane my neck out my dorm window. The trash can is still sitting outside the Morse College gate.

Fuck.

My mind is still flying a bit, barrel-rolling and spin-stalling, when my friends get involved. I start to digest the academic consequences, and I realize I need to ask for help. I've always been a night owl, always had obsessive thoughts, had my obsessive picking rituals, but they've never really interfered with my established patterns of life. I've always just thought that I could go from sad to super-productive to sad again really easily. It was just my artistic temperament, something to be proud of. A talent to be used. Never before had I accidentally skipped an exam or not turned in a paper. Never before had I really believed that objects and the ways I interacted with them could control me. And though I am now rational enough again to know that the trash can is not trying to destroy me, I'm not sure how long I can hang on to that thought.

I tell my dad. The whole thing tumbles out—the missed classes, the paper. I feel like I have broken some invincible life rules, but my father doesn't see it that way. There is no judgment. He just listens. Then he says he understands. That he had started to feel something slightly similar when he was in college. Then he starts to talk about the Vietnam War and the draft and the anxiety of the love generation, and my clam shell starts getting ready to close. But he circles back. It helps to talk to someone, he says. He immediately finds me a doctor.

Even so, it takes me two years to really get into what is going on in my mind. I spend those first two years telling my psychiatrist almost anything but what is actually happening with me. I'm not hiding anything on purpose; it's more like I don't even know how to put it into words.

But I show up every week because I know I need to be there.

And I also find help in discounted handles of Captain Morgan.

CHAPTER 19

One spring evening right before graduation, I was invited to a party in the basement of Trumbull College in a rundown student lounge called "the Buttery," known as "the Butt" for short. A friend would be DJing, and someone had convinced the Trumbull master to buy a keg for the seniors. As was my habit, I pregamed with shots of Rebel Yell in my vintage 1968 "They Can't Lick Our Dick Nixon" highball glass.

After four years of chasing after guys, the idea of being alone in my dorm bed, where I still slept clutching Zena Melina, the Cabbage Patch Kid who had been with me in the operating room in the children's hospital, had started to seem more alluring than the prospect of hooking up with any of the usual suspects. So many Yale guys seemed delicate, like they were intimidated by the idea that women might outdo them in the intelligence department. What's more, when pressed for any type of commitment, usually for the formal appellation of girlfriend, they often went into lectures about how love was not philosophically rational.

But that night, I promised myself to really try to have a good time. I pounded liquid courage, slapped on drugstore makeup, and wrestled on a pair of super-control-top tights. I blasted Pavement's *Crooked Rain, Crooked Rain* and sashayed out of my room. I was ready to party like it was 1999, which it actually was.

I was wearing one of my favorite shrunken baby tees, a soft-pink one emblazoned with an "Ollie for President" logo, which I meant as an ironic

nod to the ultra-conservative Iran-Contra scandal crook Oliver North, and teeny wire-rim glasses with bubble-gum-pink lenses. I pulled my hair into low pigtails and secured flyaway strands with barrettes to which I had hot-glued alpha-beads—one said *lust* and the other *sloth*—part of my set of homemade jewelry featuring the seven deadly sins. Around my neck I wore a black ribbon choker. At that moment, even though I felt self-conscious and awkward as always, I was probably as hot as I have ever looked—a highly strung bundle of insecurities and contradictions, but a cute one.

Mamaw had found the Ollie North shirt in a donation bag near Gander-bill. Every weekend she went down to Riverside Church and waded through the donations. For a quarter, you could fill a garbage bag with anything you wanted. In addition to collecting broken baby dolls, Mamaw loved to bring home bags of cast-off Happy Meal toys and action figures, which she knew I sometimes liked to use for sculpture projects.*

Mamaw's politics were baffling. She hated "that old crook Nixon, that nasty ol' cur," but had a soft spot for oafish Ronald Reagan. Even so, they were all part of "that corrupt Washington outfit" that was tapping her phone up Ganderbill and opening her mail. It seemed a little arbitrary that Oliver North would not end up on her blacklist. But when we pulled into the holler last summer, Mamaw was wearing the "Ollie for President" shirt. I begged her for it.

"Oliver North is an American hero. Don't you mock him."

"I'm not mocking him, Mamaw. I just like the shirt."

I lied. Of course I was mocking him. I mocked everything, especially mili-tantly patriotic Republicans. The shirt was the perfect addition to my growing collection of morally dubious paraphernalia, which included a "KGB Still Watching You" T-shirt purchased on the street in the Czech Republic; a fire-works collection named "Guadalcanal"; a floral Hawaiian dress with an image of the sunken, exploded USS *Arizona* covering the crotch, and a box of Toxic Waste candy.

* Years later, I would sell parts of my vast collection on Etsy to cover my monthly health insurance premium.

Down at the Butt, I became a one-woman mosh pit, throwing myself around the room to Chumbawamba's recent hit, "Tubthumping." And like Chumbawamba's protagonist, I interspersed downing diametrically opposed alcoholic beverages with crashing into pieces of furniture. I almost took out a wall sconce with my head. I felt no pain, just the desire to pop back up and smash into everything again. I was getting a bit out of hand, even considering my usual level of out-of-handedness. Two years past my trash can episode, I was able to manage better on a day-to-day basis; although I still hovered over the spoons in the dining hall, I could always eventually eat my soup. I would still, however, regularly lock myself in the darkroom or sculpture studio and work for two days straight, then collapse in bed for the next day and a half. I had two modes—wide-open throttle, all engines go; or stone-cold passed out—no in between.

I slammed into a café table, then pumped a beige folding chair over my head. I tried to run up the walls like Donald O'Connor in *Singin' in the Rain*, which I bragged out loud to no one was written by my third cousin Betty Comden.

I was awesome.

From the corner of my eye, I saw Philby Whitman, dressed in a crisp, light-blue button-down, bopping his head on the sidelines, smoking some pot, and surveying the damage I was doing to the room. I hadn't realized how cute his nose was. Celtic.

I wanted to flirt, so I headbutted him in his chest.

"Ow. Watch where you are going, Liftig."

"Ya wanna dance?" I shouted over Chumbawamba.

"What?"

"Ya wanna dance? With me?" I repeated, high-fiving some imaginary friends.

"Liftig, you're totally out of control. Are you on something?"

"No, are you?"

"Maybe. I mean, shouldn't everyone always be on something?"

"I'll calm down when I die."

I headbutted him again.

"Seriously, Liftig. You've always been too rambunctious. You might hurt yourself." Then, looking into my eyes, "You have to be careful about your leg."

He remembered.

And even after everything that happened, I always remember that he remembered.

CHAPTER 20

I t's Yale graduation weekend, and at Philby's private graduation party, the
butter is molded into fleurs-de-lis. Each pat sits shimmering on a bed of ice
in a polished silver tray. I look down at my place setting, an arsenal of sharp
utensils and gilded bowls. Plates nestle inside slightly larger plates over an
expanse of white Irish linen. Chiseled glass goblets flirt with candlelight. And
doilies. Not the brittle paper kind you paste macaroni shells on in nursery
school. Not the greasy petroleum yarn kind Mamaw decorates her thrift store
pillows with. These are hand-tatted cottage lace, delicate as fresh snowflakes.
These are rich-people doilies.

I look through the carved-ice centerpiece at my mother. She is uncon-
sciously grinding her teeth. I am chewing the inside of my cheek. I notice her
lipstick is lopsided. Her bra strap is peeking out from under what I know is
her most expensive blouse, and though she is so vigilant about ironing, a big
wrinkle has emerged across her chest.

The more I look, the more I notice is out of line.

"What's with the doilies?" she mouths.

"I don't know."

"Why are there so many of them?"

"I told you, I don't know."

"I thought you learned this stuff here."

Then, too loudly, I launch into a summary of what I have actually learned
at Yale: how to bullshit about the intricacies of seventeenth-century British
poetry; how to drink cheap vodka from cheap plastic bottles; how to take in

the salient parts of an anthropology lecture while disco napping under your winter jacket; how to learn the entirety of pre-Colombian art history in under four hours, your only sustenance: vending machine coffee and a dusty box of Cheez-Its.

My mother rolls her eyes.

Always uncomfortable in settings where manners are exposed front and center, she casts an accusatory glance at my father. He is staring slack-jawed at the pomaded pianist, both elbows digging into the crisp tablecloth.

"Elbows!"

"Huh?"

"Your elbows are on the table."

"Huh?"

If my mother is panicked and hypervigilant at formal social events, my father is hyperactive and loud. As he kept reminding me on the car ride to the country club, they didn't have fetes like this at the state U where he went to college.

My father surveys the glittering dining room. The lights discretely dim to make everyone seem younger, more elegant. The pianist continues to tickle the keys.

"Do you hear that?"

"Hear what, Dad?"

"That lovely music. What a classy place."

"It's a pretty fancy party."

"Pretty fancy? Anya, I feel like I'm in an Edith Wharton novel. I'm just waiting for someone to hand me a crumpet, and I don't even know what a crumpet looks like."

"It looks like a little pancake, with a lot of holes."

"Oh, that's a little disappointing, isn't it? I thought it looked more like a cornet or a French horn."

"Nope, sorry, tiny pancake."

His oohing and aahing is annoying me. We seem so awkward here, like we are trying too hard, like we don't belong. What I need to do is to get the hell out of here. The past four years have taken all the optimism I had in high school, dumped it out, lit it on fire, and chucked back a pile of steaming shit.

But there have been high points. All senior year I worked on a photography project about Ganderbill. Everyone in the photo department was fascinated. They said my work was like peering into a forgotten world. I spent so much time at Yale trying to act upper crust only to discover at the last second that when I let my surreptitious poverty-flag fly, people treated me like an exotic bird.

What I have learned at Yale, more than anything else, is that I am truly middle class. That I don't have *zero* money, but that I can *very easily* have zero money. What I have learned is that I live in a country where I *need* to make money, *much more* money than I have ever contemplated before. And instead of falling in love with something like computer science or engineering, which might have led to a lucrative career, I have fallen in love with art.

And I paid for it.

OK, my parents also paid for it.

Lord have mercy on their souls.

So when people ask me what I am going to do after graduation, I tell them I am going to work on a sheep farm in New Zealand because it is the nicest way I can think of telling them to go fuck themselves.*

Everyone I know has some sort of job lined up, mostly with management-consultant companies and internet start-ups. Apparently, earlier in the year there were recruitment meetings, meet-and-greet cocktail parties, and interviews. I didn't even know they were happening. I was sprawled out in my sculpture studio, listening to Stereolab on repeat, making photographs of photographs of photographs into a durational immersive installation about existential liminality.

Or something.

It also involved a lot of hot glue.

"Do you think they have mozzarella sticks or maybe some of those jalapeño poppers?" my father asks.

My mother glares at him, but he persists.

* September 1999, three months after graduation, my friend Sam Stern and I will buy one-way tickets to New Zealand and go work on sheep and organic kiwi farms for three months.

"I'm hungry. What are they going to serve us? Baby quail? I picture every-one here eats baby quail, or better yet, Cornish hens. Am I right, Anya? This is a Cornish hen kind of crowd—"

"Bob," my mother interrupts.

"I'm just trying to lighten the mood. You'd think we were at a funeral, not an Ivy League graduation party, at the Lawn Club nonetheless. You know your grandparents weren't allowed in here back in the day. They had a strict no-Jews policy until I don't know when. Probably used to have a sign on the door, No Jews."

So then why can't my parents take a cue from all the WASPy parents in the room and give each other classy icy stares instead of bitching like old hens?

"Can I go have a smoke?" Allyson asks.

"No," my parents answer in unison.

"This is so boring."

She takes a pinch of salt from a cut-glass bowl and sprinkles it on my head.

Allyson had landed in Staples High School the year after I left as the Key Award winner, surveyed the landscape, and, quickly realizing that she was expected to be a mini-me, vowed utter rebellion. She was now a pack-a-day smoker whose glove compartment (she got a new used car—unfair) was stuffed to the brim with cut slips.

My father is still loudly going on to no one about how now he feels like he is in a Henry James novel. My mother's lipstick has made its way onto her front teeth. My father puts his elbows back on the table.

I am melting in front of the bone china setting and the look of shame on my mother's face. It's contagious. It sweeps across my face too, as if we are reliving all the humiliations of our lives. At this moment we hillbillies, we Jewbillies, are crashing into the waves of high society, like the sewage water that sometimes runs down Ganderbill.

Tonight, I know I am just a holler rat, too.

The holler rat of the Ivy League.

CHAPTER 21

There is a blank gallery wall with a table in front of it. On the table are piles of thick markers and at least twenty-five magnifying glasses, the kind used in fourth grade to explore flowers, insects, and tree bark. The sign on the wall reads: "Use these instruments to examine the object and circle any flaws you see."

Around the corner, I'm lying on the table, waiting.

The Atlanta night is already muggy, but inside the gallery it is cold. I hear the uncertainty of the audience. They whisper low and slow. They are not sure whether the instruction is meant to be taken literally.

Maybe this is a trick.

Maybe the actual "performance" is seeing if anyone will really get up the nerve to scrutinize the naked body of this woman they know as a mentor, instructor, student, friend, lover, classmate, enemy.

Minutes pass.

I hear footsteps and feel the gentle breath of someone nearing my left arm. Then, pressure as a circle is made on the freckle that emerged the summer I learned to drive.

Tiny marks are being made all over my body. People try to whisper to me. Taunt me. Tickle me.

I'm very ticklish.

The first marker strokes are hesitant but then come faster. Drawing on human skin is different than drawing on paper; the marks seep in rather than lingering on the surface. Circles start to move my torso. More and more pressure. Some overlap. What are they seeing? Fat?

It's always fat.

Someone circles the entirety of my belly.

Someone marks the scars from my operations.

Then a shift.

Now I'm a sketchbook. Now they are doodling. Someone hovers over my right breast. Drawing a face? A pirate face?

But the challenge of this piece for me is not having people see me naked. It's something only I know about.

My right leg.

I still have no tactile feeling there, but I can feel significant pressure. When anyone comes close to the part of my leg joint where feeling meets numbness, I want to throw up.

No one ever touches that part of my body. Not doctors, not my parents, not men.

Only me.

Tonight, for the first time since I was a child, I am letting my right thigh be touched.

Sometimes coming up with performance ideas turns into a game of "I dare you to . . ." with myself.

A man, a big man—I can tell by the heft and sweat of his fingers—is coming toward me. I don't even have a moment to inhale.

He touches my right thigh and presses.

I could scream.

Instead, I remember I am still alive.

I slurp my milkshake of pain.

It's over. I've done it.

And I never want to do it again.

The next time someone comes for my leg, I jolt. And the time after that, I jolt.

Someone starts to make a game out of it.

But I manage to keep everyone else away from my leg for the rest of the show.

I stay on the table for two more hours and the scribbles continue.

When people use my shins as coasters, my line is crossed.

You do not put coasters on the art.

I exit the gallery.

CHAPTER 22

Mamaw has something hanging off her eyebrow. It's like a fatty, lopsided marble, and it partially blocks her vision, making her a touch cross-eyed. It's so large, her eyeglasses wobble on the bridge of her nose. It goes without saying that she has refused to let any doctor examine it. She says she doesn't understand what the fuss is about, but I can tell that she's spooked. She's started to lay off the Salems.

My mom is staring down the mouth of the holler at the gathering thunderheads, estimating how long we have until the storm rolls in. I rip the string off a bean, roll it into a tiny ball, and flick it off the edge of the porch. I look at Mamaw; her lips pucker around her gums like a mummy. Sasha, Mamaw's saltwater-taffy-obsessed mutt, wags her tail hard against the floorboards. We three sit cross-legged, a big mess of fresh-picked green beans like a fire in the middle, their seeds preserved, sheltered and sown year after year. Like these beans, we descend from one another.

I glide along the bean's edge, close my eyes, and snap each pod at its neck, breaking it into even segments. I check my pieces for flyaway strings.

"Here's a flat one."

"Pitch it. Ain't no good."

"Here's a bastard."*

"Pitch that one, too. Lotta bastards in this mess of beans."

* A discolored hybrid.

Then I toss my good pieces into the dented pot, the pot Mamaw has been cooking beans in since she was a girl, one of the few possessions she brought up Ganderbill when she married Ed.

"See, here's how you do, Anya. You hold your bean in your hand and you mash between the pods, slow and steady. Makes them nice."

Mamaw puts her hand in the pot and sighs as they slide one by one through her fingers, the ends of her mouth curling into a shadow of smile. It's a rare thing, to see Mamaw happy. The last time I saw her this happy was when she won the nail-driving contest down at the Riverside Church carnival five years ago. She won fifty dollars and got to keep the nailed stump as a trophy.

Mamaw rinses the mess of beans over and over, covers them with water and adds a tablespoon of Fischer's lard from her eight-pound bucket. Then, she boils the water down at least three times, each time checking to make sure the temperature is right. Mamaw never stirs and never adds salt, not until the very last moment when she declares the beans are done.

"You youngins better get here. These beans are done. You're gonna miss 'em if you don't come on now! They're so good I bet you can't sit still enough to eat them."

Hot beans are the best beans.

"I feel sorry for fellers who buy their beans at the store. You know what they do? They breed them so they don't have no string on."

"I know, not many people keep up the old way of keeping a garden," I say.

"Not me, I love the string. It's like unzipping a new pair of britches. That's what I think. Brand new. I say those people lost the seed off 'em. They got too lazy to grow their own. People here wouldn't be so fat if they grew their own food like they used to, even just some 'maters and melons. But people do like they do, I guess."

This strain of beans that we eat, along with the strains of most of the vegetables in Mamaw's garden, dates back to colonial times, passed from generation to generation, our parallel genetic heritage. My mom plants them every year in the silt loam of Southeastern Connecticut. Usually, deer eat them before we get to harvest them. But a deer wouldn't stand a lick of a chance up

Ganderbill. It'd be mounted on the wall of some trailer before it knew what happened to it.

Every year, at the very end of the summer, Mamaw picks the best-looking beans and lays them out on the edge of the porch to bask in the sun. Every night she brings them in to keep them from getting mildewed and puts them out in the sun again in the morning. When they are completely dried, they are stored in a Mason jar until spring, another generation ready to be sewn.

* * *

Allyson and Jason, her boyfriend, drove down to Ganderbill together after she graduated from high school. They were sitting on the porch when Cousin Sonny, better known as Ol' Sonny, pulled up in his rusty yellow pickup. I'd heard of Ol' Sonny but never seen him. He was never around when I was growing up because, folks said, he was in jail doing time for a felony. He'd been away so long, he might as well have been forgotten.

Lately, though, he'd been making his presence known up the holler. No one was quite sure what to make of it. Ol' Sonny hadn't waited long to say what he wanted from Mamaw. He wanted to put what he called a "temporary trailer" on the edge of her property, high up near the cemetery, a place for him and his sons to live just until he got his feet back on the ground. It was unclear to me whether this was phrased as a request or more of a declaration.

Mamaw told Allyson she was a mite worried about living next to Ol' Sonny. This didn't surprise me. After all, she was already paranoid about the FBI tapping her phone and the US Postal Service opening her mail. When she talked about these things, she spoke in a whisper in case the shack was bugged. Still, though, she said, "I'm not one to turn a feller out who wants to redeem his ways. If he looks to the Lord, then I got to look out for him. Now that's the way I see it. Don't make no matter what he's done in his past. We all sinners."

No matter who was seeking redemption for what, the truth was that probably more than one family member was relieved when Ol' Sonny went to prison, and now more than one was frightened he was out.

One afternoon, Mamaw, Allyson, Jason, and Ol' Sonny were up on the porch smoking cigarettes and rocking back and forth in the white chairs.

From afar they heard an incoming helicopter, a DEA chopper, flying low up the creek. It was well known the Feds were using new infrared technology to hunt Kentucky's biggest cash crop, marijuana, a plant growing unabashedly all over Ganderbill.

Ol' Sonny ran off the porch to his rusty yellow pickup.

"What's he doing, Mamaw?" Allyson asked.

"I don't know, youngin'."

The helicopter dipped low toward the garden and then turned toward the family cemetery. As it banked north and over the distant treeline, Ol' Sonny emerged with a rifle and pointed the gun in the direction of the chopper as though to fire.

Allyson and Jason looked at each other.

Maybe he was just trying to impress them? Maybe he thought he was being funny? Still, it was clear that Ol' Sonny was on a circuitous path to redemption.

And Ol' Sonny was going to be trouble.

I doubt Mamaw thought it would be wise to say no to him, even though he didn't actually have any technical, legal claim to the land in the first place. Of course, no white person had any claim to the land except for the Cherokee and Shawnee people who had been chased out of the hills by my ancestors. It should be noted that during this chase, some of the Cherokee and Shawnee also became some of my ancestors. But since after that they were few and far between, property lines were drawn, and deeds filed in the courthouse.

The land up Ganderbill had, for as long as anyone could remember, been lived on communally. As a result, these deeds were spectacularly nebulous. I had gone to find a copy of one in the courthouse in Jackson a few years earlier. It read something like: "This deed is for the property that starts at Little Bark Holler and goes along the ridge until the big blackberry tree, then goes across to the old root cellar, and then back up toward Granny's cave."*

Things weren't exactly precise.

Here's what Mamaw told me she said to Ol' Sonny:

* Granny had a penchant for hiding people running away from the law. She would put them up in one of the caves on the hill and bring them food.

"Ol' Sonny, I thought about it, and I'll let you set your trailer up on that there ridge. Now when I go, that'll be poor little Inez's land, and you have to leave. It's her daddy's land, from her daddy's people. But as long I'm alive, and you try to walk in the way of the Lord, you can stay there, but then you got to go."

There's no way to know what she actually said. Either way, I think what Ol' Sonny heard was that the land was his.

The land that was at stake was not oil-rich Texas ranchland or waterfront Nantucket sand dunes. It wasn't exactly worthless, but it certainly was not worth much. Even if you wanted to strip the land of every natural resource—timber, coal, water, and so forth—it really was not worth that much more than a hill of beans. Yet, its meaning as the sum of identity, destiny, and pride for my family was invaluable.

When I think about Mamaw's conversation with Ol' Sonny, I think about how her declaration of my mom's inheritance was never set on paper; there was no actual will. This always seemed deliberate to me.

"I don't want no bigwig lawyers. Y'all should be able to just do what I tell you I want done. Just listen and do, youngins."

This reluctance toward formal legal processes was selective. She had given my uncles deeds to their inherited portions of the property without question, all signed, sealed, and delivered by bigwig lawyers. As a matter of fact, depending on who you spoke to, Mamaw had even initiated the legal transactions. It was just my mother she refused to sign for.

It was retribution for having left the holler.

Once, when my parents weren't around and Mamaw thought I was too young to understand, I'd heard her say, "Not like poor little Inez gonna come back home. At least not for a right while. Maybe when ol' Bob dies."

My mother would never be forgiven.

Never.

And because my mother was an exile, Allyson and I were involuntarily exiles.

One night, a year out of college, it was just Mamaw and me eating from the salad bar at the Ponderosa in Hazard. I asked her why she wouldn't give my mom a deed.

She flipped the vanilla wafers out of her banana pudding.

"Child, let 'em fight it out."

"But don't you think Ed would have wanted Mom to have land in the holler? The land is from his family. Make it so she could come back and a build a little cabin, maybe? Or so Allyson and I could come back and live. I mean, had he lived he might have said these things."

"Ed's dead; gone and dead and left me. Now don't you make no mind, child. It's my property and I say let 'em fellers fight it out. They gonna remember their Mamaw. You gonna remember your Mamaw, too."

I could understand Mamaw's obstinance about some things. She had had a tough life and had suffered greatly. Maybe holding back signing the papers was connected to Ed in a way I didn't understand. Maybe there was some history about that part of the land that I couldn't know. But when she seemed to enjoy holding it over my mother's head, my feelings changed. It was something she almost taunted her with, like a cat with a partially gutted mouse. Periodically, she would say that she was ready to go to a lawyer and sign papers. Then she would change her mind right before the appointment. This was cruel. I couldn't solve the problems of the past, but I could easily imagine their future consequences. As self-appointed protector of my mother, I knew this did not bode well.

While all of this carried on, Ol' Sonny sat up in his "temporary" trailer up on the hill, watching the whole thing from his perch, calculating, digging in.

And no one seemed to make any mind about it at all.

CHAPTER 23

The chimney is wrapped in black garbage bags and silver duct tape. A garbage bag is taped over the window in the upper room, rags caulking the places where the wall has collapsed, water stains dappling the coal-dusted sheetrock. The kitchen door doesn't lock anymore, so Mamaw ties it with shoelaces and props a wooden chair under the doorknob. A love vine has wound its way inside through a crack in the window over Mamaw's bed, quickly climbing the wall by the white door. A potato vine worms through another crack, creeping above the faded photograph of Granny and Old Man Gran. The bathtub has fallen through the floorboards, a moment away from fully descending into the crawl space below. Mamaw has taken to washing herself by dumping lard buckets of water on her head.

My mom and I have come here to convince Mamaw once and for all that she needs to move into a trailer, for her own safety. For every one of the past ten years, we've tried to move her into a trailer. She has a little money saved from the strip mining of some coal up on the hill, just enough to buy her a lovely new trailer with new appliances, heating, and air conditioning. But convincing her she should spend this money on herself and her safety is the major obstacle.

"I'm fine making do. Got to make do in this life, so as to get on to the next."

"But you don't need to make do, Mimmy. All you need to do is spend a little money."

"Now stop pestering me. I don't want to see no trailers."

We bring her brochures, show her exactly where the trailer would sit, how easy her life would be, and repeatedly say, "If you lived in a trailer, you could . . ."

Sometimes Mamaw comes close to relenting.

"Well, I could see what all the fuss is about showers."

But as soon as she gets close to saying yes, she comes up with another excuse. A trailer might not be able to fit up the holler.

Ol' Sonny had one pulled up, we point out.

By now three years have passed since he arrived, and Ol' Sonny has a real house. A permanent one, made from stone.

He just built it.

He did not ask this time.

He also has a mailbox and an address with the US Postal Service.

No permission asked.

Ol' Sonny does not understand the definition of *temporary*.

Ol' Sonny has dug his feet directly into my mom's ground.

I know Mamaw doesn't think she deserves something new and expensive.

"Leave me be. I lived in this house 'bout all my life and it done me fine. I never complained a day in my life. A body has to make do with what a body has. That's the way the good Lord wanted it. But Lord! If He ain't given me a heavy row to hoe. Left me up the head of this holler by myself."

It goes around and around like this. Over and over. It's endless. Oh, is it endless.

My mom and I share the big bed by the kitchen and each night we are visited by raccoons that climb in from under the sink to raid the Little Debbie cakes. When we tell Mamaw that there is a pack of raccoons living in the kitchen, she sighs.

"You fellers think I don't know they're in my house? They don't bother no one."

While we are there, a new hole to the outside opens in the bathroom. I dream a copperhead is slithering between the baby dolls in their fancy lace dresses on our bed.

Just like that, Mamaw says she wants a trailer.

CHAPTER 24

E very trip I made up the holler, Mamaw let me photograph her a little more: gazing out across the potato field at the old Studebaker, under the big pine with the locust shells, peeling a bushel of tart apples. She was patient while I fumbled with the twin lens reflex Rolleiflex that Pop won in a pinball championship at an army PX after the war. He gave it to me as a graduation present, along with several of his exquisite German-made lenses.

I was trying to use this new camera to get a different understanding of my Kentucky family, one both more and less attached. I had decided to extend my undergrad photo project and see if I could go deeper on my own. With the camera, I discovered I could find some control in a place where I never had any control, where everything always seemed to be wild. The camera also allowed me to become invisible. Controlling my absence made me feel more permanent. Of course, I wasn't actually invisible in Kentucky. Despite trying to calm down my thrift-store-hipster look, trying to soften my slight New York accent, it was always abundantly clear that I was not a native. My presence had to be immediately explained to anyone we met out of the holler. Whether it was wandering the aisles of Winn-Dixie looking for hot sauce or sifting through T-shirts at the opportunity store, I was a space alien beamed into holler country.

Mamaw waited docile as a lamb for me to tell her what to do. I think she trusted me with the camera. Maybe I played on her fear of the judgment of the outside world. Maybe that is what all portrait photography is partly about anyway. I sometimes was afraid, am still afraid, that without intending to, I exploited her.

I photographed Mamaw in front of the Hi-C jugs in the grocery store and snapped her frowning at the sorry-looking sausages in the meat department. People loitered around as I took her picture, wondering if she was going to be in a magazine or a movie. It wasn't every day that someone came into the Hazard Save A Lot with an aspiring professional photographer in tow, especially one with a fancy, vintage German camera. Even though she was painfully shy in public, Mamaw loved having the gaze turned on her. Yes, her skin was wrinkled as a reused paper bag, but it was clear and soft.

But sometimes I can think of nothing sadder than Mamaw posing for me, concerned that her teeth are in right and her clothes are pressed. I knew all of this and still I asked her. Photographing Mamaw, I understood what it meant to "take" pictures. It was so easy, like an eight-year-old grabbing anything they want from a toy store. But being photographed was the only time I ever saw her giggle. That and the time we saw this old man walking along the road who couldn't keep his britches up and they kept falling down no matter what he did.

I knew what would happen when I brought my pictures back North, printed them in the community darkroom I belonged to, and tacked them to the wall to check the contrast and exposure. I knew this because it always happened after I returned with a batch of film from Kentucky.

"Who is that?" people asked, incredulous. How did I convince such a wrinkled, weathered woman to sit for me so casually, so closely for so long. How had I photographed her so intimately? How did I get such access? To them, Mamaw was a person you saw in books, not someone people from the fancy towns in Fairfield County knew, unless maybe I was on a volunteer mission trip. I must have been on one of those programs, right? Helping those less fortunate is so important, they say.

It was true, Mamaw gave good poverty face, the crags of her skin as calloused as Dorothea Lange's *Migrant Mother*.

"That's my grandmother," I'd say, pride and shame embodying ambivalence. They would look confused. How'd we get from Mamaw to me with my arty eyeglasses and indie band T-shirts?

"Where is this place?"

"East Kentucky."

"Oh, Kentucky, I have a cousin who went to the Derby last year. I didn't know it looked like this. He said it was very fancy."

"This isn't where the Derby is. Or anywhere near it actually."

"Oh, so this is more like that movie *Deliverance*?"

It always ends with *Deliverance*. Or these days, *Hillbilly Elegy*.* Fuckin' *Hillbilly Elegy*.

Mamaw also let me record her voice on my MiniDisc player.

I asked about Ed, and she straightened up the doilies on both arms of the sofa before she spoke. I could tell she was debating if she should speak to me as if I was her granddaughter or as if I was a grown adult.

Then she began.

She had known who he was her whole life. Of course, he was kin to her in some way, but no one bothered to figure out how. As long as they weren't brother and sister, no one made any mind. People said he already had two babies out in the country by different women and maybe a few more hiding somewhere, but she didn't pay no mind to that either. Lots of men had children out in the country, but so far no woman had managed to get Ed to the preacher. She was the only one (she knew of) who ever accomplished that. Ed made her feel loved for the first time in her life. He was her escape from the truly miserable poverty she had grown up in—Ed's family shack had more than one room and a real coal stove, so his family was much better off than hers.

"He used to come flying up our holler bareback, his red hair flamin'. He was a wild one, but he was right smart and handsome with his square jaw and his red stubble. He warn't a tall man, no he warn't. But by G-d did he have a temper, just like your mother, just like poor little Allyson. He took it out on himself, punching and biting himself when he made a mistake, or smashing up something when it didn't work right. Oh, he got so mad."

"I can get that mad at myself. I don't smash things though. Do you think that came from Ed?"

"Well, it probably did youngin'. Probably did."

She paused.

* J. D. Vance's family were known as "big-city folk," fancy people, to my family. They lived in the city of Jackson, not deep in hollers out in the country.

"You see my daddy, he was a peddler man. He went up and down the country and he sold all sorts of things he could to the people in the hollers. Just things like thread and kitchen things and all whatnot. Anything he think he could sell, he did. He never did know too much about how to take care of the house. My poor mommy and me and my sisters, we did that."

She lit another Salem.

"But now, see here, because my mother had died and my older sister Mildred had gone off with the WACs in the war, it was up to me to do all the cookin' and cleanin' and everything else for my daddy. Well, when he heard I done eloped with that redhead rascal Ed Fugate, he done had him a shit fit! Oh, did he have a shit fit."

She threw back her head and laughed and laughed. She slapped her knee and almost dropped her cigarette on the rug.

"Really? What did he say?"

She started coughing and laughing at the same time, trying to catch her breath.

"Oh Lordy, he was so mad; I swear he never did stop being mad. Mad right till his dying day. He said 'Vesty, don't you ever step foot in my house again.' And so I never did."

"Ever?"

"Ever. He was a mean man. Now Ed and me we had no food, and this here being our wedding day, Ed was hungry, and I now being his wife, I need make us some supper."

"Of course."

"So I done hid in the bushes at my daddy's house. Done waited and waited, and then I stole me some green tomatoes from the garden. I done did all the tending to 'em myself. We fried them over a campfire up here in the holler. Best I ever tasted."

Mamaw was garrulous.

So I thought I might solve a lifelong mystery.

I asked her what was behind the white door.

Out of a clear sky, Zeus's lightening.

"You make no mind about that white door."

CHAPTER 25

After a trip to Goodwill to buy a boxy business suit, I got a job as a paralegal at a white-shoe law firm on Wall Street. The interview was brief. The HR rep asked me where I went to school and what interested me about the law. I said democracy.

The previous paralegal left the firm to focus on planning her wedding. She had been an excellent photocopier. As we walked around, the HR woman pointed out other Yalie paralegals, associates, and partners.

"Alex, class of '97—wave, Alex—and Veronica in the far cubicle, class of '95. You probably know a lot of the same people. I think Alex is from Connecticut, too. Oh, no, you just prepped at Choate. And, of course, we have Yalie partners as well. Last year they funded the restoration of pews in Woolsey Hall."

I murmured approval, trying to imagine the day I would have enough money and give enough of a shit to restore pews.

"Basically, you just sit here, study for your LSATs, and look pretty. We give you a nice letter of recommendation, and then hopefully we see you again in three years after law school when we hire you as an associate."

On my official start date, I confirmed the commencement of my corporate employment by wearing sneakers over my nude pantyhose to and from the subway.

They gave me a firm cell phone and a firm messenger bag. I toured the in-house gym and the swag closet with custom L.L.Bean boat totes. I watched frightening videos from the SEC about the lurid temptations of insider

trading. I was given a list of job perks: black car service home if working after 7:00 p.m., free admittance to all major museums, and dinner credit for working overtime.

One of the partners asked me if I had questions about the work we were doing.

"So this one," I pointed to a file on his desk, "Basset Hound Corporation, do they make supplies for basset hounds? Or maybe they are a clothing brand?"

"These corporations produce nothing,"

"Nothing? I'm sorry, I don't get it."

"What did you study at Yale, may I ask?"

"Oh, um, English. English major. I did a lot of studio art, too."

"That explains it."

Then, as if I my brain was filled with corn puffs, he explained that the department takes people with millions of dollars—it takes at least twenty million to qualify for representation—mostly South Americans who are from countries with some type of "traumatic" political situation, and sets them up as offshore corporations. That way their money is "protected." He used a lot of air quotes.

"I'm not sure I really understand."

"You don't have to understand. You just need to know never, ever, *ever* to ask anyone where their money is from. Do you get what I am saying?"

I got it.

They turned Bassett Hound Corporation into Beagle Corporation and six months later they turned Beagle Corporation into Boston Terrier Corporation and so forth. You went down an alphabetized list of dog breeds, changing one into the next. When you ran out of names, you named the corporations after species of birds or musical terminology. You did this for every client. Sometimes many, many corporations for a single client.

"It creates a huge paper trail, which is the point. Makes it difficult to find out what is happening. You'll be doing the paperwork to change the names, filing that paperwork, making binders out of that paperwork, etc. You'll mostly be making binders. Lots of binders."

"But isn't this like, illegal?"

He laughed, then stared at the picture of his yacht on the wall.

"It probably should be. It probably should be."

People went to law school for this?

* * *

By my second day, I hated my job. I also knew I could fake it there. I could make sure that Golden Retriever Corporation became Gordon Setter Corporation became Great Dane Corporation. I could study my ass off and ace the LSATs. With some spit and grit and lots of student loans, I could probably become the partner in the corner office who had introduced me to the world of dubious offshore shell corporations. I could probably own a bigger yacht.

I looked at my firm lunchbox and my firm thermos all set for a day of work. I felt like I was staring at the tombstone of my intelligence.

After a few weeks of commuting, I rented a room in a one-bedroom apartment that had been cannibalized into three. I recently learned this was common in the city, people renting parts of their spaces to other people who then also rented parts of those smaller spaces to other people. Everyone was trying to make money off someone else.

I met my roommates on a Yale listserv. The guy in the humane-size bedroom worked at Smith Barney and had everything in his life delivered to the door. The woman in the room that used to be the living room was a first-year at Columbia Law. My room was formerly the breakfast nook. My roommates were rarely home when I was, so when I came back from bindering Blossom-Headed Parakeet Corporation into Blue Bird of Paradise Corporation, I made photographs of plastic dinosaurs that I perched on various food products on my shelf in the fridge.

I signed up for a continuing-ed class in self-portraiture where I replicated my barnacle dream by smearing my face with hunks of wet oatmeal, then snapped picture after picture while I tried to scrape it off. I cut out pictures of myself dressed up for parties at Yale and assembled them into dioramas where plastic crocs, tigers, and sharks attempted to chew my head off. I found a palm-sized plastic baby doll in a junk shop, dropped it in a saucepan, and photographed it boiling. But except for showing my demented little vignettes

to my classmates, I kept my photos in a small cardboard box, which I kept inside the bigger cardboard box my TV stood on.

I desperately wanted to have a big artistic idea. I wanted to make work of seismic proportions, artwork that would bring me fame and fortune and magazine covers and get me away from the hellfire of the Cocker Spaniel Corporation's board of director notes. I kept searching and searching for some statement to make, a political position, but no matter how many articles I read in *Mother Jones*, I couldn't find a cause I wanted to protest for. Books and movies had taught me that good art created social change. Good art helped people confront truth in new ways. And more importantly, once confronted, good art helped fight for better truths. Art needed to be mighty.

I didn't realize then (and struggle to now) that making art about what it is like to live in my body and my brain was enough. Just sharing what it is to be human, really sharing the ugliest bits and all, can be a radical act. What I didn't see then was that the personal could be political. I just needed to get out of my own damn way.

To save money, I processed my film in the tiny bathroom of the cannibalized apartment and kept my silver processing reels, tanks, and caustic chemicals where my shampoo was supposed to go.

Home from an all-day company golf outing in the Hamptons, Smith Barney guy said, "Are you kidding me? You have all your film hanging in here again."

"Oh, yeah, I forgot, I'm sorry, it's almost done drying. Could you like very carefully hand it to me? Just don't touch the non-shiny side."

"This is ridiculous. Why don't you go to a photo shop?"

"Well, this is special black-and-white film that you really have to process by hand to get all the tonal values."

"Yeah, but not in a bathroom when you live with two other people."

I should have had more patience for them. Finding plastic soldiers hovering around the sour cream must have been disconcerting. They thought they were getting a responsible LSAT-studying Yalie for their roommate, not an insomniac with a penchant for splodging herself with food products.

The New York art world seemed watertight, like a mallard duck on a rainy day. I couldn't find a way in. For a while I went to the Thursday-night gallery

openings in Chelsea, but I knew no one and I felt stupid standing around hoping I would see a familiar face. Even if I did, I wouldn't know what to say. Most of the shows were for students in the Yale grad program, people whom I only knew from dismissing their overdue fines with a wink at my job in the art and architecture library. And honestly it was depressing to witness everyone with their backs turned on the artwork as they got wasted on box wine and stale peanuts.

Then I had some dumb luck with a cold portfolio submission to the *New York Times* magazine Lives page. It was a spec story about one of my college roommates getting married in Oman. I didn't even have to develop the film in my bathroom; they paid for it to be shipped to a proper photo lab. I thought it was my big break and that fame and fortune and magazine covers were headed my way, but as quickly as it came, it left.

Around the same time, I was offered a spot on the wait list at a very prestigious MFA program at a very prestigious school. During my interview with current students and the grad director, I had been asked a baffling question. We were talking about a picture I took of a very insane-looking dog. I liked it because the dog seemed a bit like some of the weirdos in Diane Arbus's portraits.

"So where do you locate yourself sexually in this image?" One of the students asked. Her classmates nodded their heads. The grad director looked at me expectantly.

"In this picture? Of the dog in the park?"

"Yes, this one."

"I've never really thought about that. You mean how I am connected to the dog sexually?"

"Maybe, or just to the work as a whole," the grad director said.

"I'm not sure." And then, deploying a tactic I had learned at the law firm, "I'll have to get back to you on that."

I left the interview unsure of why I even wanted to go to this school. Did I want to spend my days in conversations like the one I had just had? Taking pictures of dogs I discovered I was somehow sexually attracted to? But then, I knew why. Collectors came in and out of its studios, often buying things straight off the wall after critique sessions. The students' thesis shows were

usually entirely sold out. By the time they graduated, most students had representation with galleries and at least a few international credits and reviews. This program was a path well-traveled by its famous alums around the world. It was also a gateway to the secret doors the art world hid in the mist: special summer camps in the Maine woods, old cracker factories to be filled with installations, Italian villas for rest and artistic contemplation.

Then I came face-to-face with the numbers.

The tuition, plus the equipment (up until this point I'd gotten by with janky hand-me-down stuff), plus the studio fees, plus the cost of all that paper and film (and professional printing because few people in the program did it themselves), plus just day-to-day life equaled vomiting on myself repeatedly.

CHAPTER 26

———————

"Anya! You turn this dial right here. Got cottons, delicates for your under-things and brassieres. You can wash your pillow or your bedspread or even a whole rug. You don't need scrub on nary a board neither."

"Wow," I said, pretending that I'd never seen a washing machine before.

"You just set the dial like this and then you mash the button. Then you get some detergent. I like Tide—it smells nice-like even though it's a penny more—and you put it on top. Then you close the lid. Only takes twenty minutes. It's right fast, I tell you."

Mamaw stood back and admired the washer. She stroked the white enamel top with her long fingers.

"I always wanted me one of these. But did the best I could with what I had," she said. "You wanna see it go again?"

"Sure."

She turned the dial again.

"I'm just so happy you decided to get the trailer, Mamaw. It's the perfect place. You deserve it. It's lovely."

"Well, I ain't had no gravy train. No, I ain't. I had a hard life, but it kindly seemed that ol' house was a-falling down around me. I made do with what the good Lord gave me. Was a good home. Kept me and my youngins safe for a long time."

Mamaw ashed her Salem in a condensed-milk can.

"But it was a-starting to get right dangerous."

It was the first time I'd heard her admit this.

We both looked across the garden toward the darkened shack. From the safety of the new trailer, it sunk in how poor my mom's family, my family, really was. The shack was literally held together with duct tape in places. There were no stairs to the porch, just a pile of worn rocks on top of one another. A thick moss covered the entire back section, which was about to split in half. It was returning itself to the land.

"You been back over there?"

"No youngin', makes me too sad. Too many memories. I born my babies over there." She rearranged the cigarettes in their pouch.

"You know I had me another baby before Inez?"

"His name was James Edward."

"That was his name."

She tapped her cigarette again.

I waited for her to say more.

She might this time.

"But that's past. Don't make no mind about what done and gone. Best to accept it. That all a-body can do."

We sat in silence.

I thought about telling Mamaw how little direction I had in life, how purposeless I felt, but I knew that would be a mistake. Being both an insider and an outsider to these hills meant keeping the left hand from knowing what the right was doing. Don't mix your worlds. Instead, I tried humor.

"Remember when those raccoons came in and ate all the Little Debbie cakes up on the kitchen table?"

She laughed.

"Won't be busting in here. This trailer is as sturdy as they make. The very best. Ed always said you buy the best you can afford, it'll last you a right long time."

Though it made me happy to see her so happy, it also made me terrifically sad. How long had Mamaw denied her needs, how long had she suffered in the old house, how long had I been watching her do this?

And then I wondered.

Would I do the same thing?

* * *

Over the next few months, Mamaw discovered she loved taking long, hot showers. She said that now that she had a shower of her own, she saw what the fuss was about.

Mamaw loved shutting the door to her bedroom; it was the first real door she had had in her entire life. The shack just had curtains except for the white door to Ed's office. The house she grew up in had one room for all eleven. Now, Mamaw loved her bedroom door so much that she announced when she was about to close it.

"I just gonna close my door here. Just go up in my room and lie down for a spell. You need me, you just knock on my door, and I'll open it right quick."

This was an invitation. She got a kick out of answering her door.

CHAPTER 27

I got back together with a mischievous old boyfriend. His hijinks were behind him, and now he was a mostly sober adult in grad school in Atlanta. I had moved home from the city to save money and again had zero life plans. So I followed him to Georgia, into the same cookie-cutter corporate housing complex as him, but in a separate apartment.

At twenty-three, I thought art had dumped me. I would never have any recognized success. I couldn't go to the famous MFA program. I couldn't spend my summers at the special Maine art camp.

I was going to dump art back.

I was going to be conventionally career oriented at something.

These were my rules for my job: It should be a profession where I could wear what I wanted as long as it was clean. I should be able to sit cross-legged in my chair in meetings. It should not bring harm upon anyone knowingly (or unknowingly). It should not enforce harmful dogma or doctrine. It should not be primarily motivated by profit. It should begin after noon, but I guess I could do 10:00 a.m. It should not involve direct sunlight or climbing staircases or steep hills. And it should allow pets in the workplace and preferably have a workplace pet, like a guinea pig or bunny rabbit, that everyone shared.

It was realistic that I would have to give up all of these to keep food in my mouth, but I knew it would be less embarrassing to fall flat on myself in failure in Atlanta than in New York. Anything geographically south of Washington, DC, didn't count for Yalies; you might as well say you moved to Senegal.

My boyfriend and I disagreed as soon as I arrived.

"What is all this junk?" he said, looking at my packed, rusty Subaru that I'd bought with the money I saved working in the Yale admissions office.

"I brought some pots and pans so we could cook."

"We don't need that. I have the George Foreman grill. It cooks everything. It's great. I make chicken on it every night before I go to Tae Bo."

I was going to live in a lean, mean fat-grilling-machine world. Ick.

I'd probably have to go to Tae Bo, too. Double ick.

Maybe I hadn't thought this through.

When I came home with a pile of used books from Goodwill, he said they were dirty and that the only books one ever needed to read were the top three of the *NYT* bestseller list. That was all anyone talked about at cocktail parties or golf anyway. He wasn't the first guy who shamed my literacy habit. But when he said that my steel-toed Doc Martens and DIY patchworked bellbottoms made me look "a bit like a hobo. A cute hobo, but still a hobo," a line was crossed. I liked to make fun of myself. Sometimes I took it a little far even. But using as many objective powers as I could muster, I did not dress like a vagabond. I dressed like the inside of my head.

"I have a surprise for you!"

He handed me a garment bag from Nordstrom.

"Open it! I got it for you for parents' weekend. Hey. Did you know that Hank Aaron is speaking? We'll get to meet him afterward, and he owns a Jaguar dealership, in Cobb County, I think. That's the first thing I am going to buy when I get my signing bonus. I'm going to tell him."

I pulled a boxy teal linen dress out of the bag, as sexy as a bucket of nacho cheese. I got the message. I would never be banker wife material without a Nancy Reagan makeover.

So when I found out he was cheating on me, I didn't even bother to be sad about it.

But I was unwilling to ask my parents for money to come home and I'd spent my last dimes on my security deposit, so I was stuck in Atlanta. I had no friends except for Jimmy Carter.* I looked in the penny pages and got a job

* Who was president when I was born, and therefore I considered him an obligatory lifetime friend.

as a telemarketer. They were OK with me sitting cross-legged in my chair and the room was shady, so that was something. Work didn't start until 6:00 p.m. (right in the middle of dinner, the industry-acknowledged sweet spot), which was also something.

"Good evening, I'm calling from the Atlanta Theater Company. We are hoping you loved our production of *A Christma—*"

"Go to hell."

"Good evening, I'm calling from the Atlanta Theater Company. We are thrilled to announce that our new production of *Our To—*.

"Now, why are ya'll calling me in the middle of *Jeopardy!*? This is almost the Lord's hour. You better pray he don't come after you."

"Good evening. I'm calling from the Atlanta Theater—"

"Twat!"

Getting screamed at and hung up on repeatedly became somewhat fun once you realized it wasn't personal.

I also adopted a dog I named Ladybird after Lady Bird Johnson.* Ladybird looked as discombobulated as I felt. One of her ears stood straight up; the other flopped over her eye. Her body was like a root beer barrel candy with little pegs sticking out of it. She had Lucille Ball's timing and Janet Flanner's intelligence, and except for the fact that she occasionally licked her butt, she was utterly unaware that she was a dog.

I took her to the dog park every weekend. I hoped to use her as bait for making friends and meeting cute guys like in romcoms, but she always made a beeline for the farthest corner, plopped down in the dirt, and surveyed the assembled crowd. We watched as more svelte dogs and their manicured, prosperous owners jumped high for Frisbees and chucked neon tennis balls. Even in the dog world, there was a popular crowd and an unpopular crowd. We were both wallflowers, more comfortable sitting on the sidelines, judging.

Honestly, Ladybird was snobby for a dog rescued from a Walmart parking lot in Alpharetta. Maybe she too was getting above her raisin'. For one thing, she only liked folk music. Pete Seeger was her favorite, but when I played old

* I do believe that all Democrats who have held public office and their partners are extended family in some ways.

Bob Dylan bootlegs, she tipped her head back and howled in tune with his harmonica. She loved "She Belongs to Me."

On my nights off, after doing miserably at selling radiators or satellites or whatever I had to withstand that week, Ladybird and I would ride up and down Peachtree Street, my leaky sunroof open.

We'd turn Bob on real loud, almost blow out the Subaru's speakers.

He'd sing about a woman who has everything she needs, is an artist, doesn't look back.

I wanted to be her.

Howling, howling, howling in the soft Georgia night.

After a loop or two up to Buckhead, we'd stop at the Varsity for hot dogs and vanilla ice cream cones.

Ladybird saw me the way I wanted to be.

* * *

Art wanted to get back together. It kept hanging around me. My camera kept whining to be picked up and held. I tried to ignore it, but damn if that thing didn't have a bunch of accessories to join in the chorus. It wouldn't shut its trap until I at least took a few photographs of Ladybird, at least walked around town and let it stretch its legs, took a few useless pictures of chubby babies and tombstones. It wasn't long before we were looking for a place to play together again.

I found out that one of the art professors at a mostly commuter state college downtown, Georgia State University, was a Yale MFA, that another was a CalArts MFA, and that the director of the program had been a student of the legendary photographer Harry Callahan. As a reluctantly reforming Ivy Leaguer, these credentials meant a lot to me.

When I told a New York art friend about GSU she said, "Why would you do that to yourself?"

"I'm not sure what you mean?"

"Well, let's say you do go to this place in Atlanta, and then you come back to New York. Will people take you seriously? Real art people. I know that is harsh, but the art world is here, not in Atlanta."

"Hey. Elton John lives here. So does Whitney Houston."

"OK, but where does Larry Gagosian* live?"

"I get your point."

Still, I called GSU to see if I could take a night class. They asked for a portfolio.

The next day the phone rang.

"Ms. Liftig? The director has a question. We still have some space in our MFA program for this fall. Well, actually, we have a lot of space because no one is entering at all, but would you like to join the program? School started three days ago."

"Three days ago?"

"Yeah, it's not a problem. We aren't stressed about things like that."

Where I came from, people stressed about things like that.

"If you help run the university gallery, be a teaching assistant, and eventually teach some undergrad studio classes, we can waive the tuition and give you a stipend. It's not huge, but it will help you with you living expenses."

I had spent enough time as a telemarketer to doubt the validity of anything a stranger on the telephone told me, but I showed up the next morning and discovered that the school was real, the department was real, the offer was real.

As Mamaw would have said, I fell into a tub of butter.

* * *

GSU was the antithesis of Yale: public, urban, epically overcrowded, criminally underfunded, and unapologetically pragmatic. Instead of buildings named after philanthropic bluebloods, like Yale's Tiffany-windowed Linsly-Chittenden Hall, GSU named its buildings after their purpose: General Classroom, Music Building, Classroom South, Library North, Auditorium. The buildings were as attractive as parking garages, which the art school building had actually once been. Yale boasted legendary architecture; GSU was four blocks from the World of Coca-Cola.

* Arguably the most-famous modern art dealer in the world.

But GSU had a scrappy hunger. The future was here already. State students worked hard and dealt with the actual world that actual people lived in, not the one they peered at through stained-glass windows from high above.

Instead of WASPy legacies and athletic recruits, GSU's classrooms were filled with first-generation college students and immigrants, many taking advantage of Georgia's HOPE Scholarship program, funded by the lottery, which guaranteed free tuition to any student graduating a Georgia high school with a B average or better. Instead of the usual gaggle of mid-twenty-something grad students, my program had army veterans, single moms, a ninety-seven-year-old retired teacher, and a former NFL player.

We were a motley crew.

At GSU, nothing was handed to you, but with a willingness to chase down paper and people, to work your way through the system without blowing all your fuses, the possibilities were endless.

And the sweetest words to an artist's ear: It was free.

Let me write that again:

IT WAS FREE.

* * *

"Who are these people?" My new professor asked, scanning the images on the wall in our seminar room.

"My Kentucky family."

"Why don't we see pictures of you like this? All soft in black and white?"

"The project is not about me. It's about capturing life in East Kentucky."

"These people look like they are in an antique travelogue, not living in the twenty-first century. These people are alive right?"

"Yes."

"So, exactly why you are making these pictures this way? Like in some dream fantasy?"

This is not how I expected this to go.

"Look, you put those lines around the picture so we would think it was a fact, true, legitimate, documentary. And the lighting is blown out, I imagine

intentionally. And wow, is that sepia toner? I can't remember the last time I saw someone use sepia toner. This is a real place, Anya, in color."

"I know that."

"But you want it to be a dug-up time capsule."

Now, wait one second. I was a star in the Yale photo department, and I'd already done a version of this project there. I am not supposed to get my ass kicked by some rookie at a public university, a public *commuter* university in a city that is so rabidly racist it not so long ago had to rebrand itself with the slogan "The City Too Busy to Hate."

Go for the beauty defense. The beauty defense always works—it trips up the conceptualists.

"No, it's just that black and white conveys the beauty there. I just want to focus on the beauty. I want to glorify it so that I counteract the negative images people see of Appalachia with, um, beauty."

"Who are you to make that determination? About what is beautiful?"

What is this lady even saying now? I have to prove something is beautiful?

"I would say I can make that determination. I have the right to. I am from there."

"And sort of not. Aren't you from New York?"

"Connecticut, yeah."

"So not really New York either? Seems like this might be a pattern."

My classmates titter.

"I've always been in between."

"So how can you represent these people like this if you don't subject yourself to the same scrutiny?"

This wasn't a rhetorical question; it was a provocation.

"I wouldn't mind taking pictures of myself if I had half an idea of who I would be photographing."

My professor pounced.

"Isn't it about time you figured that out?"

* * *

Every week it was the same routine. I'd bring in new images, hang them on the walls, and the professor and my classmates would skewer me for an hour.

"Just because you have a camera doesn't give you the right to run around randomly objectifying people, Anya."

"I'm not objectifying them, not deliberately anyway."

"I don't know what's worse, that you can't even see that you're objectifying them or that you're sitting here calling it art."

I scrambled for new ideas. I rephotographed my own photographs to make a conceptual statement I couldn't explain, and instead just blabbed incoherently about some Walter Benjamin article I read freshman year.

I thought I landed on a good idea taking pictures of people sitting in their cars in traffic. That got me thrashed. "But they are in a liminal state," I whined. Liminality was popular in 2001.

I photographed a street festival near MLK's birthplace, then said something idiotic about the unity of American history unconsciously dug up from my second-grade social studies textbook. I deservedly got my ass handed to me.

I bought a fifty-pack of fluorescent orange cupcakes from Sam's Club and photographed them with a large-format 4 × 5 camera just to confuse everyone. At least no one yelled at me.

I printed some old negatives I bought at a flea market—mostly pictures of beefy guys holding up big fish. I said I hadn't taken the pictures, so I really had nothing to do with them. Also, it was a feminist statement.

"So, you're saying you bought some things and now we are looking at the things you bought."

"Yes. I think that's what I am saying."

"OK, why are you in an MFA program for photography again?"

Then, a friend on the phone from New York: "Did you hear about Katherine? She sold out her show at the opening. And now she has a show in Zurich, a dealer in Amagansett, and she might be in Documenta."

And I was about to feed my shutter finger to the African lions at Zoo Atlanta.

My Southern venture was officially not going well.

I thought I was a talented photographer, but now I was becoming aware that I might completely suck. How humiliating to find that out at a school I

didn't even apply to, didn't even know existed until four months ago? All my college friends were finishing law school, business school, starting to buy condos, getting their first promotions and raises. I was now running behind.

I felt backed into a corner. Apparently, I had no right to photograph anyone and anything other than myself, as I was the only person who could give myself permission to be represented, examined, captured, taken, objectified, stripped, violated, and any other number of other verbs we used to describe the photographic act.

Screw this piece of shit MFA, and screw this sorry-ass city.

I was really going to break up with art this time. I knew we were not destined to be together. It was not meant to be.

Ladybird and I would tuck our tails between our legs and head home to Westport, where I would throw myself on the pyre of the management consulting gods.

But I still had one more week left in the semester. One more week before I walked into the main office and said, "Thanks but no thanks. I'm going back to New York, oh wait, I mean, Connecticut!"

So, drunk and alone, I had a hilarious idea.

I would photograph myself backed into a corner.

Art imitating life and all that.

Take that, motherfuckers!

You're gonna remember your Anya.

I brought the image into my last crit of the semester and stabbed the metal thumbtacks into the four corners of my print.

"What are we looking at?"

"This is me backed into a corner, otherwise known as the only subject I am apparently allowed to photograph according to all of you."

"Now you're on the right track."

CHAPTER 28

I realized that the rigid orthodoxies under which I had trained for so many years in dance and even photography were holding me back. I made a conscious decision to let go of as much of my preconceived aesthetic crap as possible. With no fellow Yalies to impress, no high school peers to dazzle, no parents to explain my behavior to, I gave myself permission to open up other ways of art making and being. I started to embrace the freedom of not giving a fuck. I vowed that any whim I had, and could afford to enact, I would indulge.

I didn't realize it then, but I was starting to perform in front of the camera.

I smeared cake frosting all over my face and then filmed myself throwing rainbow sprinkles into my eyes.

I made my first iteration of a piece called *Jewbilly*: nine portraits of me dressing up like a proverbial "white trash" girl followed by nine portraits of me changing into a JAP woman.*

I photographed myself holding up signs with each of my imagined married names for every boy I ever had a crush on, then arranged all forty-nine images in a huge grid.

I photographed myself all blurry and smudgy in suburban strip-mall parking lots—their strange blend of businesses and vacant spaces a metaphor for my confusion.

* Jewish American Princess. I did not have a bat mitzvah, and I did not go to Hebrew school, but I desperately wanted to do both. For years, I harbored bottomless envy for the elaborate bat mitzvahs of my peers. I fantasized about what theme I would have, what my centerpieces and party favors would look like. What dress my mom would wear.

I thought of the nasty things people had said about my body and made photographic responses—smearing cottage cheese on the back of my thighs and turning myself into a frog.

Then I jumped off the page and into the third dimension by making objects that performed.

I shellacked green peas onto abandoned baby dolls, like the ones Mamaw kept on her bed, their covered bodies emerging diseased and deformed.

I taught myself how to cast resin and made rubber molds on my porch. I created a thick, clear penis with small babies swimming in the shaft. When I went to shake hands with people at gallery openings, I would place the penis in their palm.

I dipped a granny bra and granny panties in polyurethane, then attached more miniature plastic babies all over them. Babies were the ultimate barnacles—that childhood image that had electrified my nightmares about Dr. X. I discovered that my long-embedded rituals of scratching and picking found form and some relief when I created protective, hard crusts around objects.

Then I took a leap from making things to making me. I vaulted from making 3D objects to becoming a performer in space myself, often using objects I made.

I fashioned undulating, sculptural waves out of chicken wire and canvas, covered everything in Bondo filler, then shaped them around a child's bed and added thirty thousand miniature pink plastic babies. I slept in the bed in the gallery over two weekends, babies attacking me and the walls.

I stockpiled old Operation board games from yard sales, then filmed myself being repeatedly electrocuted while I tapped the right thigh of the imaginary patient on the game board.

I photographed every single item I owned, including buttons and pins and dull razor blades (a nod to Mamaw's collections of gimcrack). These pictures were hung in huge grids and took up an entire gallery.

I photographed all my rejection letters from schools and magazines and art contests. I hung them in a coffee shop so everyone could witness my ambition and subsequent rejection.

I covered myself from head to toe with fifteen pairs of pantyhose, stood in front of my classmates, and slowly ripped each pair off with a nail I had hidden

in my palm. Each layer that was removed made a projected image on my body become clearer. I recorded the sound of the nylon ripping and my panting as I struggled to breathe under the fabric.

I wanted to smother, encrust, consume.

If I could unpeel myself, survive picking off the scabs, the barnacles, if I could survive my wounds, I could regrow myself, and I might survive.

CHAPTER 29

Thesis season. Every week, different third-year MFA students fill this gallery with a comprehensive show of their best work. Paintings and sculptures usually line the walls. Tonight, the vast space is empty, save for a single black wire chair. The visitors are uneasy. Something is up.

It's an Anya Liftig show, and I am known for always being up to something.

Teetering on the edge of the rules, but so overly productive that the administration is hard-pressed to crack down on me.

Taunting the boundaries since the day I found my groove and let loose.

From my perch in the stairwell, I can see the backs of their heads. The space is full. I have made some enemies here, and now that squad of antagonists is seated near the black chair, ready to pounce. According to them, I am always mentioning books I've read just to show off where I went to school. It's been stated on several occasions that "just because you scored really well on a test one day in your life doesn't mean we should have to listen to you tell us that we need to read David Foster Wallace over and over" (or Proust or Bloom or Butler). Worse, I won't stay in my place, because I am now not only in the photography program but have also wedged my way into the drawing and painting program. But my major flaw is that I make too much artwork too fast. It makes them feel inadequate. I could kind of care less.

I go to the gallery door, place my feet on the gray linoleum, nod at the text large on the wall. My name and the words *self-evidence*, all lowercase.

I drop the robe. The first moment without clothes always feels a little cold. I walk forward into the space, step over a pack of kids from Intro Drawing, the ones who still freak when the nude models spread their legs.

I stand in front of the black wire chair, poached from a dumpster behind Sweet Auburn Market last week. Wonder how many people see that my right boob is bigger than my left. Wonder if my right leg limped.

I keep my chin up. Longer than I think I need to. Then longer. Take longer. Stand from strength. Nothing to support me except me.

I sit down.

Stare.

Go around the room.

Stare.

At each single person.

Wear them to the bone.

After twenty minutes, a portrait painter breaks the silence, asks me how I feel.

I say: "I came here to see if you have any questions."

That sentence is the entirety of my master's thesis.

They have no idea what I am even talking about. Questions about what? They are looking at each other frantically. The Intermediate Photo kids, my class, are giggling. They know my artwork spills in every direction. The director of the school is in the back of the gallery, hands on hips, shifting his weight, wondering which head he is going to roll for this. Who gave this the go-ahead? No one has done a performance art thesis here before. Is this really the whole thing? The Intro Drawing students look really terrified. Their parents were right. Art is total bullshit. How can you sell this? What are you supposed to do? Put the naked lady on your living room wall?

Reaction. Response. Openness. Experience. Phenomenology—I don't know how to spell it, but that, too.

A combatant speaks. She is mad about having spent a year in her studio painting canvas after canvas only for me to come along, take off my clothes, say six words, and call it a year's worth of work.

How is that fair?

I answer every question I am asked.

It's all being recorded. It will all be played back into the empty gallery, set with the empty black wire chair, for the next week.

They yell and ask and listen (mostly) until someone wants a hamburger three hours later and they all get up and leave.

CHAPTER 30

Lachlan, a painting grad student at GSU, likes to work outside in the scorching Georgia heat with his shirt off. He lifts my heavy boxes and changes my windshield wipers. He is the rare man who can get away with wearing a gold necklace.

I fall in love with him one night when, for no discernable reason, he starts punching a boulder in a parking lot until his knuckles bleed. I attempt to stop him, but he is all manly and inarticulate about his feelings and keeps thrashing the rock. There is something wild in there.

Lachlan teases me the way my Kentucky cousins do, taking the piss out of me as a form of affection. He picks me up and tosses me into the deep end of the apartment complex pool, secretly ties my shoelaces to each other when I am not looking, then takes uninvited bites out of my lunch.

At our favorite bar, a dump called Trackside Tavern, he matches me shot for shot until I'm too drunk to walk and have to be fireman-carried home. When our pockets are almost empty, we stack dimes and quarters together and split cold PBRs and rounds of darts. Lachlan's favored palette is a spectrum of rust. He likes to talk about entropy. His canvases remind me of cave paintings.

I ask him if he loves me and he says, "You're a pain in the ass, but yeah, I love you." We have major fun doing simple things together, like playing hide-and-seek in the studio building and rearranging the furniture in the state surplus warehouse. He is the only Gen Xer I know who isn't entranced by all

things ironic. He's a straight white male artist who proudly listens to country music and earnestly does dorky dances when he gets excited.

After we graduate, we decide to move to New York City. Ladybird, who has spent most of her time in and out of darkrooms, studios, and galleries, is eager for a change. I don't know why Lachlan wants to go to New York, but I know that I have gotten a little too big for my Atlanta britches. I've hit most of the milestones for emerging artists, and it's hard for midcareer artists to survive there. Also, there are no university teaching jobs at all. Everything is taken. To go on the job market, I have to compete with my own professors. This does not yield glowing recommendations. All the adjunct jobs are filled to the brim. I tried to go on the national job market for a few spots in distant Midwest towns, but my naked performance art didn't win me any points on the hiring committees of small Christian colleges and schools catering to students who idolize Ansel Adams. My choices are to either bide my time in Atlanta and try to produce a more sanitized portfolio, or to cut my losses, go north, and give up the chance of a university teaching job.

So Lachlan and I, imagining living in our own mid-1960s Soho, head to the city. We think if we can say we live in New York, our work will look better and people will take us more seriously. If we have to sacrifice more to make our work, it will make us more legitimate.

We answer a Craigslist ad, "Bushwick If You Dare," and soon find ourselves in a completely raw, industrial space on Troutman Street. This place on the border of Brooklyn and Queens—the boundary between Bushwick and Ridgewood actually runs through the building—feels like we crash-landed into a wasteland of shattered glass and chained, chewed pit bulls. When we tell people where we are moving, they look at us blankly. "I've never heard of it," they say. Every artist we know lives in Williamsburg. A few crazy people live in Greenpoint. Even they say we are nuts.

The lease looks super-shady. It's printed on already-used paper with multiple misspellings and poorly applied Wite-Out.

We are about to sign the crumpled papers in our landlord's "office"—the back table in a Chinese takeout place off Grand Avenue—when we get cold feet. Should we try to get a real apartment in a neighborhood that taxi drivers

are willing take us to, one where we could use the subway after 6:00 p.m.? Even though I grew up around and lived in the city before, I really have no idea what is happening in Brooklyn, save for what I heard from a few recent Atlanta transplants. All my Yale friends live on the Upper East Side.

"Hey, do you think we should do this? This guy looks weird."

"Everyone looks weird here; that's part of why we want to be here."

"The space doesn't seem to be a living space. Do you know what I mean?"

"But we could get a normal apartment in Atlanta."

"We came here to do this. Let's do it."

We high-five our special high-five.

At just less than one dollar per square foot, our space will cost way more than in Atlanta, but we are willing to pay to be in the greatest city in the world.

Lachlan hands over our wad of cash, money scraped together from our blowout going-away yard and art sale. The landlord's "assistant," a guy who claims he plays in a really important metal thrasher band and rides a comically too-small motorcycle, assures us that the building has a "C of O"—a certificate of occupancy issued by the city. Our space is definitely zoned for live/work. Not knowing enough to verify his claims, we say we will heed his warning about not having our mail delivered to the building, a request which seems perfectly rational and legitimate at the time, and unload our U-Haul.

The building has a massive freight elevator, just like in every movie about artists in New York. There is also a rickety roof deck where we let Ladybird roam, watch the Fourth of July fireworks, and BBQ on a ten-dollar metal grill from CTown. Until a few months ago, the building had been a textile sweatshop, and old sewing machines, spindles of yarn, and empty food containers litter the floors. Before that, it might or might not have been a pesticide-storage facility. We try to avoid touching any unidentified metal drums or containers.

Not only are we stupid, we're so stupid that we believe a can of paint and some spray foam can fix everything. We clear our space of dirty syringes and turn it into his-and-hers art studios, a small bedroom nook, and a general living and kitchen area. No doors, just curtains made from unusable canvas and clip-lamp clamps. Things are looking a bit like Mamaw's old house. I pitch a small tent to read and nap in. I place a photograph of Ed playing his guitar

above our television. Sometimes I imagine him, just a torso, playing a country tune. He looks at us while we make periodic attempts to steal cable.

Our kitchen has a single-burner hot plate, a manic-depressive microwave, and an old fraternity beer fridge. We make a pantry out of a cabinet my mom saved from a neighbor's kitchen renovation in 1979. The sink is a plastic, industrial laundry tub with one spigot and two ceremonial temperature dials. But we also have these: a working shower stall, toilet, and sink. We didn't even have to put them in ourselves. It's such a miracle that we choose not to acknowledge that the bathroom fan just blows shitty air over the hot plate.

It's like playing house in a Samuel Beckett play. One of the *really* depressing ones.

When it rains outside, it rains inside. When it snows outside, it snows inside. On nights of inclement weather, we sleep under a strung-up blue plastic tarp and wipe the stray droplets of precipitation off each other. We don't have closets; instead, we have a bank of yellow school gym lockers that I dug out of a dumpster in central New Jersey.

We also have a rolling desk chair that we found in a parking lot out near Coney Island. Both Lachlan and I were flabbergasted when we saw it.

"Holy shit, do you see that?"

"Is that an office chair? It's like brand new!"

"Someone must have been screwing around and wheeled it out from that Office Depot over here. Oh, we are so taking it home with us."

"It looks like maybe it was in that swampy place over there."

"We can wash it. We can race it up and down the hallway! This is awesome."

"If we put casters on that IKEA table, we can race that, too!"

"G-d, I love you."

We kiss.

Hillbilly life has been excellent preparation for starving-artist life. Mamaw was right to save everything, because when you have nothing, having something is better than having nothing. And though Lachlan and I sometimes growl about how crap our microwave is, or about how our artwork gets soaked in the puddles of rain under the bed, we never really complain. Our poverty is romantic. We have both always had multiple day jobs, have both worked our way through grad school, and both have loans. We feed ourselves and pay

our own bills. But underneath, I know that I can live my dream because, at the end of the day, if I get in serious financial trouble, I can move back home. My parents don't have money to offer, but I can rely on their love and support and stability and the fact that they will give all of that freely. That fact alone probably accounts for any chance I ever had at being an artist.

Other spaces in the building start to fill up. Soon there is a dollar-store warehouse on one side (Ladybird likes chasing their flotilla of mice at night, especially when they nest in my sock bin and chew through my favorite pink leg warmers).

On the other side, some trustafarian art school dropouts build a half-pipe out of plywood, double down on club drugs, and practice kickflips day and night. On the floor above us is an insomniac welder; below, a company with a massive pneumatic drill. The sewage pipes from the upper floor bathrooms run over our bed, and more than once, we are awakened with a light spray of brown fluid on our faces.

We take the first jobs we can get. Lachlan spends an unpaid week "auditioning" to become a graveyard-shift bagel maker, then ends up stocking art books at the Strand even though he flunks their fabled literary exam. It's his charming stories of his childhood in Scotland that win over the interviewer. Ladybird and I scavenge discarded books and housewares from Park Slope stoops the night before trash pickup, then sell our finds outside the Bedford L-train stop.

A friend from Atlanta gets me a job at the Williamsburg vintage clothing store Beacon's Closet. I sort through dead-men's suits and soiled hipster heroin pants looking for sartorial gold. We are famous for our snotty attitude toward the used clothes our customers bring us. They retaliate by leaving cups of pee in our dressing rooms.

Amanda, my Yale roomate, puts me in touch with a boutique education company in Connecticut. Weekdays around 2:00 p.m., Ladybird and I blast the Subaru down the demonic Brooklyn-Queens Expressway to Greenwich in order to tutor kids and coach them through college application processes. Now I work in bona fide mansions, and I sleep in a bona fide industrial warehouse.

Wealthy parents pay me to drive to boarding schools all over New England and tutor their kids. I spend more than one luxurious weekend at the Andover

Inn ordering room service and taking long showers. I sleep the sleep of someone not troubled by the scuttering of mice and psychedelically induced skateboard kickflips. Every so often, there is a tentative knock at my door, and I rhapsodize about sentence-completion questions and dangling modifiers for an hour. Later, a personal check and an embossed, monogramed notecard will show up in my illegal mailbox in Bushwick.

One afternoon, staring out into his backyard Greenwich sculpture garden, an eleventh grader with a terrible vocabulary cuts to the chase:

"You went to Yale and you're just a tutor? Isn't that like, sad, for you?"

Sometimes it is.

But sometimes, I am learning that what you do for money and who you are in your mind might not be the same thing. And the parents of eleventh graders with rotten vocabularies will pay you decent money to teach their kids a few fancy words.

CHAPTER 31

B ut the tutoring does make my art take a hit. I rarely have time to create because I work seven days a week, and what's more, I don't know how to get into group shows or meet other art people. And when I do have time, I have no ideas. My one idea is to wrap myself up in skeins of yarn until I can't move.

I call it *body weaving*.

I try to "conceptually attach" myself to places, physical or psychological, in the art world where I am not welcome. I want to be like a wart or a cocoon or a bug. So I perform out in public, guerilla style—just show up unannounced and do my thing. I quietly sit down near the place or person I want to be part of or associated with, and I tie the beginning of the skein of yarn on my ankle. I slowly and silently wrap my entire body in the yarn as I twist and writhe on the ground. I try to move outward in every direction, send my energy into every corner of the space. Sometimes a crowd gathers and watches. Sometimes they try to talk to me. Sometimes they ask me if I am having a nervous breakdown. I usually go through two skeins before I can't move anymore. I stay there, immobile, as long as I can handle it. Then I cut myself out of my cocoon with a tiny pair of scissors I keep in my palm.

I've tried to attach myself to the Armory Show, the biggest art fair in New York, one of the biggest in the world. There, I sat in the middle of the open space, where all of the human traffic converged, and started weaving myself. People pretty much tripped over me.

I've tried to attach myself to Art Basel in Miami, but I was chased out by security. Instead, I attached myself to the handrails at the back entrance of the convention center. I got kicked out of some other Miami fairs as well and ended up weaving myself alone on the beach.

I leave the small piles of cut-up yarn behind when I am done: evidence of my attempts to find a way in.

CHAPTER 32

After evenings spent hopping from mansion to mansion, coming home to our jerry-rigged loft is depressing. At 11:00 p.m., when Lachlan gets back from the Strand and Ladybird and I get back from white-knuckling it on the BQE, we make a box and a half of Kraft Mac & Cheese and douse it with dollar-store hot sauce.

My college roommates are getting married, buying co-op apartments and candy-colored KitchenAid mixers. I am a bridesmaid in *Groundhog Day*, endlessly straightening veils; they talk about fertility monitors and charitable deductions. I am almost clueless enough to think that a Roth IRA is a Zionist Irish terrorist organization.

They have expense accounts, travel in business class, and collect big bonuses. When I get depressed, and man can I get depressed, I can't help but think, while they were climbing the corporate ladder and dazzling in the ivory tower, where was I?

I was hot gluing things to other things.

But my moods oscillate wildly, and hoping to dazzle them with the kooky coolness of my current life, I invite them over to the loft for part of our annual reunion.

They all agree that they are too scared to take the subway to my sketchy neighborhood, so they arrive by black car. After much foraging at the demoralized grocery store across the rail yard, I provision us with the best appetizers that can be prepared with a hot plate. I also obtain the most artisanal of the Kraft cheeses and the finest dented can of olives in the store.

Ladybird looks on mournfully as I do what I can to gussy up our lives. I wipe up a lingering puddle of rainwater under the bed and plug every mouse-hole with steel wool and spray foam. G-d help me if one runs across the floor.

When we all get together, it takes an hour or so for us to get past formal pleasantries, to let the walls built by time away from one another get knocked down. But they always fall, and soon we are gossiping and laughing just like late nights at Yale years ago.

As they are leaving, I overhear one say, "Should we be worried about her? I think we should." Another says, "She's sort of falling out of step with normal life, isn't she?" Another, "Is it even legal to live in a place like this? Can we somehow figure out how to give her money? Maybe like a gift card?"

And when I overhear this, I want to give up.

A year in, it turns out that our lease is completely illegal. When the housing department locks out everyone in the building for fire-code violations, the landlord flees the country. Someone pays someone off, and we are let back inside, but it's becoming hard to justify living in a former pesticide storage facility.

The next year, awash in a constant stream of friends' engagements and weddings, I broach the topic of commitment to Lachlan. He says he thought that our arrangement was working out fine. According to him, we are "artistic roommates," and we stay together because it is a "good financial arrangement."

This does not go over well with me. Lachlan moves out. To an apartment with nonartistic roommates, but with doors and windows and a legal occupancy. But we stay together. Sort of. Maybe.

A year later: "Anya, I got a residency and I'm going and not coming back to New York. It's not my place; I want to be near my family. I haven't been able to really breathe since I have been here."

What we had, our goofy, carefree, and freewheeling ways, had been crushed by the reality of trying to keep living here. Maybe if we had stayed in Atlanta, where living was easier, where we had friends, where it cost less, and where we could easily keep showing artwork, we could have carried on. It was an experiment that failed.

Without Lachlan, it is hard to remind myself that the whole reason I am flinging myself back and forth into Connecticut—the trip alone takes two

and a half hours a day—is because I am trying to be an artist. On particularly demoralizing days at work, coming home and seeing Lachlan at his desk drawing with his headphones on or marking a new piece on the wall, had reminded me that I had a calling. He reminded me of Atlanta, the brief time when I knew what I was trying to do.

So when he leaves, I don't cry, I just stare at the water-stained walls. I walk Ladybird around the neighborhood, kick used condoms and needles out of her way, and try to figure the fastest way out of Brooklyn.

But then my phone rings.

It's my mom.

Mamaw has cancer.

CHAPTER 33

The tumor is on the side of her tongue, right between her salty and sour spot. Mamaw said she noticed it as it grew but refused to get it looked at. Soon it was interfering with her swallowing; soon she started coughing up blood.

Dr. James down at Mountain Health Clinic, the same man who removed the tumor from her eyebrow a few years before, did some tests and determined that it was late-stage lung cancer, terminal. She had maybe six weeks left.

I thought of the day Mamaw and I went to the cigarette outlet to buy Allyson a carton of Marlboro Lights, a peculiar gift to give to a grandchild. Mamaw said something is going to get everyone in the end, might as well enjoy it. Now, we were at the end, but the birds still chirped. Nothing was that different, except that Mamaw was going to die before the leaves turned. My Mamaw, the only person I knew who would kill for me.

I don't know what I thought Mamaw might do if she ever got a terminal diagnosis, but it wouldn't have surprised me if she shot herself with the gun she still kept under her pillow. How many times did she say dead was dead was dead? Her brother had died by suicide, and her double nephew. But she agreed to try chemo.

"It won't cure it, Vesty. But you may be able to add a few months on," Dr. James said.

Maybe she wanted more time to say goodbye, maybe she wanted us to fuss over her, or maybe she just wanted to enjoy her trailer a little more. It took her nearly twenty years to decide to move, and by the time she did, she was almost

dead. G-d was a bastard. Mamaw would flay me for saying that, but I'd lived long enough to know it was true.

My mom and I drove down together, not knowing what we would find. Up the holler was Mamaw with boxes upon boxes of pills, a walker, a wig. She was still smoking, said those sticks were still her best friends. Mamaw wanted me to photograph her, even as she lost her hair, even as—like that coal she had hauled almost her entire life, like the cigarettes she clung to— she turned to ash.

She let me photograph her in the hospital. One night, after a nurse gave her Ambien to help her sleep, she woke in a trance. She climbed out of bed. I thought she was going to the toilet, but she kept walking, crossed the hallway, and stood on the threshold of another patient's room.

Then, apropos of nothing, she roared, "I'll shoot the shit out of you!"

Even on the edge of death, she was still trying to protect herself.

I said goodbye to her on a damp August morning. She had been moved home and was lying in her old oak bed, shivering under a mound of hand-stitched quilts. I kissed her and told her I loved her. Then I backed out of the room slowly. She held my gaze as I went to close the door.

As she disappeared from my view, I lifted my camera, snapped twice, and left.

I've always been grateful that it was the eye of the camera and not my actual eye that took that last fraction of a second from her. It let me linger with the possibility that in that last fraction of a second, she was cured. She would once again spend afternoons peeling cucumbers for me on the back porch. To this day, I have never looked at those pictures. I hid them from myself, but I know exactly where they are.

My mom stayed in the holler till the end of the summer and into the beginning of her school year. She stayed until her principal called and told her that she had to return to her classroom or commit to an unpaid leave of absence. By then, the hospice nurse said Mamaw was in a coma and would likely never wake. She was reassured that Mamaw wouldn't be alone when she died, that kinfolk and visitors were constantly coming through the trailer, sitting up with her through the night, stroking her long fingers and hands.

But my mom had to make a choice.

She came back north.

I think that even in her comatose state, Mamaw knew my mom had left again, had ultimately chosen Connecticut over Kentucky.

Later, Kaylee told us that Mamaw came out of her coma, raised her hands in the air, and exclaimed, "I see my Jesus." There was a freak thunderstorm that same night. A hemlock tree fell on the trailer, smashing through the kitchen ceiling. Had Mamaw been sitting there, she would have likely been split in two.

* * *

Allyson comes back from the front of the line in the funeral chapel. She has been up to see the open casket and reports back that it wasn't that bad; just imagine Mamaw is sleeping.

"But she never slept."

"I know," Allyson says. "It's so weird. Actually, she looks kind of rubbery in there."

I remember driving Mamaw to Lexington for an outing to Cracker Barrel. The smoke of her Salem wafted out the cracked window. She always appreciated that I let her smoke in the car. I detest the smell of smoke, but Mamaw's smoke, that was different.

She giggled at the people lined up.

"Why looky there, Anya! Lord have Mercy. Can you believe all them there lined up to have some sorry hillbilly supper. Fat ones, too."

Inside, she ordered chicken and dumplings. When they came, she said the ones she made were so much better, then she ate every bit. The waitress brought us fried apples.

Mamaw looked up at the old-timey metal country things the restaurant hangs on the walls. She pointed up to a metal tub and washboard hanging from the ceiling.

"I used to use me one of those. But now I have me a real washing machine. The best they make."

She cracked an enormous smile.

* * *

My uncle continued to feed Sasha, Mamaw's beloved mutt. He came up and spent a little time with her each day, fed her some of her favorite bologna and saltwater taffy. She refused to leave Mamaw's doorstep, steadfast in her watch, waiting for her to come home.

Two months after we put Mamaw up on the hill, someone shot Sasha in the head.

PART III

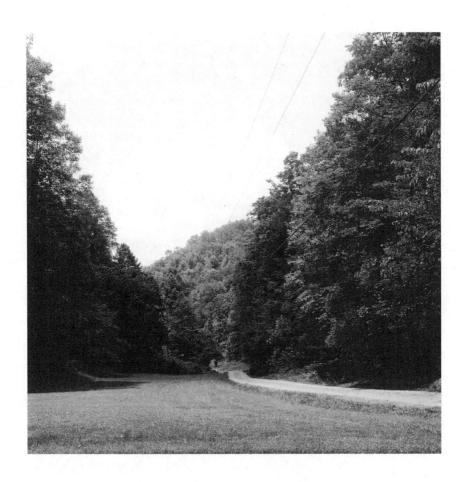

CHAPTER 34

I n the photo, his hair is still intact, still hanging long in front of his face, skimming his eyebrows. He looks slightly more filled out, but other than that, he is exactly as I remember him.

I scrutinize his profile, snoop around for pictures of a wife, a husband, a girlfriend, a boyfriend, a toddler. Nothing. Instead, he is behind a desk at a famous company, drinking a café crème at La Rotonde, napping in a hammock in Belize.

In college, I could tell there was something wild living underneath his blue-blooded facade—something untamed, a little tragic. I wonder if it's still there. I hit the Add Friend button. A few days later: "What are you up to these days? In New York? Coffee sometime? —P."

I'm not exactly in New York, but I'm not far. After I got dumped by Lachlan and Mamaw died, I ran away to Asia and worked for a company that took wealthy high school kids on deluxe service trips around the continent. I led students to India, Thailand, Laos, Vietnam, Burma, and Cambodia, then came back to the company's headquarters outside Cleveland to start their gap-year division. Finally, I had a proper job, one with PowerPoints and health insurance. Traveling constantly was fantastic for a while, and working for the company meant that my expenses were few, but I started to long for home and making art. I'd gone to the other side of the world to try to shake my art demon, but it was now undeniable: I wanted to be an artist. Now, I'm living in Westport again, tutoring again, and trying to show my work in New York again.

I ride the F train to Cobble Hill, the fancy part of Brooklyn—nowhere near where I lived several years ago with Lachlan. It's an early January night, frigid. I emerge from the subway, scanning the street for the French café where he has suggested we meet. I see Philby from a distance, warming his palms with his breath, doing a tiny shuffle to keep his circulation flowing.

We walk inside Robin de Bois—it smells of garlic and cassis; Serge Gainsbourg is melting through the speakers. Philby removes my best secondhand winter coat, gently brushing off the flurries. I am wearing my new favorite skirt, a short red corduroy flare, with a Peruvian rainbow pompom belt, purple turtleneck, and purple wool tights. On my feet are green suede Peter Pan boots with leather ties that wrap around my ankles.

We sit across from each other on the red banquette and, almost right away, break out in giggles.

"You always cracked me up."

"So, how have you been these ten years?"

We giggle again, the waiter pausing until we collect ourselves. Without looking at the menu, Philby orders.

"*Je prendrai le steak frites avec la sauce en accompagnement. À point.*"

Only in New York could you pretend to live in Paris.

"*Je prendrai aussi l'escargot et du cognac, peut-être le Remi Martin?* Anya, you'll have some?"

Public school French is not helping here, so I take a guess at what he is talking about.

"Cognac? Um, do you have beer?"

"Why don't you get a Chimay? It's always invigorating, even in the winter. But you'll have some escargot with me, right?"

"Why not?"

Though I had eaten monkey-hand soup in Thailand, swallowed live shrimp in Malaysia, and accidentally eaten stray-dog stew in Laos, I was unprepared for escargot. It didn't seem like something people under the age of sixty ate anymore, like beef stroganoff and chop suey.

Philby is now a high-profile professional. He is what Mamaw would have called a bigwig. He has inside information on the most important things and

some of the most important people in the world. He's comfortable asking them questions and challenging their answers. I am a bit in awe. Philby sips his Remy Martin. I sip my Chimay. He leans across the table, his tie grazing the baguette basket. Only ten minutes after we begin catching up, he asks, "Anya, are you down?"

"Down for what?"

Then softer, so only I can hear, "I mean, are you depressed?"

Philby is a high-powered microscope, peering into my cells, watching them squirm. It's uncanny.

"Me, um, yeah. I guess I'm down. I haven't really become who I thought I'd become. I'd grown up expecting to be a real career woman, and now I'm basically a starving artist. As great as that can be, as much as I love it, I can't help but think I failed in some way. I wanted to make art in order to make things mean something, but like, things already mean something, or they don't, you know?"

He places his hand on mine. His eyelashes flutter.

"You?"

"Oh yeah," he said, "I'm down. Very down."

I wait for him to explain, but he just stares into the breadbasket.

Despite the fact that we've both unmasked our unhappiness, we gossip and giggle for three hours, then, drunk on Chimay, cognac, and snails, we walk the two blocks to his apartment. The facades of all the brownstones on his street are immaculate. They face the street proudly, secure in their easy superiority. A place in this neighborhood means he really has it together.

He opens his front gate, and we step inside his studio apartment.

It looks like the Weather Underground had exploded one of their counterculture bombs, and reams of newspapers and empty take-out containers had flown in every direction. For some reason, all the furniture is piled in the middle of the room. Magazines and books threaten avalanche from almost every corner.

It takes me a moment to catch my breath. I don't know what I expected Philby Whitman's apartment would be like, but it wasn't this. What is really going on with him? He looks so put together, but maybe he is falling apart?

I am fascinated.

Philby clears the *New York Times* off a broken Eames lounger so I can sit. He opens his fridge, and a sticky Brita, a copy of the *Nation*, and half a jar of olives look mournfully back at me.

"How long have you lived here?"

"About six years. I love it. I can get everything delivered: laundry, dry cleaning, weed. I know it's messy, sorry. I wasn't really expecting you, but now that you're here, I'm happier than I have been in a long time."

He places his water glass on a pile of *New York Review of Books* that doubles as a coffee table. Most of the furniture is constructed of scholarly publications. A tensor lamp perches on a tower of *Paris Reviews*. His alarm clock lives on a batch of the *Atlantic*. Also, it smells like a family of dancing skunks lives here.

"You still smoke?" he asks.

He pulls down a gray box from the top of a bookshelf. Packs a bowl.

"I haven't smoked pot since this Cleveland Indians game two years ago," I say.

"You a fan?"

"I mean, I know nothing about baseball, but I spent the night dancing with two guys dressed up like mustard and ketchup bottles at the concession stand."

"Still a little bit crazy, Liftig? I guess it's just who you are."

He passes me the bong.

"I can't light it myself," I say. "It hurts my thumb."

"Anya, let the men handle it." He takes the blue lighter out of my hand and lights it for me.

I pull hard, then hack like a ninth grader.

"Careful there."

We settle into the mudslide of periodicals. It turns out they are pretty comfortable to sit on.

"Can I read you an article?"

"Sure."

"OK, it's from the last issue of *Dissent*. It's about Deleuze."

He pulls the magazine out from between the cushions of the sofa. I guess he has been sitting on it like a broody hen.

"So, I've been trying to figure out what I think about this. I wonder what you think of the argument." He starts to read.

With these words my love levee breaks, its spill ringing the cobwebbed gong of my heart. Most guys I've been with have been cowed by the fact I went to Yale, that I'm well-read. My education was always a source of tension, and so I've often acted a little stupid to keep the peace. But Philby and I could be equals. We may not come from the same class or cultural backgrounds, but we share an intellectual one.

He continues to read from the magazine. I move closer. He lowers the Deleuze. I brush back his hair, revealing the slightest hint of a retreating hairline. He brushes back my bangs, uncovering the little crease that has recently emerged between my eyebrows.

I kiss him.

Lying in Philby's arms, I am a deformed puzzle piece that has finally, after circumnavigating the globe and summitting Everest, found its home.

We dance naked to "Street Fighting Man." For the first time, I fart in front of a guy who isn't my father.

Philby shows me the scar from his childhood surgeries, says that he suffers from chronic pain, that it can sometimes make him miserable and limit his mobility. I trace where it forms a delicate web over his hip, follow it as it creeps up his back. I hold it in my hand like fresh porcelain slip.

He parts my pubic hair to reveal my hairless incisions from my surgeries. He runs his finger along my scars.

"Angel Baby," he says.

His eyes are still Gatsby green.

CHAPTER 35

I don't know the people who invited me to perform, but I said yes anyway. The space is a much safer, much more sanitary version of where I lived with Lachlan.

Philby hasn't really seen me perform before, and I invited him tonight. He even helped me test my new video camera out and is going to sit by it and make sure no one knocks it over.

I haven't told him what this piece is about, but I know he is smart enough to understand that, in some way, it might be related to him.

I'm dressed in a pink cotton tunic from the clearance rack at American Apparel in Williamsburg, and I'm wearing bubble-gum-pink tights. Slung on my front is a monster-sized fabric breast I ordered from a company that specializes in naughty Halloween outfits. (They also offer gynecologist costumes— white lab coats embroidered with names like Dr. Seymour Bush and Dr. Howie Felthersnatch.) To make it look fuller, I stuffed my boob with piles of the *New York Times* arts section from Philby's apartment and plastic grocery bags from the back of my car that I'd meant to recycle.

My music starts, old jewelry-box style. I rise to demi-pointe and spin slowly, my arms in a wilted *Swan Lake* pose, a stupid smile on my face. From out in the audience, three balaclava-clad assailants emerge. On the top of their heads are single boobs, the nipples popping out of the center of their skulls. These three assailants lay twenty Styrofoam boxes of grade A eggs on the floor. I bought them from the Fairway in Red Hook a few hours ago. They open each box slowly. The jewelry-box ballerina music fades. One boob-headed assailant

hands me a pair of eye goggles. He pulls out an oversized silver cheerleading megaphone from under a table and positions himself next to me, megaphone at the ready.

One boob-head picks up an egg, warms it in his hands, then throws it hard, aiming for my abdomen. The audience giggles uncomfortably. The boob-headed assailant with the megaphone shouts, "One!" Another egg is lobbed, he shouts, "Two!" Another, "Three!" Then another, "Four!" Then another, "Five!" Eggs start being hurled faster and faster, each making landfall somewhere on my body. Soon my fabric boob outfit is dripping with egg yolk; the audience is completely dripping with egg yolk; the photographer is swabbing down his lens and cursing. I can see Philby trying to protect my camera with his sleeves. The shouting from behind the megaphone is relentless, "Fifty-six! Fifty-seven! Fifty-eight!"

Into the one hundreds, I feel welting; by one hundred fifty, I'm almost numb; by two hundred, I'm on the verge of begging them to stop or running out the door. But I'm the one who orchestrated all this, who bought the eggs, who made the megaphone, who sprayed it silver, stitched plastic boobs onto the assailants' heads and insisted they pelt me as hard as they can. No really, as hard as you can. To back out now, to back down from the challenge—yes, may be an idiotic and masochistic challenge I set up for myself—would be humiliating.

I have to last through this.

"Two hundred and forty-three!"

The two-hundred-and-forty-third egg is the last.

Two hundred and forty-three is the number of eggs that my body has shed since I first got my period at age thirteen.

Two hundred and forty-three chances to fulfill my biological imperative.

Two hundred and forty-three shots and no slam dunk, no big stuffed animal at the carnival.

As the shouting and smashing stops, I remove the egg-soaked boob from my chest.

Then I contemplate the mess I've made.

CHAPTER 36

"I'm in love with you, and I think you should move in with me. I went to Tony's Hardware to get a copy of my keys made for you."

Philby places the freshly cut metal pieces in my palm; they feel like spontaneous applause.

"I've never lived with anyone," he says, then goes back to eating his eggs Benedict. We are at another French café, Café Luluc on Smith Street.

This seems a little quick to me. After living with Lachlan for two years in the scary mouse loft, I am a bit hesitant to jump into living with someone again. But I realize that I have slowly been making my way into his apartment already. Over the past three months, I've started to clean and arrange in surreptitious bursts. When Philby leaves, I swipe the toilet bowl, swab down the kitchen sink. When he goes to work before me, I recycle his empty bottles of French Volvic water and scrub the bathtub. The pantry is no longer only home to the salt he uses to clean his bong; it now has low-carb snacks and whole-wheat couscous. New bath towels appear, paper towel holders, antibacterial sponges. I light fancy scented candles to cover up the weed smell that permeates everything. With me around, his life is getting brighter, cleaner, healthier. I am making myself integral to his everyday operations.

In most of my past relationships, I've been less concerned about whether I love someone than whether that someone loves me. It's like I'm a pit, a gaping hole, waiting to be filled in with love gravel. It's like that piece I made back in grad school when I photographed everything I owned. Maybe it looked like I

was documenting the width and breadth of my collections, my accumulated stuff, but as years passed, I realized that I only saw what I was missing.

I've felt like that with men, too. Somehow, since Yale, I've become reliant on them providing me with everything about myself. Alone, I just feel the void. In fact, Philby and I share an overwhelming sense of relief that we reconnected in the nick of time before the heavy mantles of *lifelong bachelor* and *old maid* were officially draped around our shoulders.

Looking out at Smith Street, Philby's certainty makes me certain.

I actually hug myself with happiness on the train ride in to see him; I hug myself because I have to act out my joy or I am pretty sure I will explode.

I also recognize parallels between Philby and me and my parents' relationship. My father lifted my mom out of her holler. Philby might lift me out of mine. His world has no hollers.

* * *

So I move in, and we merge books.

"Should we keep your *Riverside Shakespeare* or mine?" he asks.

"Keep yours. Yours has notes from Manley's lectures and Bloom's."

"What about Joseph Mitchell?"

"I mean, what's the harm in keeping all of them? I have the first-edition hardcover of *Up in the Old Hotel*, so we have to keep that, and maybe the paperbacks are just our reading copies?

"Good idea, we can have reading copies. You're much harder on books than I am. I use bookmarks; you like to crack the bindings. So put the Mitchell first with my Caro firsts."

"What about Didion? I love that essay about the Royal Hawaiian Hotel. You know, where she doesn't know if she is about to get divorced or just going on a family vacation?"

"Haven't read that one yet. Should I?"

"I think you should," I say.

Philby pauses. He looks at me as if he is about to say something important. Something he has been thinking about for a while.

He can't quite get it out. Another minute goes by before he can say it.

"There's one thing I wanted to say about you moving in. I don't want to move out of here for a while. I love this place. It's really become part of me."

I get it. Mamaw didn't want to leave her shack up the holler. Over the years it had just become part of her. She could no longer see it as a physical object; it was a best friend who stood by her. She had to fully grieve it before she could move on.

Philby says someday he will think about moving "if."

I mentally fill in the ifs: if we get married; if we gut renovate a brownstone with repurposed wood from an upstate schoolhouse; if we have a wildly gifted kid whom we name Banjo or Bowie, Baudrillard or Baez; if we grow old and blind together reading books and watching apples ripen; if I keep making myself indispensable vacuuming, installing, baking, scrubbing.

"But I think I am really ready to change things around in here," he says. "We can get rid of all of these papers, this broken stuff. We should get some new furniture, places for you to put your stuff, new linens, just start over. It will be great. I'm cool to get rid of everything except these." He pulls down a gray box from the very top of a bookcase, puts it on the counter.

"And everything in here." He opens a cabinet that is too high up for me to reach. It is jammed with bottles of prescription drugs. Some are organized in shoeboxes; some are just tossed in the cabinet. I don't know if he was hiding them from me or if it was just that he was so tall that he could reach things I couldn't.

"I need to find space for these, where I can reach them. Basically, everything else can get trashed."

It's no secret that I am nearsighted when it comes to spotting red flags, but even I can see this STOP sign. I pause to think. For Philby to show this to me after all this time means that it's important, that he's sharing something essential about himself that I need to understand. I've always known that he was in pain, but it's possible I never previously understood how much. I think about Mamaw, the way the pills for her cancer overflowed her brand-new kitchen island, and my own college shower caddy at the bottom of my childhood dresser back in Westport, filled with bottles of expired, unhelpful attempts to remedy my bipolar depression. When you have a chronic condition, doctors

try a lot of different combinations of things, different doses. It seems that for Philby, there have been a lot of failed prescriptions. There are so many bottles. His pain must be extraordinary. I take a breath, and I know that this is a STOP sign I can roll through. Keep the car moving, Anya. Give me another chocolate milkshake. I can suck this up, too.

After all, this is Philby Whitman we are talking about.

I've known him like forever.

My friends have known him like forever.

We are going to make a home.

Ladybird included.

Together.

CHAPTER 37

A s I start to get more gigs and become more integrated into an emerging performance-art community in East Williamsburg, I invite Philby to come to more of my shows. I'm pretty sure he had no idea where the L train went beyond Bedford Avenue before we got together. When I start taking him into jerry-rigged lofts out in places he has only heard about in police reports, I can tell he feels like he is discovering a secret world.

"People live in here?" he asks me before one performance. "It looks like an auto mechanic garage."

"It was, up until about a year ago. That's why it's a great space. I'm sure it's a little cold in the winter. You have to get some space heaters that won't set on fire and an industrial heater, and they make an awful noise, but you can splash and spill anything you want on the floor, take a hose, and wash it off. The things this floor has seen! Like literally every bodily fluid imaginable."

He recoils a bit. He knew I lived in a place like this, but I don't think he had any idea what a place like this actually looked like.

"Is that—this—legal?"

"Nope, you just have to enjoy it while the gig lasts. Everyone gets shut down eventually. Either the city gets you, you run out of money, or the scene just breaks up, people move away."

"But wait, they really have to wash their dishes in the bathroom? And they only have that scary hotplate that looks like it's from the sidewalk? This is how they live?"

"Oh, it's definitely from the sidewalk. The sofa you are sitting on, also definitely from the sidewalk. *La vie bohème*. I know a lot about it."

My French is getting better.

I appreciate that Philby never says, "You know what would make a really great performance?" He never invades my mental space when I am making work, but he's always a great sounding board and gamely pitches in when I want to test out a prop or a pose. He even lets me take his special Belizean walking stick to a gig at the Tate Modern. And he didn't make a fuss when he saw that I'd stuck it up inside a raw chicken carcass that I dyed blue and carried through the Turbine Hall.

I've started photography again because of Philby. I had thought I was just taking cute pictures of him until one day I realized I was making a body of work about him. Just catching him at little moments that I loved, like the way he turns up the stereo and dances around every night when he brushes his teeth, or the way he smears too much sunblock on his face and doesn't know about it, or the way he looks super serious reading the Book Review over chocolate-chip-and-bacon pancakes on Sunday mornings. I'm not sure if he has caught on that he is starting to be a muse, but I print all the photos and keep them in a box on the bookshelf. When he is in the office till late, I organize them into piles.

I am certain we are the golden ratio.

* * *

Like a bowerbird, I start to build our nest. I bring my thrift store collection of French enamelware and purchase a pair of mesh string bags to go "marketing," because that is what we are going to call it. I hem delicate Burmese fabric into curtains by hand, then use Allyson's old pull-up bar to fashion a curtain rod that will separate the sleeping area from the rest of the studio apartment. Unable to find the right size curtain rings, I employ holler handcrafting and hack it with some binder clips.

"Hey, do you think you could make me a pillow?" Philby asks.

"Sure, what kind?"

"One that's longer than this. More of a rectangle for putting behind my head when I read; not a sleeping pillow."

"Yup. I can whip that up."

I repurpose some vintage Vera silk scarves and sew and stuff his new pillow the way my mom taught me. I mend his Paul Stuart shirts, rewire a dormant television monitor, install an air conditioning unit. At Goodwill, I find a rug that ties the whole room together. And while I am completing my upgrades, I cook Mamaw's hot beans.

Almost everything I do involves a heavy dollop of hillbilly engineering. My philosophy about repairs is the one I learned from Mamaw and my mom. You do it yourself, you fix it yourself. And if you can't fix it, you live without it.

You make do.

Philby is not a make do kind of guy. He does not fix broken things. He gets rid of them.

"My Angel Baby. Do you know how much I love you? Do you?"

I smile and wipe my forehead as I mix the grout in the bathroom.

* * *

On Fridays after he's done with work, Philby buys me raspberry-red dahlias. On our way to the movies one night, he notices my winter coat is inadequate for the cold, hails a cab, and takes me to REI on Houston Street. He asks the clerk for their warmest winter jacket.

"I will always surround you with warmth, with love. I never want you to do without. You will not pay me back." He plunks down his credit card.

Philby often just opens his wallet and pays. We go out to dinner every Friday and Saturday night, and Philby always pays in cash, opening his calf-leather billfold and leaving a generous tip. When I offer to pay, to even just split the bill, he laughs and says, "Put it away, Anya. Let the men handle it."

Never once in our relationship do we have a straightforward conversation about money. He comes from a family where money is not talked about because it is déclassé. I come from a family where there really isn't any money to talk about. All that is acknowledged is that he has it and I don't.

At home, Philby pays most of the bills, though I desperately try to earn my keep in sweat equity. I'm pulling in OK money tutoring, but it's freelance and unpredictable and I have to drive to Connecticut and back four days a week. I have student loans and health and car insurance and car payments and a whole host of bills that just seem to pig pile. But I've never had anyone pay for me before, and the only way to describe it is that being supported financially makes me feel really weird. I guess it might be a dream for some people, but it twists my brain into a state of constant submission. I get a huge lump in my throat and want to burst into tears every time it happens. I feel like I'm worthless. I feel like I have to apologize for just being around, just breathing. So I start neurotically apologizing for things that aren't my fault.

I am terrified of being a burden.

I know how Mamaw felt.

I don't tell Philby that though I am knee-deep in the radical chic of Brownstone Brooklyn, my head is all the way up a holler in East Kentucky; my self-worth is the battered steel washboard Mamaw used all her years.

Some of my thrifty hillbilly habits are hard to mask. When Philby throws a soda can in the trash, I wait till he isn't looking, and I retrieve it. When I have a trunkful, I use the refund at the grocery store. I shop out in Connecticut near where I tutor because the prices are cheaper, and I canvas for deals with coupons. I am the queen of promo codes and BOGO deals. My mom and I have an ongoing competition to see who can save more on gas and detergent. Philby does not understand the joy of having bragging rights over the best deals. My wallet is filled with loyalty cards and frequent-customer club memberships and not much else. It drives him crazy that I don't carry cash.

"What if you are stranded somewhere? What if you are mugged? Are you going to give them your CVS ExtraBucks card?"

CHAPTER 38

I am wearing an adult diaper.

Today is going to be a seven-hour staring contest.

I step into the atrium of the Museum of Modern of Art. This is not some piss poor pop-up gallery in a defunct dog grooming salon. This is the MOMA. And for the duration of her midcareer retrospective, performance artist legend Marina Abramović will sit in silence in the atrium. Viewers will have the opportunity to sit with her, a wooden table between them.

The rules about sitting with her are that you cannot speak, you cannot fall asleep, you must stay in a sitting position, you must consent to having your image photographed on film and video, and you cannot do anything deemed by the security staff to be egregiously disruptive or dangerous to the artist.

Marina Abramović is a mortal god to me, to almost all the performance artists I know. I want to pay tribute to her but also call her into question—this ascetic, avowed performance artist who is now selling tote bags with her face emblazoned on them.

I take a breath, straighten the heavy, shapeless blue dress I rented from a costume shop, and adjust my long, fake black braid. It's just past ten thirty in the morning.

I sit down in the wooden chair in front of Marina. I suspect they deliberately made this chair extra uncomfortable so that people would be encouraged to leave.

I am not leaving.

Marina's eyes are focused on her lap.

She lifts her face.

There I am, dressed exactly like her, a fake mini-me, hopping onto her for a ride on the famous artist wheel.

And I am staying until the museum doors close.

Even if I have to pee on myself.

When my visual pun settles in, the security guards move into high alert. They tightly ring the atrium perimeter and take sniper-like positions on the upper floors. The audience of people lined up to sit today are mad as hell. Apparently, they don't appreciate live guerilla public intervention art.

I just keep looking at Marina with my nanny-goat stare.

And is it my imagination? Maybe there is a slight smile on her lips. A tip of the hat to my audacity?

Today, I infiltrate; I am the parasite.

CHAPTER 39

"But it's just a piece of paper. Really, that is all it is. Like this—literally just paper."

Philby picks up a part of a draft of one of my student's admission essays for Cornell. He waves it around, smacks the paper, flaps it around so it wafts in the air.

"But it's not. You know that. It's much more than that."

He mutters to himself, then continues talking.

"Some good it did my parents. That piece of paper made them miserable."

"Well, we won't be like your parents."

He puts down the paper, picks up his lighter, and spins it mindlessly.

"How do you know?"

"Because we are different people."

"You do realize that some people might call this emotional blackmail?"

"And other people might call it a fear of commitment."

It's been a year and a half and Philby thinks that we can be in a committed partnership without the piece of paper, just act like we are married. I want to build a home and a family with Philby. I want the paper. I really want the paper. Everyone else has the paper. If I don't have the paper, it means Philby doesn't truly love me. Or he doesn't love me as much as my friends' husbands love them.

I grew up with the impression that all men need a kick in the pants to get married. I think of all the movies where Hugh Grant realizes he can't live

without a rom-com heroine and fumbles a proposal at the exact moment she is about to give up. My mom says that my father was terrified of getting married. That he briefly broke up with her and went backpacking in Ireland to sort out his feelings, to see if he really missed her. I was raised on a full diet of *The Muppet Show*. How many times did I watch Miss Piggy chase Kermit— watch his comic reluctance to commit, her shattering karate chops and tireless attempts to tie him down. How many books did I read as an English major where the plot was the heroine's quest to reform the rake by bringing him to the final glory and goodness of marriage.

I think being married means you complete someone, means that you are complete. I have never been complete, but I want to be. I want someone who loves me for my irrational fears and whims, who believes in love writ large, and I think that Philby is that person.

When Philby asks what I want for my thirty-fourth birthday I say:

"I want to get married."

"This again?"

"It's really important to me."

"You know what," Philby says, "let's get married."

"Really?"

I'm not sure what changed Philby's mind, and it seems risky to ask. Maybe it was the blowout fight when I'd screeched that he better shit or get off the pot. Now, the matter is settled. No scattered rose petals. No bended knee. His acquiescence is his proposal, and I think it's more romantic that way.

A few weeks later, I am getting ready to make stir-fry when Philby asks, "Am I supposed to get you an engagement ring? My mom says that it will be embarrassing if I don't get you one, because her friends will want to know about the ring. They will want to see pictures. She says you should get a yellow pear-shaped one like she had."

"You talked to her about it?"

"She wants to know every detail. She wants to know how I proposed."

"What did you say?"

"I told her it was very postmodern."

"That's an interesting way to describe it."

"What should I do then?"

I'm not sure why Philby is hesitant to get me a ring. I feel like it's sort of par for the course to get an engagement ring with marriage, especially marriage in the world that he operates in. But I also don't think I can say I want one and not feel weird about it. Philby bought me that super-warm coat on his own volition, but now he seems to be, I don't know, looking for a way out of getting me an engagement ring. Am I overreacting? I'm probably overreacting. But I don't want him to ever say, "And I spent all that money on that stupid ring you made me buy." It would shatter me.

Then there is this: I don't want to ask for a ring because asking would somehow make it less special. I already asked to get married, and frankly— and I have to keep this in a very inside voice—it is making getting married a little less special. Besides, Mamaw didn't have a diamond. Na didn't have a diamond. My mom didn't have a diamond.

But when I close my eyes, I see an oval cut with an east-west setting—east for East Kentucky and west for Westport, the two compass points of my life.

I want an engagement ring. I really want an engagement ring. Everyone else has an engagement ring. If I don't have an engagement ring, it means Philby doesn't truly love me. Or he doesn't love me as much as my friends' husbands love them.

I keep chopping onions.

I want him to read my mind. I want him to know me so well, to be so deeply connected to the grime and gunk in my soul that he knows I could never actually say the words "I want a diamond ring," and then he just goes and gets me one anyway.

Because I am my own worst enemy, I say, "French women don't wear them."

* * *

Before the wedding, we go to Brooklyn Borough Hall and apply for a marriage license. Philby takes my hand and lightly squeezes it. We exchange a glance. His mouth curls into the wry smile I love so much; the one that says, *It's you and me against the world, kid.* We are briefly questioned about our parents, their places of birth, their marital statuses, and our places of birth.

The interviewer turns to me.

"Where was your mother born?"

"Well, I don't know the legal place. It's more like a spot, a creek really."

"Was it a hospital?

"No, it was at home."

"Could you point it out on a map?"

"Do you have a topographic map? That's the best way. Or maybe you can put Lost Creek, Kentucky. That's the nearest post office."

Philby looks slightly green around the gills. He knows about the holler. He has seen my photographs and heard a few stories from my mom about climbing in the hills. And, of course, my father has tried to show him charts of my esteemed bloodlines. "Anne Hutchinson! Brilliant woman; not a witch!"

"My mom's birth certificate was signed with an X by a midwife, Granny Isabel, actually she was kin. It's kind of hard to read because she wasn't good at making her letters, she couldn't sign her name. But it probably says Lost Creek."

Philby looks a little greener around the gills.

I suppose I haven't widely advertised this part of my history to Philby. Though he knows the very broad outlines, I haven't told him about the blue people or the shack or much about any of it, though he perked up when he heard Granny used to grow her own weed and smoke it out of her homemade corncob pipes.

One night we were high, about to watch another movie from the Criterion Collection:

"You ever think about going on a road trip?"

"Anya, you know I don't drive."

"Well, I would drive. We could go anywhere. I've always wanted to go to Memphis. Maybe I could get a gig there, or in Nashville, and we could drive down."

"How long a trip is that?"

"Oh well, it's mostly a straight shot on I-81. I guess about fourteen hours. Hey! We could stop for a few days in Ganderbill. I could show you the homeplace and the creek, and we could meet some of my cousins. I haven't been to my Mamaw's grave in a few years actually."

"Hmmm."

"They'll let you smoke as much pot as you want. You can pick it yourself."

"Angel Baby, I don't go to flyover states."

As far as planning a wedding, I come from a long line of elopements—my parents were married on a rooftop by a justice of the peace in New Britain, Connecticut, with three drunk friends as witnesses; Na and Pop ran away to Elkton, Maryland, in a "borrowed" Packard; and Mamaw and Ed were married by a snake-charming Kentucky preacher near an abandoned well up Ganderbill. In my family, love and marriage are private affairs. It is your business to whom and how you want to be married, as long as you know no one is going to give you anything more than a midgrade microwave oven.

Allyson bucked the trend. She'd always been more self-conscious than I was about growing up in Westport without having all of the things. For her, having a traditional blowout wedding with matching bridesmaids and engraved invitations was tied to her need for my parents to compensate for being schoolteachers. Also, as the youngest, Allyson was offering my parents a chance to make up for their poor choice of birth order. They footed the bill then, though now it is clear that they cannot afford, either financially or mentally, to go through it again.

Philby's family will expect pastel Jordan almonds in organza pouches and a bone china pattern, preferably one that matches his mother's. They will expect a bridal shower with games like Guess the Dress and Pass the Bouquet. They will want control over the guest list, the seating chart, the place settings.

I think that getting married at the Office of the City Clerk in New York City is romantic, like being in a black-and-white 1940s noir thriller; it's the kind of thing you would do before embarking on a mission into the heart of the Amazon jungle together. I have no attachment to the ritual itself. My parents offer to have a daytime party later in the year at a restaurant, and we say fine. Both of us are relieved.

Philby announces to his family that he is getting married, declares that it will be at the city clerk's office, and that none of them are invited. Since Philby isn't inviting his family, I don't invite mine.

Philby's mom is not pleased, not pleased at all.

I imagine what her objections might be. She thinks it is not proper. This is not how she raised her son. But perhaps it is just as well, she might think. The bride's family is supposed to pay for the wedding, and while there are many things that she doesn't know about the bride, she is certain of one thing: Anya's family has what seems, to her gracious eyes, to be meager resources. And isn't part of her family dirt poor? The kind of people you raise money for at charity balls? Didn't Anya go to Yale on scholarship? Maybe she wouldn't want to be associated with any kind of wedding my Jewbilly family might put on. Maybe it's just as well to keep it quiet.

A week before, I buy my dress. My mother made hers with salvaged calico and a borrowed McCall's pattern. In the few blurry pictures, she looks like the Sun-Maid raisins girl. Mamaw stitched hers together from feedbags she'd collected throughout planting season, and Na wore her best suit with a day-old lily tucked behind her ear. For my part, I do the only thing a New York bibliophile can and ask myself, *What would Joan Didion do?* My pin-thin oracle whispers, *Bloomingdales.*

As I walk through the doors on Lexington Avenue alone—it never occurred to me to ask anyone to go with me—I talk to myself: *Self, I am giving you permission to pay full sticker price. You may not pick from the sale rack. You will not buy something in the wrong size just because it is cheaper. This is for your wedding. You will do this once. You have the rest of your life to dig through the clearance bin. Also, you will try everything on with a properly fitting bra and high heels. Both. No exceptions. And buy yourself some real hosiery. You should not get married in Walgreens's saddest control tops.*

I choose a silk jewel-toned polka-dot shift that matches the borrowed blue fascinator my college roommate Laura sent me from London. I buy a size larger to accommodate my hillbilly bosom, paying full price and even springing for tailoring, which I had no idea could actually make a difference in the way something looked. I charge it to my new American Express card, one that I very proudly took out and gave to Philby as the second holder. I emerge onto Lexington with a fistful of Medium Brown Bags. Riding high on the hog, I hail a cab home.

Twenty-four hours before the wedding, we take the subway into Manhattan. It is a cold November day, and we walk briskly, our feet falling in sync.

Philby holds my gloved hand in his. Our hair blows in the chilly wind. The world is our inside joke. In the Bergdorf's men shop, Philby purchases a silk tie the exact color of my eyes.

"Now we need to go to Tiffany's to get the ring," Philby says.

The way he puts this, it's a little vague. Is it *the* ring?

We sashay through the revolving door, trailing a bit of clove-scented air. On the second floor we sip from long-stemmed Tiffany champagne flutes that we hold on powder-blue Tiffany napkins, which I quietly pocket for my scrapbook. I look out on the floor. I am blotto in the presence of so many diamonds—so many shapes and sizes, all flickering in the November dusk.

The staff gathers around. They congratulate us, smiling in their immaculate suits.

"When is the wedding?"

"Tomorrow."

They exchange quick glances. One subtly nods at my bare ring finger.

A woman leads us over toward the diamond-ring displays. She knows what I want. She will probably be responsible for wiping my drool when I turn around. I am peeing-in-my-pants-hoping that Philby will ask to see an oval cut with an east-west setting.

But he is quiet, enjoying his glass of champagne.

I can't help but feel sorry for myself when I say, "Just a simple gold wedding band."

He will interrupt me, right?

This is his moment.

Even if it's a yellow pear-shaped diamond, I'm ready.

I can get behind the yellow pear-shaped if I have to.

The woman raises her eyebrow again. She waits for Philby to say something. He doesn't. She brings out a small tray with a few classic, thin gold bands.

"What do you think?" I ask Philby.

"Oh, looks good."

He is fiddling with his phone.

So I pick Tiffany's second-least-expensive ring, just because it isn't the cheapest.

When she asks Philby what he would like to see, he replies that he won't be wearing a ring.

My father didn't wear a wedding ring for years because my parents couldn't afford one when they eloped. We can afford it. Philby just said he didn't want to wear one. He said he didn't want something on his hand. It might feel strange.

Hearing it aloud now hurts.

We are sort of failing Tiffany's.

I don't want to fight. I'm not going to fight. I am going to smile and chew the inside of my cheeks. I'm going to drink my milkshake of pain. I should be able to say, "I want you to buy me a lovely diamond wedding ring, and I want you to wear a lovely gold band." But my mouth will literally not allow me to form the words. All I can do is hope that he reads my mind like he did back on that night in the French café.

That night, I lie on my back and listen to the last of the leaves of the season falling outside the window. I hear the slight whoosh as they land, their life cycle complete. At 6:00 a.m., birds chirp. I imagine them trimming my dress like in *Cinderella*. I watch Philby sleep for a while. He smells like burnt sugar and bergamot.

CHAPTER 40

By 7:00 a.m. I'm outside the flower shop. I buy a ten-dollar bouquet of white daisies. Down in the subway, I crouch against a graffitied wall and pull out my bag of salvaged ribbons, scrounged from birthday and Christmas presents. I tie a red one and a purple one around the stems.

At New York's most famous punk-rock salon, a lovely woman, Eunai, teases my fragile brown hair and makes sure the strands cover the bald patches where I have pulled and scratched—a habit I still can't give up—and uses a few mesh bumpits to make up the difference in volume. She glues on eyelashes and cakes concealer where my forehead furrows. I pull my purple hose up high over my hips and slip on the colorful silk sheath. Eunai zips me up and bobby pins my fascinator. "To a lifetime of happiness," she says as she closes the door behind me.

I always imagined I would be like Mary Tyler Moore's TV best friend, Rhoda, hopping a ride on the subway to my wedding, but my amethyst Steve Madden pumps are too uncomfortable to make the trek over to the Delancey stop. Instead, I hail a cab to get farther downtown. Philby is waiting on the corner wearing the tie the color of my eyes. He touches my shellacked hair.

"Wow, that is a lot of hair spray."

"It sure is."

"I love you, Angel Baby."

At the city clerk's office, our friends gather around us. Philby's bachelor buddies Chadwick, Sam, and Charles, liberated from their office jobs on this random Monday afternoon, heartily pat each other on the back. "We never

thought we'd see the day," they say. I have three people with me—my college roommates Amanda and Dawn, and Tom, one of my oldest friends, who I met at a model UN conference when I was sixteen.

We take a number from a ticket machine and wait in the crowded lobby. Just like at the DMV, we are called to a kiosk to sign papers. We pay sixty dollars to have a ceremony conducted in an official chamber and thirty-five dollars to process the certificate, bringing the total cost of our nuptials to ninety-five. Dawn signs as witness. Our officiant is a diminutive woman from Queens with an old-school New York accent. She sounds like Jimmy Breslin with a cold. She has the standard vows in a plastic binder.

"And who is this?" She points to Zena Melina, my Cabbage Patch Doll. Amanda is holding her for me.

"That's Zena," I say. "She's been with me almost every day since I was six. Gone to college and grad school and around the world, too."

"Like a blankie?" she says.

"I guess, if you want to put it that way."

"And you need a blankie to get married?"

All eyes turn toward me.

"I guess I do."

"I haven't seen one of those since the early '80s, when I got one for my son, *who was eight years old*. Never seen one at a wedding before."

I laugh even though she is making fun of me.

I breathe deeply, look into Philby's eyes, and repeat the vows. Sam hands him the blue Tiffany box, and he places their second-cheapest gold ring on my finger. The officiant asks me to place my ring on Philby's finger.

"I don't have one."

"You don't have one?"

"No, we just have this one."

"But it's an *exchange* of rings. He gives you one, and you give him one."

I don't know what to say. Do I say that Philby doesn't want to wear one? Should I say it might make his finger feel funny?

"Never mind, we don't have time for this." She shakes her head. "By the power vested in me by the state of New York and the city of Manhattan, I now pronounce you husband and wife."

We take pictures together in front of the city hall mural in the lobby. Philby's smile is as wide as the mouth of Ganderbill Holler. He fist pumps in the direction of his friends.

"I did it!" he says. "I actually did it."

After a celebratory bottle of champagne at a deserted Mexican restaurant, Philby and I take a cab uptown to Jean-Georges for a late lunch. Sitting in the back of the cab, I pull Pop's Rolleiflex camera out of my bag—it was my "something old"—and adjust the light meter. We kiss and laugh as I take pictures of us, the camera's exposures bumping up and down with New York City potholes. The documentation of this moment is up to chance, but I guess everything is. I shoot a whole roll and hope that some will come out, be more than blurs and flares. As the cab pulls up to the restaurant in Columbus Circle, I promise myself not to develop it until our twenty-fifth anniversary.

It will be a gift to us from our past selves.

Later that night, back in Brooklyn, we call everyone we know in the city and ask them to come over and celebrate. Yes, on a Monday night. Yes, right now. Philby puts in a call to his mother. She is upset she wasn't even invited to the ceremony; she's upset she didn't get a picture of a diamond ring to share with her friends; she's upset that someone posted a picture of us to Facebook and that she wasn't in it. "What will I tell my friends?" she asks Philby.

"Tell them your son got married and you weren't invited." He hangs up the phone.

Soon fifteen people cram into our apartment.

We drink and smoke ourselves silly. I've put on my second dress of the day, a royal-blue and black velour shift from Marimekko, and I promptly spill champagne and ash right on the front. Amanda flips through our DVDs and puts my favorite Peter Sellers movie, *I Love You, Alice B. Toklas,* on the TV. The bottle of Rebel Yell is cracked open; the bottle of Basil Hayden is cracked open.

I pound champagne, watch Philby giggle uncontrollably with his friends, and ponder what it means that even though I now have a special piece of paper, I feel just a little bit emptier than I did before.

As we crawl into bed, Philby says that one night, shortly after college graduation, when he was wandering in the Village, he went to a psychic. "The psychic looked at my palm and said that I already knew the woman I was going to marry, and her name starts with an *A*.

"Now, I know that was you."

CHAPTER 41

I 've just finished shaving my legs with Cheez Whiz.
At the next spot in the gallery I open ten economy-sized containers of Kraft Parmesan cheese and begin to shake them over my head like I'm shaking down a snowstorm. The cheese blizzards through my bangs and sprinkles onto the floor. I shake and shake until my arm is tired and I have no more cheese in the container.

It been a quiet performance, just me and the cheese and the photographer and the curator. A lot of people said they would come, but no one showed up. I had hoped that Philby would have made it out of the office by now, but earlier in the day he said work was "blowing up" and he didn't know when he might get out.

I'm out of sorts because I really wanted him to be here, so I slow my movements down to a crawl, just go into complete Japanese Noh-theater mode, stall for time by rolling around in the mound of Parmesan I've accumulated.

I am grinding my cheek into a mixture of Cheez Whiz and mozzarella when I hear the click of dress shoes on the wooden floor. I can tell by the slight smoker's wheeze that it's Philby, dashing in from the train, collar sweaty from a day of infinite deadlines.

He is just in time.

I move to the final spot.

I unwrap a brick of Philadelphia cream cheese, named for the city of Philby's birth, and peel the thin silver foil from the edges. As a kid, I

sometimes broke into the refrigerator and ate these creamy bricks like ice-cream sandwiches.

But tonight, I carefully shape the cream cheese into a heart.

I lay it on my chest and look at Philby.

I let the warmth of the hot lights and my body soften it just enough so that I can smear it all over my body.

I'm shocked how easily it melts. It starts to disintegrate as I spread it on my lips.

CHAPTER 42

"Now, Janey, which blue cheese do you want? They have Stilton, Roquefort, and Valdeón."

"Mama, I want the Maytag. I want the Maytag."

"Janey, I told you, Maytag is not real blue cheese. It's from *Iowa* for one thing, and they sell it in Costco. We don't buy from evil corporations like that. I will not have you grow up to be one of those beastly children who does not acknowledge their privilege and supports hideous capitalist monstrosities. Now what about this nice Bleu d'Auvergne?"

I'm standing behind poor five-year-old Janey and her very well-dressed mom at a gourmet grocery store on Court Street. I'd make fun of them except that I'm there to buy two packages of French-butter madeleines myself. Philby and I eat them when we watch old movies, though he likes them more than I do.

It's been three years since I moved in with Philby and lately, Cobble Hill is getting on my nerves. This part of Brooklyn really thinks it's the most important place in the world, which is part of the reason Philby still doesn't want to move even a few blocks away. It seems like every week the *Times* drools a Style piece about someone in the neighborhood gut renovating an old blood-caked slaughterhouse and turning it into a sustainable, LEED-certified, cultish-vegan-chef side-project restaurant, with free yoga and college-educated chickens running around. In Cobble Hill, we have six-dollar cups of licorice-noted pour-over coffee, ice cream made from the milk of cows rocked to sleep with Albanian folk songs, letter-pressed note cards embossed with

fresh boysenberry ink, pimento loaf imported from the most ass-backward county in Alabama. Everything here is sourced, curated, and sustainable, each moment a precious opportunity to be more authentic, to live our best lives. Here, we are encased in a bubble of beautiful people perambulating with basketfuls of beautiful children who know the taste of capers before they know the taste of failure.

Rather than donate their unwanted books to the library, here people place them on their stoops, a sort of high-brow swap meet. There are entire libraries of Italian children's books, crates of queer theory, bushels of Booker Prize winners. It's a backhanded advertisement for your superior taste and intellect. You don't see anyone leaving their *Uncle John's Bathroom Reader* out on the stoop.

There are book pickers who swoop in right before trash day to round up these books and sell them back to the same people who recently tossed them, only this time they will buy them from quirky used bookstores with limited-edition tote bags. I know about these book picker people because when I first got to New York from Atlanta, I was one of them. In those days, if Ladybird and I sat in Williamsburg ostentatiously reading a book by someone like William Burroughs, which all the hipster guys wanted to read but were just "waiting for the right time, man," we could usually get someone to chat us up pretty quickly. And if they chatted us up, they bought our books.

Like Mamaw said, "If a feller ain't got, a feller's got to do."

But sometimes I forget to hide my pickerisms from Philby. "Oh wow! Look at those tiny Blundstone boots—they must be for a four-year-old or something. They are almost perfect!" Philby and I are walking to have dinner in Carroll Gardens on a Friday night. It's one of our favorite things, just walking, pointing out the small day-to-day changes in the neighborhood. On the sidewalk ahead of us is a box filled with barely worn designer toddler clothes and shoes. A neatly handwritten sign says: "Free—Never Refuse to Reuse! Save the Planet!"

"Just keep moving, Anya. Look away. I believe in you. You can do it."

He's laughing because he knows I always slow down when I see a sign that says "free."

"But they are so cute. Do you know how much they cost? They are so expensive. And if you polished this bit here . . ."

215

"Who cares how much they cost? They're in the trash. If we don't go now, Frankies will be packed, and they'll run out of the cavatelli and sausage."

Philby tries to lead me down the cobblestones of Tompkins Place, but I'm still halfway turned around, looking back at the box.

"That is *not* trash; that's basically Bloomingdales right there."

"Anya, you know how I feel about the cavatelli. C'mon, Frankies is waiting. Think of the olive oil! You love the olive oil!"

"OK."

"Honestly, Anya, what if someone saw you going through the trash?"

"Trash is a relative term. And it's a giveaway box, by the way. Not trash."

"It doesn't matter. It's a matter of self-respect and it's unsanitary."

"This from a man who had furniture made of newspaper?"

"Alright, what would you do with them? Just save them till we have kids?"

Thank G-d he hadn't forgotten we are going to have kids.

"Well, I mean, I'd be saving the planet, right?"

"Not if we have kids you won't."

Philby doesn't know that I regularly pick up things I find on the street and sell them on eBay. I stash them in the back of my car, cover them up with a heavy piece of an old theater curtain. He never sees them because he doesn't drive; he says he prefers to be driven, even if he has to pay for it. I don't want to upset him, but I can't fathom basically leaving money sitting out on the street when, with a little spit and shine, you could squirrel a few nuts away for winter.

Two years have passed since we got married and Philby and I are still living in the studio apartment. Mamaw hoarded shampoo bottles and deodorant sticks. I hoard miniatures. Lately, I've been displaying my collection of thimble-sized porcelain houses in the medicine cabinet. I've stationed a few Smurfs on the faucet, not far from where Gumby now contorts around the hand soap. They remind me to be tiny, to not take up too much space.

The city, this neighborhood, is starting to make me anxious. So is driving back and forth to Connecticut on Satan's racetrack, the BQE. Philby and I get along very well considering our only door is attached to the bathroom, but it's hard when Philby works late. My schedule is the exact opposite of his for months at a time. So while he sleeps, I stay up, as silent as I can be, head

dipped below a small tensor lamp, making drawings of women with appliances growing out of their heads.

I bring our living situation up more often than I would like to, but I have learned Philby needs a little prompting.

"Two people aren't meant to live this closely for so long. I mean, I think the fact that we do it so well is a testament to how much we love each other, but really, we should start making a home together, a place we both find and put together, where we can grow up a little. Be like real adults. Well, a little like real adults."

"Alright, Angel Baby, look up some places if it is important to you, and we can go look."

We go to open houses and comment on cabinet space and overhead lighting. We knock on walls and nod approvingly at closets. But then Philby always balks. He says he will never give up his apartment, that I will have to get someone to take him out of there in a body bag. He isn't going anywhere. It's his home. It's his place. I'm pushing him to do what he doesn't want to do. He doesn't want to move. I am always so pushy. I won't stop. He's hearing me in his head all day complaining and whining about the apartment and it's affecting his work. He's slipping up and it's all because I am making him move, and he has already said he does not want to move, and I keep pushing.

He's right, this is his apartment. It's also his money, and it's also his city. He would be the one financing buying an apartment. The cards are fully in his hands. I could ask for what I want, really what I absolutely need, which is for us to build something together and not for me to always feel like I'm trying to fit into the cracks in his already fully cast concrete life.

I want to feel equal, but I'm afraid to take a stand. I'm afraid he will say that I am not worth that much and toss me out on my ass.

And between fight or flight, my response has always been the same: flee, repeatedly.

"Good evening Ms. Liftig, nice to see you again."

Dawn's doorman recognizes me, and when I come barreling into her building's lobby after 11:00 p.m., he gives me a sympathetic look as he buzzes me up.

"The apartment again?" Dawn says as I blubber in her living room. "I put your pajamas on the bed, and your toothbrush."

I come here a lot, I guess.

I stay for a couple nights in the twin bed in her husband's office, picking at the scabs on my head and crying myself to sleep, and then, as usual, I schedule out-of-town performances or set up artist residency gigs in far-flung corners.

Philby, this time, will miss me.

CHAPTER 43

"Ol' Sonny says he's going to push Mamaw and my father's and James Edward's graves over the hill with a backhoe."

"Wait, what?"

My mother is breathless on the phone.

"He says he's going to kill us. Actually what he said was that he was going to knife our guts out."

"This is insane. He's a maniac—"

"It's a full-blown death threat."

"Say it again: you told him you were going to literally *give* him the land around his house? And he didn't want that? What the—?"

"He says he should get more, that I'm cheating him, that I'm 'Jewing him down.' Which means—"

"I know what it means, Mom. I'm a Jew. But you are *giving* him land."

"He says it's not enough. He says he owns all the way down to the home-place, not just to the Cowburned. You know, the place—"

"Where Old Man Gran burned the tubercular cow—yes, I know."

I can picture my mom, pissed as hell, her jaw square as Ed's was, gritted against the world, hair in a coxcomb, ready to blow.

"You don't have to deed him anything at all! It's not his. He has no claim in the first place. He invaded the holler and built all those crappy outbuildings up where he didn't belong."

"He says I'm going to have to dig him out. I don't know, he might have enough dynamite to blow the whole holler to high heaven. That psycho wants

to shove your dead grandparents and your dead baby uncle off a cliff and then come and kill us, kill you!"

"I still don't get it. So you told him you were going to *give* him land, and he said no and he wants to kill us?"

"Goddamn it, yes, Anya. And that sorry sonofabitch called me a whore. And you a whore. A New York City whore."

I listen to her cry.

"Why did Mimmy leave it like this? Why did she have to make such a mess?"

"I really don't know, Mom."

"That's my home, your home. It was my daddy's home. My poor dead daddy. This wouldn't have happened if he lived."

"I'm sorry—"

"My father would have made sure it was settled, and everyone would have respected him. But he had to go and die."

"I'm sorry, Mom."

I want her to keep talking about Ed, but she doesn't.

"And to fight that sorry sonofabitch, I have to sue him, sue all that side of the family because of the way the court rules are. I have to send the goddamn law after him. I wish they'd kept his ass locked up."

"Shit, Mom. It's so fucked up down there."

"By G-d I don't want to, and Lord knows we can't afford it, but that's the only way. I don't want you and Allyson to have to deal with this."

East Kentucky, the gift that keeps giving.

CHAPTER 44

When Ladybird was twelve, the kennel where she was boarding alongside my parents' dogs called to say she had died in her sleep. I was at a rest stop outside Gary, Indiana, when I took the call. I stepped out of my car and sobbed in front of a gas pump. I sat down under it. Gasoline dripped on my head. I hoped someone would run me over.

Almost from the moment I adopted her, when she was just a year old, I had dreaded this day, when I knew that part of my heart would die. But hours later, after making arrangements to have her dead paw cast in bronze and her ashes placed in the family safe-deposit box to be mixed with mine at a later date, our vet called to say he had some good news and some bad news.

The bad news was that one of our pets had indeed died, but the good news for me was that it wasn't Ladybird, it was my parents' dog Ethel. Their collars had become mixed up after they were groomed and they were misidentified. For the first time in my life, I almost became a believer. I rushed home to be with Ladybird and she ran straight into my arms, her butt shimmy waggling happiness. She handled her near-death experience with aplomb, scarfing down a celebratory plate of baked ziti.

A year later, Ladybird fell in a hole in the backyard in Westport chasing a chipmunk and sprained her right front leg. The vet said she would never walk on her own. It was time.

I moved home to Westport temporarily. Philby tried not to say that he was glad to have the apartment to himself. I administered my own sketchy course of physical therapy. I warmed her leg, carried her down the back-deck

stairs, and helped her learn to hop. After three weeks of training, she became more confident in her hopping, even started to put a little weight on her right front leg. Though I tried to stop her, hopping did not keep her from chasing squirrels.

But a year after that, the day came when she couldn't breathe. I took her for a final ride in the car, to the vet's office. I held her nose to mine as he administered the shot, and I watched the light go out of her eyes.

CHAPTER 45

The room is quiet and warm. By now, people know to expect a few things from my performances. I often sit on a chair behind a desk while I perform. I never speak, and I always stare at the audience for an uncomfortably long time. I usually wear bright-red lipstick.

Tonight, clothed in one of Philby's old undershirts, I pull out my lipstick. Without a mirror, I layer it on thick, smacking and sucking my mouth as I pound my most-intense stare into the faces in the darkness. Even in this art-hardened group, even among people who know my schtick, some still look away.

When I am confident I've started to tilt the energy in the room, I rub my hands together. A table skirt protects what is under the desk from view. But now I reach underneath.

I rise slowly, and from below the lip of the desk emerges a very tall cactus. It looms over my head like, as the horticulturist I bought it from said, a very aristocratic penis.

Placed firmly on the desk, the cactus takes command of the space while I cower a little bit by the rim of the pot it stands in.

I slowly raise my head, bringing my bright-red lips, my mouth and eyes dangerously close to the cactus.

The audience thinks it's funny at first. My face is so small compared to the towering cactus. It stands there in its pot, imperious. They don't believe that I will actually go so far as to put my face on the needles. I can't possibly do something so clearly harmful to myself.

I climb on a chair so my face can reach the very top of the cactus. I look down at the tip, then back at the audience.

Then I fellate the cactus. For twenty minutes, until my lipstick is smeared all over and my face is bloody with scratches. Pleasing it despite the pain.

The next day, tutoring in Greenwich, I lie and say I fell into a briar patch.

CHAPTER 46

There is almost a foot and a half of snow outside. I tiptoe, barefoot, through the back gate. It's midnight and I'm shivering in a T-shirt and panties. I walk to the far back of the backyard and stand still. I am waiting for Philby to find me and carry me the ten feet home. He will find me.

Ten minutes. Fifteen. I can't take it anymore and I slip back through the gate. I fall into our bed. I lay my wet, freezing feet on top of Philby's and say, "I just went out in the snow in my bare feet, and I looked up at the sky and tried to imagine that I could fly away from here, and you didn't even notice I was gone even though I left the door open so you would know where I was."

No answer. He's a deep sleeper these days.

I tiptoe into the bathroom, pull the Benadryl down from the medicine cabinet, then walk over to my dresser. Ladybird's collar is buried in my underwear drawer. I pull it out from under my thermals and the metal tags jingle. I rub her nametag in my hand. She is here with me. And she is telling me to follow her into the light.

I snap her collar around my neck.

I wake Philby.

"I just took ten Benadryl. I think I want to be with Ladybird."

He looks at me. Gets up and calls poison control.

This is just one festivity in a season of similar celebrations.

I'm sliding closer to an edge. I can feel it, but I can't stop it.

I love Philby more than I ever have, but I also feel him drifting away and I don't know how to stop it. It seems like I make him happy about half of the time that I used to, maybe less.

"You're always around," he says during one argument.

I don't think I'm always around. In my mind. I'm always on Hellfire Highway on the way to and from work in Connecticut, or performing in sketchy lofts, or grocery shopping, or going to the dry cleaners and the shoe repair shop. I console myself that if you have no doors, it might seem like the other person is always around. It's just a matter of spatial proportion. But I don't feel that way about Philby. I wish he was around me more. I honestly never get tired of being near him, except when he roars at me like a hellcat.

I still love the hellcat. I just wish I didn't feel ripped to shreds.

Philby says he will pay for the therapist, but I don't think I can have him pay and still feel like I can say what I might need to. I'd just feel too guilty. So I take on more students so I can pay the bill myself. He gives me a name on a piece of paper. I call her.

Another night, unable to sleep again and done with my insomniac exercises—naming every word I can think of starting with the letter S, listing every female author I know, every store in Herald Square—I invent a new way to try to get him to love me again.

I get up and open the utensil drawer and pull out one of the old steak knives. It has a worn wooden handle, evidence of dutiful battles with skirt steaks.

I crawl back into bed. Philby does not move. I scrape my forearms with the blade, first on the left side and then on the right. My arms are white canvases when I put the blade on my skin.

I hang on the threshold of puncture for a while, waiting for him to wake.

CHAPTER 47

Christmas with Philby is my favorite. Over the past few years, I have tried to establish our own traditions, most of them involving the twenty-four-hour broadcast of the yule log fireplace on WPIX, channel 11. I purchase a very tiny Christmas tree, which I drape with tiny garlands and even tinier ornaments. I make sure Philby's boss and physical therapists all get nice holiday presents and custom make Christmas cards, (each with a handwritten, personalized note) to send to all of our friends and family.

We are headed upstate to see his family for a late Christmas celebration. Philby had to work on the day itself. I've carefully picked presents for everyone in his family, starting my search in early July so I can find just the right thing at the right price. Before I wrapped them, I made sure that Philby knew exactly what they were, so they might not be able to tell that he didn't buy them himself.

"WCBS traffic and weather together. Watch out for snow squalls in lower and central Westchester, especially in the 684 corridor. They will become treacherous at times."

I turn the radio down and merge onto 684. Philby is in the passenger seat, which, even set all the way back, always cramps him a bit. My car is one of those tin cans designed to be driven into the ground and tossed in the trash.

"We need to get you a better car. This one is so uncomfortable for me."

I roll the window down a crack. It smells like snow.

"C'mon, this will be fun," I say.

The gray clouds get grayer.

"I just hate having to leave the city. Couldn't we have mailed the presents?"

"It's your family. They love you. They want to see you."

Snow is starting to swirl. It's coming down fast, suddenly covering the road. I put on my blinkers.

"Maybe if you get your license this summer down the shore, we can get a bigger one."

"Watch out, there is a car coming up on the left."

"I see it, Philby. I got it."

"Jesus, I was just warning you. You don't have to be an asshole about it."

"I'm not being an asshole. I just knew the car was there already. You don't need to tell me how to drive."

"What the fuck is your problem lately?"

"I don't have a problem. What the fuck is your problem?"

"Why do you have your blinkers on?"

"I have my blinkers on because . . . If you know so much about driving, why don't you drive?"

I'm mad; hillbilly piss and vinegar rises in my belly. I was about to pull the car over to the side of the road anyway because of the storm, but now I do it with extra righteousness.

The car is still moving when Philby unbuckles, shoves open the door, and starts to jump out. I hit the brakes, praying a truck isn't behind me, and my tin can screeches to a halt.

Philby lunges back into the passenger seat long enough to scream something, then slams the cheap metal door, starts kicking the shit out of the side of the car. He shoves it back and forth as hard as he can, then kicks at the tires. He starts to punch the windows, but then thinks better of it.

Eventually, finally, the car stops rocking.

I look in the rearview mirror.

Philby, in his green windbreaker, is beating it down the side of the highway, heading straight into the blizzard, kicking as he fades into the white.

CHAPTER 48

It's 7:00 a.m. The waiting room is full. The ladies behind the desk nod at me. They call me *ma'am*. They ask for money upfront. I feel their pity. It sticks to me like lint. I am doing what this room is intended for, waiting, alone.

There is a couple here, the man of the slicked-hair, expensive-suit variety. He masks his face with that morning's *Wall Street Journal*. He looks completely clueless, that fortunate fog of manhood. He aimlessly pats his partner's back. I wonder, Is it him or is it her? It's always one person's fault.

Then a mother with a baby boy in a stroller rolls off the elevator; she must be here for her second. I salivate with grief. I almost know the taste of baby cheek, the crunch of baby thigh. It's Pavlovian.

The more experienced women look away. But I am new, so I stare. I want to kidnap him. I will carry him in a papoose. I will stitch his clothes with silver needles. We will nose kiss. I don't know her, but I hate her—the harried brow, the dark circles under her eyes, the stringy hair. The nerve of her to come here, to this Upper East Side fertility clinic where some of us haven't even had just a chance at one, haven't even come close. I just want the doctor not to frown and mutter when he looks at my uterus. I just want my junk to work.

I have kept much of the struggle and the cost of having a child to myself. Our insurance doesn't cover much of it, so I whip out my American Express and close my eyes. I think if I pay for the baby, if I handle it all, everything will get better. I'm going to make it happy and easy, because I really want a family. And though Philby acts like a total dick sometimes, I really want a family with him.

But when my blood test results come back, I mourn.

"Well, my FSH number is shit again," I tell him.

"Which is that one again?"

"Follicle stimulating hormone. It has to be just right and it's off by a mile."

"What does that do again?"

"It measures your ovarian reserve. It's why I have to get blood taken every morning."

"Oh yeah, you have so many bruises. Angel Baby, you bruise so easily."

"I don't know what is going to happen this month."

"OK, well, just tell me what I need to do," he says.

His ambivalence about having children started not long after I put on Ladybird's collar and took too many Benadryl.

"It was a cry for help."

"Anya, let's be straight. It was a suicide attempt."

"I was—I am—grieving."

"OK, sure, but you are also emotionally unstable. You always have been, and it's getting worse."

"You aren't paying enough attention to me. You're always pissed at something you think I've done wrong."

"Anya, you just shove your way through everything and then want more. You are the pushiest person I know. Like the way you are trying to make me move out my apartment, my home."

Sometimes he says: "I already feel sorry for your kid, really, poor thing with you as a mom."

I know why I am taking this shit. I am taking this shit because I don't think I deserve better. Because partly growing up in a shack has made me feel like a shack is all I deserve.

That's my excuse for today.

I attribute these insults to a bad day at work, a missed promotion. I attribute them to almost anything but his actual feelings. He does this because of the trauma he has been through, because of the pain of his injury, the sadness of his childhood.

But then he sometimes looks at the framed picture of my father holding me as a baby and says aloud, "Do you think it would have your eyes?"

I know he will come around once he sees a little heart beating on the screen. He will get a less-stressful job. We will move into an apartment where you can stretch out both of your arms and not hit the wall. He will buy tiny lace-trimmed socks, goof around with a breast pump, test-drive strollers. He'll read *What to Expect When You're Expecting* upside down and I'll turn the book right side up. Like kale and quinoa, he will only hate fatherhood until it's foisted upon him. Then, like kale and quinoa, he will admit how delicious it is.

My rap sheet of bad test results and catastrophically out-of-whack numbers grows longer by the week. A new doctor flips through my file, looks at Philby's test results, and swoons. "Superlative!" she swoons.

At thirty-six, people make it their business to ask questions.

My relatives are invasive: "I always saw you as a mother."

My friends wax poetic about femininity and the biological imperative. "It's the hardest but most fulfilling thing a woman can do. It completely changes your understanding of life, of being."

I don't have the balls to tell off any of them.

Listening to them is like conversing across a barbed-wire fence. None of these people had trouble conceiving, none of them are going deeper and deeper into credit card debt to pay for hormones and infectious waste bins. I'm on the outside, they are on the inside, roaming free range in pastures of mommy-and-me playtime.

I do my best to pretend that a line doesn't divide us, but all it takes to puncture the illusion is hearing an exhausted maternal sigh. I'm trying to get into their exclusive nightclub wearing Birkenstocks and a muumuu.

There's also the sympathy that sometimes almost reaches empathy, which is inevitably followed by a slew of personal anecdotes. These fall into three categories:

The Stress Case: A workaholic friend who finally quit her demanding job and then wham, Zeus's thunderbolt electrocuted her uterus and she got pregnant.

The Exhausted Copulators: Couples who tried everything, then gave up and went to St. Barts, and presto chango—a bun in the oven!

And the Happily-Tossed-in-the-Towelers: Couples who adopted a beautiful little bundle from a pregnant teenager in New Orleans or Newfoundland

or Namibia, and wham bam thank you, ma'am, suddenly find themselves knocked up.

Occasionally one of these infertile compatriots will make it to the other side, an escapee from the impetuousness of her womb. And when I receive a pink or blue or gender-neutral yellow shower invitation, I'll send a box of gifts, overspending to compensate for my envy. I pretend I'll be out of town, but I'll just be lying in bed, face down.

I buy supplements to improve my egg quality, to improve the stickiness of my vaginal fluid, to regulate the surface of my cervix. Vitamins, teas, cleanses, digital ovulation kits, and endless brown bags of Chinese herbs.

And Philby still rides my brainwaves when he wants to. He can still make me spontaneously break into giggles. He still reads to me softly at night, waiting until after I fall asleep to turn out the light.

I'm mixing up my morning dose of stinky, unregulated herbs and he wraps his arms around my hips, kisses my neck.

"What's that for? Is it for the . . . ?"

"Yeah."

"*Le bébé?*"

"*Oui, le bébé.*"

"Our *bébé?*"

We giggle.

My performance work is getting more widely known and written about, and I have more opportunities and invitations to show it. Of course, very few of these gigs are paid, and the best ones—invitations overseas—require plenty of money to pull off, as I have to cover all of the costs myself. Along with greater artistic exposure come the costs of websites, postcards, and hiring real photographers.

Philby knows that a certain amount of my money is going to the effort to build *le bébé,* but I am embarrassed to let him know how much. He doesn't see my credit card bills, so I'm safe.

Eight thousand with a miracle acupuncturist.

Nothing.

"Why tinker with nature, Angel Baby? If it's meant to be it will be."

I have no remarkable reason why I want to be a mother. Actually, that's not true. I do have a remarkable reason, one that I think being a woman with a uterus that weeps blood monthly entitles me to. I want to watch myself grow up. I want to reparent myself. I want to understand why I am the way I am. I imagine my baby will be a baby me. I imagine I will be able to control those things that in my life were uncontrollable.

I've also developed a fear of pregnant people. Every time I round a corner in a store, I am confronted with a bump, or even worse, someone self-satisfyingly stroking it. My heart races, I sweat. I need to pee. And all of Cobble Hill is a nursery. Row after row of freshly scrubbed tots stream past our door every day. Strollers are triple-parked. One man uses the bike lane to push his—I shit you not—wheelbarrow full of children. A motherfucking wheelbarrow! From my basement perch, I shake my fist at all of them, just like an old coot on *Scooby-Doo*.

There is also this: I'm growing hair on the undersides of my breasts. My hair has started to clog the shower drain. My hairdresser whispers the word *Rogaine*. My bikini line has jumped its fence, follicles creeping down my thighs, and my eyebrows are going full Groucho. Though I'm not pregnant, my stomach is starting to protrude. I feel fat rolling up under the back of my bra. I have given up on buttons and zippers.

I'm on the F train at West 4th when a pretty young woman looks at me.

"Would you like my seat?"

I'm a pregnancy imposter.

I step on the scale. Twenty-two pounds in three months, more if I put my entire foot on the platform. My body, which won't perform the most basic female function, is turning into that of a middle-aged bald guy.

I'm growing bigger, taking up more space, at just the moment I need to take up less space in order to survive in our tiny home, to survive the shrinking space I seem to be taking up in Philby's heart.

CHAPTER 49

A crowd has gathered. Some are stepping forward to examine the "flesh" we have strewn about the path. Others have been watching Seraphina, a fellow artist, and me long enough to know that our babies smell like craft-store candy and strawberry jam—nothing like real babies. That doesn't stop them from fretting.

Our public art guerrilla intervention on 14th Street is really confusing the hell out of people.

I take a bite out of my baby's head. My teeth dig right into the soft surface, swiftly cutting through the scalp. Seraphina dives into her baby, gnawing like a woodchuck just over its perfectly shaped ear. She takes out a squeeze bottle of strawberry jam and water that we concocted earlier in my apartment. She squeezes the goopy red fluid onto her baby's gobbled head, watches it puddle in the cracks and spill down the side of the blanket. I take some of the jam, douse my baby, then rock back and forth violently on my heels, chewing at the head with angry abandon.

Someone in the crowd wants to call the cops; two people complain that we are ruining their otherwise lovely walk on the sophisticated, institutionally deemed–artistic new High Line (which we deliberately chose as our venue to subvert the idea of what constitutes art). Another person says that we are street artists, then turns to his out-of-town guests and tells them that they are having a quintessential New York City experience. Real artists! Doing inexplicable art things! For free!

We walk farther down the High Line. Seraphina is pushing a baby jogger and I am pushing a pram. They are luxury-class vehicles we borrowed from Dawn, who recently had her second child, on the Upper East Side. I am wearing the most casual-chic item I have in my closet, a stretched-out secondhand J.Crew jersey dress and heeled, heavy cuffed black booties. Seraphina has done better with her outfit: a pencil skirt, a fitted luxe cotton blouse, and heeled clogs.

We move on, chopping and chewing our way up the High Line on and off for two weekends, never responding to questions, never explaining ourselves, just cradling our beloved hand-molded candy dolls and devouring our latent desire.

CHAPTER 50

To sue Ol' Sonny to get him off my mother's land up the holler, she had to sue all nine of her double first cousins, because they were all heirs to the neighboring property as well. It's complicated. Time and money were required to officially track them down in obscure hollers all over East Kentucky. Some hollers still didn't have proper road identification, and some cousins only had PO Boxes, no physical addresses registered with the postal service. Each had to be formally served with papers, but none had money to hire lawyers, a fact that they relayed to my mother in depressing, grammatically flawed letters that arrived one after another in the mailbox in Westport. Each time my mother opened an envelope, she cried.

This was never what she wanted. She wanted to spend part of her retirement in the holler, picking black-eyed Susans and making pawpaw jam. She wanted to dig in the mud up by the spring on the hill and wait for the hole to fill with drinking water, then lap it up face first.

She wanted to sit still, listen to the creek roll over the silt, and remember her father.

"Why did Mamaw do this? Why couldn't she have just signed a will?"

My dad, Allyson, and I know there would never be a conclusive answer to this, or any answer that didn't involve spite and revenge. So now, when my mother asks it, we treat it as rhetorical.

"I don't want to sue my cousins. I don't. They don't have much to begin with. How many times can I explain to them that because of the way the law works, I have to sue all of them and can't just sue that bastard's ass on his own?"

She considered sending them money just so they could defend themselves against the lawsuit she had to bring against them in order to get Ol' Sonny off the land. We had to explain why that was nuts. As it was, my mom had already spent more money than the land was worth.

What I never said out loud is that Ol' Sonny's irrational determination was matched by hers. It's something in the blood.

It's something in my blood, too.

CHAPTER 51

D r. Livingston looks at me. "So what has brought you here today, Ms. Liftig?"

"Well, I've been trying to get pregnant. I can't seem to do it on my own."

"Of course you can't do it on your own!" he says. "A little fertility clinic humor for you. You see, we are very happy here because we make so many happy babies. Everyone is happy when there are happy babies. Do you take any medications?"

How do I speak and not hear my voice? "I've had a depression and obsessive-compulsive diagnosis for almost fifteen years."

"Do you take antidepressants?"

"Do I take antidepressants?" I repeat in my best borscht-belt bravado.

"Yes, Ms. Liftig. Do you?"

"A few. Lexapro mainly, Ativan if I can't deal. Until last year I took Topamax for migraines but I've weaned off it."

"It's depressing to want a baby and not to be able to have one. I can tell you one thing for sure. Once you get a baby, you will smile all the time. The baby will make you smile, smile, smile, and there will be no more of this depression. It will just go away, poof!"

If this is the opinion of modern science, I haven't heard it, but I am hesitant to challenge anyone in authority, even when I know that the whole weight of the *DSM*-5 is behind me. "Really, I thought my depression was due to my genetics and . . ."

"A baby will make you smile. No more depression. Poof! You will have your own happy little donut. Maybe even two. Double-donut happiness! Abdominal surgeries? Ever had one?"

"Yes. Why?"

"Well, early abdominal surgeries in a female can make scar tissue that can strangle the ovaries, or sometimes the uterus gets dislocated or nicked. Medical imaging at a young age might affect fertility."

I cannot speak.

Dr. X didn't just take my childhood, he might have also taken my motherhood.

Dr. Livingston fires up his ultrasound wand and slides its length into me. I look at the screen and shift uncomfortably. I expect he will find termites.

He swishes the wand side to side. "Oof, that's not good."

"What's not good?" Black-and-white blobs streak the monitor.

"Very simply put, you have lots of follicular cysts. They form when the ovary does not release an egg. They fill up the ovary and make it impossible for a mature egg to be released."

He takes his pen and starts scribbling into his file.

"It's called 'polycystic ovary syndrome,' or 'PCOS.' We see that it often runs in families. Can you tell me, have you gained weight recently? Started seeing random hairs sprouting up?"

"Yes! Lots of hair, growing in the wrong places and falling out of the right places. I've gained a lot of weight in the past few months though I am eating less and less."

"Has anyone in your family had diabetes?"

"My great-grandmother, my great-aunt, some of my cousins—my close cousins, a bunch."

"Well, with these cysts you often have no ovulation, no estrogen. You start to produce testosterone instead. That is why you are growing hair."

I'm kicking and punching the table. I'm smashing the computer into bits, ripping the blood-pressure gauge off the wall.

What in the motherfucking fuck? No one has caught this before? Thirty-five grand in the hole. So much wasted time. Blood. Motherfucking needles

jabbed and my life in the shitter and Philby on the warpath. Fuck. Mother-fucking fuck!

I hurl myself on the floor, flip over the ultrasound machine, and punch a hole in the goddamn door.

Actually, I do none of those things.

I sit in silence.

I'm an idiot for not making a connection with my earlier surgeries.

"Why has it taken doctors so long to get to this—the scar tissue and this PCOS?"

"Hard to diagnose. Most women go through several doctors before they are correctly diagnosed. Let's do another IUI cycle now though, until we know more. The left ovary looks like a six on a scale of ten. That's like a C minus."

The insemination is scheduled for the next morning.

At 5:30 a.m., I wake Philby up, French press his Stumptown coffee, scramble some eggs. He sips the coffee and says, "So what are we doing today? The thing?"

"*Oui, le bébé.*"

"Are you at all worried about inbreeding?"

"What?"

"You know, some of your relatives are like inbred right? Your grandmother had an extra thumb or something? The one who smoked up? Doesn't your mom have a heart defect?"

I cannot breathe.

"I'm just saying, if we are going to all this trouble, maybe we should make sure it's not an issue."

I want to rip his goddamn head off. He has no comprehension of how genetics, quite possibly the easiest thing they teach you in high school biology, work. Also, we've been doing this for years and *now* he brings it up?

Without shouting and kicking the fucking wall, I explain my parents are from completely different gene pools and he and I are also from completely different gene pools.

"Oh, well so it's fine then."

"Hopefully yes. You know I never asked you if there was any inbreeding in your family."

"Anya, you can't be serious," he laughs.

* * *

In the waiting room, Philby holds my hand. He never goes with me, and now here he is, my man next to me in the land of sad women.

I rest my head on his shoulder. He pats my cheek.

I love him again.

"Liftig!" the nurse shouts. We are escorted to the andrology suite. The attendant asks to see our IDs and confirm our birthdates. I sign a statement saying I have requested sperm from Philby. He countersigns it. He asks me to double double-check the labels. I double double-check the labels.

He hands Philby a cup and directs him to a dark cubicle.

Five minutes later he opens the door and rearranges his jacket and tie.

"Good luck, Angel Baby."

He leaves to go to work.

An hour later, an attendant hands me a vial of purple liquid.

"Keep it under your armpit."

"My armpit?"

"Yes, right in there, keeps it warm like a chickadee."

"Why is it purple?"

"Because they take the sperm, sift out all the defective cells, and add a purple-colored booster. Super-duper sperm."

I place the super-duper sperm under my armpit and go down one floor to another waiting room. Every other woman is holding a chickadee.

"Liftig!" the nurse shouts again.

I look up at the clouds on the ceiling.

"We're going to insert the sperm into this small tube and then insert it into your uterus. Then you just lie still for a while."

I slide into the pain.

I see Ladybird, I see Mamaw, I see Ed.

He waves.

It's bubbling and churning down there. Mardi Gras in my uterus—my egg flashing her titties and Philby's sperm tossing necklace after necklace toward her. I imagine fireworks going off, a precision marching band high-fiving the crowd.

I watch the white space waft around the ceiling.

Two weeks later, I take a pregnancy test.

A faint blue line on top of another faint blue line.

And the crowd goes wild.

CHAPTER 52

My parents have already begun celebrating when Dr. Livingston declares it a false positive, a complication of the shot he gave me. Philby and I play the purple vial game many more times. By now he is deeply familiar with the porn catalog in the andrology lab and asks permission to bring in his own material. Permission granted.

CHAPTER 53

The lawsuit my mother filed to get Ol' Sonny to establish the border to her property has blown up. As a last step before trial, the court has suggested mediation. According to my uncle, Ol' Sonny still wants to knife my mother's guts out.

"This is the worst Belgian waffle maker ever. Look at this. It's all lopsided."

"Hurry up, Anya."

"I want a waffle."

"Screw the waffle."

My mom is shooing me out of the breakfast room of the Comfort Inn in Lexington.

"They will be here soon," my mom says.

"Are you nervous?"

"Of course I'm nervous."

An SUV rolls up in front the hotel. Its windows are triple tinted. My mom and I watch as two men in head-to-toe black who we have hired to take us to Breathitt County case the front of the hotel and determine it is safe for us to come out of the building. One is a former Special Ops Marine. They pull into a parking space to review their strategy. They show us their weapons and point out the features of their armored vehicle. They have studied maps of the Breathitt County courthouse, the homeplace, and images of Ol' Sonny we sent them and created a plan to shield us from ambush or snipers. We both have code names.

My uncles, who have been trying to help my mom, have been sending reports of the outbuildings Ol' Sonny has strewn all over my mother's property. He has reportedly dug a garden in Mamaw's yard and let his horses pasture all over my mother's hill, shitting everywhere. He has left his rotting husks of vehicles and vans all over the homeplace.

"A goddamn mess," my mother says.

"Do you think we can go up Ganderbill after the courthouse? We haven't been there in so long," I ask the ex-Marine from the backseat.

"Too dangerous. He might have the property booby-trapped. Based on the images we saw of the property and what we understand are the previous crimes of the potential assailant, it's possible parts of the property have been compromised."

My mother wanted to come here alone because she was afraid my father would try to fight Ol' Sonny and get hurt. I insisted on coming, saying that Ol' Sonny would find it harder and more expensive and inconvenient to have to kill both of us. When I told Philby I was going to Kentucky, he was livid.

"I can't believe you would risk your life for a few worthless acres of land."

"That's not really the point. They aren't worthless to me, and I have to be with my mom. I don't want her to go there alone."

"And what about your father, why doesn't he go?"

"My mom thinks he would go berserk and get hurt. And that he would distract her."

"And you going is a better plan?"

"I'm likely to inherit this problem, which means that you're likely to inherit this problem."

"Don't bring me into this. This is your crazy-ass family. Not mine. My family has its problems, but none of this white-trash shit."

The trip to the courthouse, though nerve-racking and frightening, is basically uneventful. The extra armor seems silly once almost all of my cousins show up, each in a more decrepit state than the next. Ol' Sonny, who I remembered as a wiry man, coiled like a snake, is completely stooped over, limping into the proceedings like a stack of wrinkled paper.

The mediation involves an ordered rehashing of every family slight, every held grudge over the past one hundred years. Luckily, it never devolves into physical violence in the presence of the mediator.

Instead, it becomes a competition for who can give the most pitiful, the most pathetic account of all the misdeeds done unto them by the others.

"When my daddy . . ." my mom begins. As soon as Ed's named is mentioned, almost everyone in the room chokes up, including me. My mother's voice cracks. I hold her hand while she gathers her emotions and makes her case.

The mediation ends with an almost–entire family hug. Except for Ol' Sonny, who reportedly shouts "Fuck you" at the mediator, a retired judge, and storms out.

The judge looks at my mother and me and says, "This will never be settled."

It takes a long time but the case does go to full court. Ol' Sonny represents himself. It's a jury trial and the case is decided in my mother's favor. The judge repeatedly explains to Ol' Sonny where the property line is and the consequences for trespassing. It is agreed that a surveyor will be allowed to survey the property line to make the border clearer to Ol' Sonny.

The surveyor goes back to try to measure the property.

This time Ol' Sonny fires his gun.

The feud is back on.

CHAPTER 54

H e's passed out on the futon and the lights are off. I open the high-up cabinets and pull down each bottle and place them into tote bags, careful not to shake them. I don't look at the labels. I don't want to see what they say. I long ago lost track. I don't care that he says they were legally prescribed. There are too many of them, piles of them, and I watch them come in and out of that cabinet. I think: *They're ruining the life we were going to have together.* If I do it quickly and quietly, he won't notice until I'm on the plane to my gig in Saskatoon. I go into the bathroom, lock the door, and turn on the fan. I pour every pill into the toilet. When the bowl fills, I flush. But Philby can still read my mind sometimes, even while he's sleep.

He starts to kick the door.

I could write the scene that followed, but I won't.

CHAPTER 55

"I want to talk," Philby says.

I'm pouring the granola into its glass jar.

"No, I really have to talk to you. I need space."

The granola spills onto the countertop.

He says that the apartment we share, is really technically his space—or at least it should be, since he pays the rent.

"I get that you do a lot, but sweat equity, it's really not the same as real equity."

An analogy: If our relationship is a flight, the emergency masks have come down. He has to put his mask on before he can help me with my mask. Actually, I gather, what he really needs is to try out his mask for a while and get a good groove of oxygen going before he can figure out if he even wants to help me with my mask or not. Because it's apparent that sometimes he really doesn't even want to help me with my mask. Sometimes what he wants is for me to flail about and for my eyes to roll back in my head, and then for me to beg on my hands and knees for his help.

But what it comes down to is this: I need to find my own space.

"But isn't this also my space?"

Maybe once it was, but now it's not; right now it's not. Maybe later.

Even though I will be finding my "own space," he has some requirements for this space that is to be "my own."

These are his requirements for my space: It should be a sufficient distance away so he won't have to worry about bumping into me on a daily basis. It would be better, I infer, if I'm out of any range in which it might reasonably

be expected that he should help if say, there is a prowler or a flood or anything that an insurance company would call an "Act of G-d." Also, and this is important, it should be someplace that doesn't cost too much money, because I'm going to have to pay for it on my own, and I don't have a trust fund or inheritance at my disposal like he does. Maybe I should move home to my parents' house. That way I could save on food and utilities. Also, if any of his friends ask where I've gone to, it should not be in a place that would embarrass him, like East New York or Mott Haven.

Sometimes he might want to visit my space, especially if it turns out to be in a nice place, like a house by the water or close to a really good restaurant or a cool place to go for the weekend. And maybe sometimes, but only sometimes and only when invited, I can come to his space. I want to remind him it is currently *our* space that we are standing in, that I am putting groceries away in, including in the eyes of the state of New York and the IRS and the Census Bureau and every other official body I can think of. And to everyone I have diligently responded to when the mail comes addressed to the two of us. At this address. Together. But I let him continue. I can come to his space and cook him a meal. Maybe if I am here, I can also refill the dish-soap thingy. Actually, ha ha, he knows how to refill the dish-soap thingy himself. And if I am here, maybe picking up some of my stuff or going to a gig, and he is feeling into it, we can also have sex, but then I should take a shower and leave, like I used to before we lived together in this space that had apparently, really, totally, conclusively, fundamentally, been his space the whole time.

And because I want so badly for him to love me again, I say OK, I guess that is all right, and:

"Can I take the SodaStream?"

CHAPTER 56

I t's quiet when the performance starts in the gallery, which was formerly a Protestant church. About sixty people are out in the audience, their faces far from mine. I stare out at them from behind a desk, my body firmly planted on a wooden chair, but my contacts are gummy and I can't see well. I am looking at a smear. I feel one contact roll up into my eyelid.

I reach under the red tablecloth and, slowly, as I have several times before, reveal a live lobster on a tray.

I place him on the opposite side of my desk. For the next thirty minutes, we communicate telepathically while the audience watches, transfixed.

We improvise a duet of small movements, me following him as he lifts his claw toward the light. We tell each other secrets. I confess my growing cutting habit. He tells me he once ate another lobster; it was self-defense. I tell him mine is self-defense, too.

Then I tell him what I have to do.

I reveal a hot plate from below the table, a double boiler.

I show it to him. He shrugs his claw.

The water boils fast, faster than I think it will.

And then, we say goodbye.

Fifteen minutes pass on stage, in silence.

I check the pot.

Not ready.

I know that the performer of the next piece, a veritable legend of the genre, is waiting behind the curtain for me to finish. He has a baseball bat stuck up

his ass, and because of this, I am sure that he would appreciate if my set didn't run long.

I check the pot again.

Not ready.

I hear rustling behind the curtain. I see the curator shuffling on the edges of the gallery.

I open the pot.

I remove the lobster.

I put him down on the table.

I take out my cracker and crack the claw.

He's still raw.

And now I must eat him.

A still-living creature. My stomach acids, my body, will poison him.

I want to create, but I am built to destroy.

* * *

I can't make real paragraphs for a while, but this is how it goes in my head:

We live in different spaces.

I move out of the city to a grimy little house by the Long Island Sound.

Maybe he'll want to visit me more by the water.

I have to go to the city for a performance.

I am allowed to sleep in his space.

In the middle of the night, I am passed out, alone, relieved to be in our bed again.

That night, when Philby returns, he decides we should have sex.

* * *

Six weeks later, I am getting ready for a show at a museum in the Midwest when it occurs to me that I haven't had my period for a while. I'd stopped fertility treatments when it became clear that Philby and I needed to focus on the issues in our marriage more than on getting pregnant.

When the show is done, I drive my rental car to the nearest Kroger and pee on the stick in the bathroom.

I send him a picture of the test.

"Take another one."

I take another one, an expensive digital one this time.

The screen says: "Pregnant."

"You're faking."

I get back to New York.

My reproductive endocrinologist thinks that the test is a fluke.

Philby says the test is a fluke.

"They said you couldn't get pregnant," he says.

"When did this even happen?" he says.

I look at him for a very long time.

He looks away.

I take a blood test.

* * *

I meet him at the apartment.

The doctor calls Philby to confirm.

"Her blood test is positive. She's pregnant."

He looks at me, "They said this couldn't happen."

Philby frantically searches for the vacuum cleaner.

He doesn't know where it is because he has never used it.

He plugs it into the wall then runs it over the floorboards shouting:

"A baby is coming! A baby is coming. We have to clean. We have to clean!"

"I'll clean."

"No, you can't clean, you have *le bébé* inside you."

* * *

Philby:

1. "What are we going to name him? It should be a family name, like mine. Maybe it should be mine. What do you think of that?"

2. "Are we going to circumcise him? I mean are you going to want a bris?
3. "Should we get him on a list for a private preschool? Do we know anyone? I'll call Chadwick's dad."
4. "I'll start sending checks to Yale and Deerfield, you know, to establish a pattern of giving. How much do I have to send?"
5. "Should we christen him? I think my mom saved my gown somewhere. Maybe it's at the beach house."
6. "I have to get a new job. So many tiny polo shirts to buy."
7. "Maybe I'll pull some strings at Goldman. Should I call Piper?"
8. "You can't eat tuna, right? And cold cuts? Can you have falafel? I'd really like to get some falafel."
9. "The baby will need space. Maybe we can have separate apartments in the same building. So I can have my space still. I mean I still need my space. This doesn't change that."

* * *

Weeks later, after I come back from prenatal swimming class at the Y, he says, "*Le bébé* is starting to show. Look at your stomach. You are getting really big."

He refuses to touch my body.

He says he will hurt the baby.

* * *

He comes with me to an ultrasound.

He sees the heartbeat for the first time.

It flickers like the last light in Ladybird's eyes.

It flickers like the lightning bugs up Ganderbill.

I search his face for the love I know is there.

I'm having trouble locating it.

* * *

"I am having this baby. I am having your baby."

"Can't you see I'm already your baby and you are neglecting me?"

"Are you jealous of your unborn child? That's really crazy."

"The only crazy one here is you, Anya. Thinking you can be a mother. That's what's crazy."

CHAPTER 57

The hoarder from next-door approaches. I know him because he often stands outside my front window and talks to himself as he picks up his dog's shit. "Little Cocoa Puffs," he mutters. Sometimes I pretend to water my cactus and spy on him through the broken blinds. His house is filled with camo—camo thermoses, camo fleece blankets, camo curtains, camo cardboard boxes, camo duct tape, camo trucker caps—interspersed with neon hunter orange.

The hoarder has a toothpick in his mouth. He flicks it up and down aimlessly. He crosses the street. Even though he thinks he is being discreet, I can hear his raspy voice.

"What seems to be the problem here, officer?"

"Just a routine call, sir. Nothing to worry about."

The hoarder stares at me strapped to the gurney in the middle of the street, nods, and flicks his toothpick.

I look like an outer-space garbage heap. I haven't showered in a week, and my hair is slick with grease. It sticks to my neck in clumps. Musk from my armpits, which now smell like pilsner, hot glue, and bleach, wafts through the air. My eyes are full *Clockwork Orange*.

Earlier in the week, I had declared a war on pants and had taken to walking around this Connecticut seaside neighborhood without them. I didn't wear them when I took the trash out or when I went for the mail. I didn't bother to wear them at Dunkin' Donuts either. I just stood there and ordered my light

and sweet and thought about dumping the glazed chocolate Munchkin donut holes down my granny panties.

Now, two young men in uniforms open the doors to the ambulance. The officer holds up the street traffic with a white-gloved hand.

I am wearing my favorite T-shirt, impossibly puckered and soft from repeated washings. It's white with black felt iron-on letters that read, "I am an Enemy of the State." I got it off a homeless hippie in the Haight. I paid for it with two slices of pizza. It makes my boobs look like breasts of mass destruction. I like to wear it at airports and government buildings.

At some point I decided to circle all of my facial flaws with Crayola markers. First, just the freckles, then smile lines and estrogen spots, but then it became more metaphorical and weirder, and I had ended up covering my entire face with triangles. I stared at myself naked in the bathroom mirror and noticed that when I jiggled my ass it looked just like dancing cottage cheese. So I smeared some cottage cheese on my butt to make the figurative concrete. Then I scooped the rest out with my hands and ate it. It was slightly moldy.

Now I'm covered in a Rorschach blot of gloppy strawberry jam and salsa. Maybe there is a little blood in there, too.

"OK, now we are going to put you into the back. Are you ready?" the blond paramedic says.

I slobber yes and chew the inside of my cheek. My blood tastes like pennies.

"Do you want your Play-Doh?" he says without a trace of condescension. I had been kneading a ball of neon-pink Play-Doh when my mom found me. It was my ectoplasm.

Earlier that morning, she'd kicked in the door of the cottage, yelling my name. Though I heard her, I couldn't muster a reply. I was laying in a puddle in the bottom of the closet, slobbering over Zena Melina's hard plastic face, sucking my thumb.

"Here we go." They fold the metal legs of the gurney beneath me. I slide into darkness.

In the distance I see my mom. She is getting directions from the EMTs, nodding too intently. She is holding a pair of pants I should be wearing. She is holding my house keys. She is holding my medications and my eyeglasses, except I thought I was wearing my eyeglasses but I guess I am not. She runs

her hand through her long, white hair and thanks the police officers. They look on sympathetically.

The blond EMT crawls into the back of the ambulance and wraps a blood-pressure cuff around the part of my arm that isn't bleeding. He tosses a lock of hair out of his eyes and pumps. A crackle of transistor static. "Thirty-seven-year-old female, deep abrasions, dehydration, exhaustion, likely 5150 hold."

The non-blond turns to face me. He searches my eyes for a moment. He sighs and says, "Def 5150 hold, nonviolent, compliant, and semiconscious; no restraints." The ambulance backs out of the driveway. I glimpse my mom adjusting the rearview mirror of her Subaru.

"Can I see the marks on your chest?"

I shake my head no.

"Clear for Yale New Haven ER, transport in progress."

I form the Play-Doh into the shape of a ball, then smush it with both hands.

"We are taking you to Yale, is that OK?" The blond asks gently. "Will you go there?"

"I've already been," I answer, gripping my Play-Doh tighter.

"I'm sure you have, hon."

Yale. Would I go there? Of course I would go there. All those French tutors, all those lab reports, all that Hawthorne. I've already been there. I've been all through it. To the top of every cupola and through the length of every steam tunnel. I've snuck out on unprotected ledges and spent a day running, performing in a human-sized hamster wheel I helped build. I've played a murderous Little Bo-Peep, a Grecian dictator, a stump of an old woman who lived in a trash can. I've puked in every courtyard, been dumped in every coffee shop. I've lived seven hundred lives there.

"Can I see your chest?"

I have sawed between my breasts of mass destruction with a paring knife.

"Did you have an accident?" he asks.

We turn onto York Street, and though I'm lying down, I immediately know where I am. I can see the top of the Air Rights Garage casting its brutalist shadow on the blacktop. Children's hospital. Tests. Ultrasounds and CT scans. Playing alone with dirty toys at the end of corridors. Drawing my feelings with crayons. Needles. Slippers. Creamed chicken and crackers. Zena Melina with

her hospital ID bracelet. Wheelchairs and weights. Tapioca pudding. Vanilla pudding. Chocolate pudding. Plastic spoons.

They open the back doors and wheel me into the hospital. The doors open automatically. My mom has beaten us to the ER.

The woman behind the desk is unfazed by my appearance. She sheathes her hands in latex, lifts herself off her stool, and comes around the desk.

"Insurance card?"

"Huh?"

She asks me again, "Do you have medical insurance?"

"Huh?"

My mom steps in.

"She has insurance, ma'am. I'll find the number for you. But she is fully insured."

"All right, but if she isn't, she will be responsible for the cost."

"Huh?"

She proffers a plastic bag and orders me to place all my valuables in it, wallet, phone, whatever I have on my body. I look at her helplessly. I have no pants to put any of those things in. I shrug. I'm barely dressed.

"Your necklace."

"What?"

"You need to take off your necklace. Now." I am baffled. She doesn't even notice my "I am an Enemy of the State" T-shirt or my breasts of mass destruction. The blond EMT reaches under my teeming rat's nest and unclips the gold clasp on my necklace with the tiny charm. He hands it to her. She examines it before she slides it in the Ziploc bag.

"Crayfish, cute."

"It's not a crayfish. It's a lobster."

"OK, whatever. *Lobster* then. Your rings."

My humble circle of gold, my wedding ring, is still clinging on. With one swift movement, she slides it off my finger.

She examines my other hand. "This one, too." She points to my Yale class ring.

"It won't come off." My finger has grown over it.

"The hospital is not responsible if it's stolen."

I don't get to talk to my mom. They wheel me away too fast. I do not want to be in a hospital alone. I do not want to be here. I want my mom. I watch her figure recede as I am wheeled down a long corridor to the Crisis Intervention Unit. She waves. The unit is overflowing, and the patients are spilling out in every direction. The halls are lined with men, all handcuffed to their beds, some thrashing and shouting. One licks his lips as I pass.

Two security guards, both holding automatic weapons, protect the door to the unit. They open the doors. They tell me not to be afraid. I know that this means I should be afraid.

I am about to matriculate at another Yale institution: Yale Psychiatric Hospital.

CHAPTER 58

My bed has restraints attached to a few loopholes for handcuffs, but they are never used on me. And though I enter the hospital a filthy, stinking mess, I am not allowed to shower or bathe until I have completed an observation period. When I finally sleep my way back to some shallow version of sanity, I am given a pink plastic wash bucket, a pre-pasted toothbrush, a small bottle of all-purpose cleanser, and some paper underwear.

A nurse supervises me while I wash myself as best as I can. She is there to make sure that I don't try to smash the plastic mirror or twist the emergency fall cord around my neck. I pee in the shower while she watches, then wash my hair with the hand sanitizer and dry myself with the tiny towel. I try to pluck some of the hot glue out of my armpit hair.

The next day my mom picks Philby up at the New Haven train station and brings him during visiting hours. I wake up and he is there, holding my hand and crying softly.

"Hi," he says.

"Hi."

"You OK?"

"I'm not sure. Maybe? I'm just tired."

"My poor Angel Baby."

"My poor baby," I repeat.

I want to scream, you should have been there. You should have been there for the four-and-a-half-month ultrasound. You should have fucking been there when the doctor looked at the screen and said the baby had a

protrusion on her head, on her brain, a thick anencephaly bursting out, prognosis extremely dire in utero, death during or shortly after delivery due to cardiorespiratory arrest. Yes. Yes. Yes. You should have been there, you fucker. You should have stayed close. You should have been there when the doctor suggested an abortion, what she called "termination," even that late into the pregnancy, because her defect was "incompatible with life." You could have shouted with glee. Done a celebratory dance with the nurses. Popped an imaginary bottle of champagne.

You weren't there when I asked them if they would give me the last ultrasound picture for my scrapbook. You weren't there when I asked them if I was dreaming. Twice. You weren't there when they refused to let me drive home; when they asked me, when they pretty much forced me, to hand over my keys until I could get a family member to come pick me up. All you said when I called you was, "Oh." Just "oh," like I told you I had already made dinner and you didn't need to pick something up. Motherfucking "oh." You should have said we would try again, even if you didn't mean it. You should have said there would be another even if you didn't mean it. You should have tried to act sad, or at least hide your newfound sense of freedom. You should have bought me flowers. Multiple times. You should have bought me flowers multiple times and maybe even a nice pie. You should have pretended that you still loved me, that you loved her.

You should not have said that maybe it was my defective hillbilly genes. That maybe I should have been eating more folic acid. Everything was already my fault.

Yes, there was that beautiful moment after we knew when we went down the shore, to your summer house, when we went out on the beach and I asked you if you would put your head on my belly and you did. We were a fragile little family. And then, even though the water was still very cold, I ran into the waves, just so she could feel it. I blasted Led Zeppelin so she could feel the thump of adolescent dreams.

Then, in the waiting room, waiting for the "termination," me clutching Zena Melina and you reading the *Atlantic*. You went for a cup of coffee in the cafeteria. And I stood up and there she was, plop, all over the floor in every direction on the gray linoleum. Then, later, you didn't hear the splash as the

rest of the tiny pieces of her body hit the toilet water. You didn't feel her arm slide out of you. You didn't watch the nurse scoop her torso out of the bowl. By the time you got back, they were mopping her up. You always missed the important parts. Lucky you.

And then the hormone drop, like jumping off the Empire State Building and having my head buried in the sidewalk. Hallucinations. I am covered in lobsters; I am James Edward, my body glued to my cradle, Mamaw looking at me one last time; my camera covered in blood, her yellow thumbnail floating in my soup.

But I just look up at the smudges on the television.

After the linoleum, the toilet, the splash, and the D&C you came, you sat under the one working lamp in the living room in my cottage by the sound. I was lying on the greasy wall-to-wall carpeting, letting myself bleed on an old towel. If my body wanted to weep, I would let it weep. I picked at the chipped lead paint. No danger now, what did I care?

I asked you to tell me a story.

"Sometimes I think we shouldn't be together anymore. Like we should make it official, you know, sign the papers. Do you ever think that?" you said.

"Is this the story?"

"No, it's not."

Liquid dribbled out of my body. I rolled onto my stomach and faced you.

"No, I don't think that. I never think that."

This was a lie. Sometimes I thought that. I definitely thought that.

You started to cry. "I never want to go through this again. Never! But you won't stop until you get what you want. You wanted me to marry you, and I gave in. You wanted a baby, and I gave in."

A clot rests like a jellyfish on the floor.

"I mean, do you need more of a sign that you aren't meant to be a mother, Anya? The world is trying to tell you something, but you won't listen."

CHAPTER 59

My outpatient stint is at Silver Hill, a fancy private facility in one of the affluent towns where I tutor. Our insurance won't cover it, so Philby puts down his credit card before he gets back on the train to the city. I promise to try to file the claim as soon as I get out so he can get his money back. It's technically both a rehab and a psychiatric program, so though I don't have a substance abuse issue, I have to get drug tested along everyone else. The parent of one of my students is a doctor here, so I duck in and out of the hospital as fast as possible after our group sessions.

Like McLean Hospital in Belmont, Massachusetts, this facility also has a storied history of celebrities hiding out in its eaves while they patch and repair themselves. Unlike inside Yale Psychiatric Hospital's urban concrete building, therapy sessions here often happen poolside by renovated Tudor-style bungalows, and a volunteer knitting circle helps patients focus on the present. *Wellness* and *balance* are the watchwords here, and we spend a day making "emergency sensory kits" to leave around our cars and homes. We are supposed to include a postcard of a soothing location to meditate on, a ball of clay to shift our attention to the physical, an uninflated balloon to help us breathe deeper, and a swatch of fabric doused in lavender oil to reorient our sense of smell.

At Yale Psychiatric Hospital we were lucky if we got a marker.

There are two circles of knowledge in this therapy group: there's the official, institution-led course of talk therapy and dialectical behavior therapy coping techniques, and then there's new-age pseudo-rituals, like chakra cleansing,

giving thanks to "higher powers," and ringing Tibetan singing bowls. We flush out bad spirits with smoldering sage sticks and welcome love and creativity by burning palo santo. The lead therapist spends a third of the sessions talking about herself, her laser skin treatments, her daughter's wedding registry. We all just sit there and listen and stare into space. During one session, we take a collection of the therapist's favorite old beauty magazines and, like six-year-olds, collage "vision boards" of our aspirations for recovery. I glue a single piece of paper, the word *eyelash*, to the cardboard. The therapist looks at it and says, "Very interesting."

I have been granted permission to doodle with fine-tipped colored pencils in our sessions because I am an artist and the psychiatrist here says that creativity is part of grieving. He wants me to talk about why I perform in front of people. What do I think it means? Why do I do it? "Because I'm not good at anything else," I say.

"Yes, but why do you do it? What does it mean to you?"

"Metaphor."

"Metaphor for what?"

"Life."

I spend the summer drawing pictures of Joan of Arc in psychedelic swirls.

Another circle of knowledge happens outside at the picnic tables next to the dumpster. It's where we all gather, young and old, during breaks. Sometimes we scope out the men's outpatient group from afar and try to muster interest.

A typical conversation between us ladies:

"What about him? He's kind of hot."

"Sex addict."

"That's not so awful. I mean, channeled in the right direction."

"What about him?"

"Complete burnout trust-fund guy. Parents threatened to sell his Jackson Hole ranch if he didn't get sober, again. Only going to get richer though. Plus side, might not notice if you spent all of his money."

"Well, I guess in some way it's easier to pick guys here. Their issues are up front and clear for all to see. You don't have to be married for fifteen years to find out what is wrong with him."

Then some laughter derived from painful experiences.

Out by the dumpster, I also learn about the other side of recovery, the insider secrets and tricks of the trade. I learn where to score dope in idyllic downtown New Canaan, how to cheat a urine test, how drinking ketchup takes the booze off your breath.

As a group, we go through multiple boxes of tissues a day.

"He lost my iPad! That little fucker," one woman wails, referring to her son. "I mean we have others obviously, but I was just so so mad. I went out to the pool house and pulled out the flask I hide there."

When it's my turn to share, I calmly tell them about the baby splashing onto the floor. Then I go back to drawing Joan of Arc.

CHAPTER 60

—————————

While I am going to Silver Hill, I also start going to one of those euphemistic "fellowship" groups. We meet once a week at the church in Westport where I attended nursery school, in the actual room where I attended nursery school. The irony isn't lost on me. At night I dream of apple juice, finger paint, and baby booties.

I also spend long chunks of every day crying in my car, looking out at gray, shallow Long Island Sound. I ride the stationary bike at the Y and cry through marathons of *Law & Order*.

I am going back and forth into the city on the days I don't have my program. I find a series of texts on Philby's phone from his private Pilates instructor. They are not about Pilates.

I still have one more week of outpatient when I am accepted off the waitlist at a prestigious artist residency, Yaddo. I have applied to the program every year for the past nine years and been rejected every year for the past nine years. Silver Hill agrees to let me out early after I do a convincing impression of having put my brain back together. The fact that I am going from psychiatric hospital to artist residency is not lost on me. They are kissing cousins of a sort.

I leave through the stone gates at Silver Hill at noon and arrive through the stone gates at Yaddo at 3:30. The studio I am assigned to is fully lined with windows and mirrors. I fill the space with children's tents and take naps on the floor. During the day, I stare out the window and watch the woodchucks dig holes. At night, I roll around the space in an office chair and cry.

CHAPTER 61

J ust three months after I am released from Yale Psychiatric Hospital, while I am giving a talk at a museum in Atlanta, Philby calls and leaves a message on my voicemail. He says that we are being audited by the state of New York (I apparently didn't file our taxes correctly), and he that wants a divorce.

One more thing.

Could I bring him some of my Vicodin and tell him where the extra pillowcases are?

CHAPTER 62

After Philby divorces me, I come back to the shack to see if I can locate Mamaw's old negatives and letters. No one has lived here since she moved out to the trailer fifteen years ago.

Ol' Sonny has taken over the land from his house all the way down to the homeplace. A collection of scrap metal was dumped in the creek. Someone has dug out Mamaw's beloved ginseng patch and cut down many of the trees Ed planted. There is a rotting trailer. Rumor has it that one of my cousins is pimping out another younger cousin in that trailer, that people come up and down the holler at all hours to sleep with the "Ganderbill slut."

I know it's probably dangerous to be up here, but I drove up anyway. I didn't bother to hide my out-of-state plates or hire armed guards. I didn't tell my parents. Since the divorce, I've moved out of the city for good; now I live in the bad section of an otherwise pleasant Connecticut seashore town. I've spent a year without most of my belongings, almost gone broke setting up my new place, lost most of my freelance day-job work due to concerns about my inpatient stint, lost most real contact with my artistic community, and seen my performance opportunities dry up. So does my hair; after my breakdown, it never grows back. I've failed another round of egg preservation ("Your right ovary is fried, and your left ovary is filled with undeveloped eggs. We've never seen this happen before. Your body is . . . unique?") and a few more rounds of artificial insemination with donor sperm (I was given a list of eligible candidates from the Yale track team—no pictures,

no interviews, nothing but age, height, and eye color on an Excel spread-sheet. I had closed my eyes and pointed randomly at a different donor each time.).

On the good side, I've stopped chewing my nails.

What I am saying is that I don't get too scared anymore.

Still, my body refuses to create life, and my heart refuses to let it go.

Ol' Sonny stares at me from up on the ridge.

Go ahead and shoot me, you fucker.

Just shoot the shit out of me.

We stand there, locked in a gaze, a weaponized staring contest, and then I turn and enter the old house.

Though it's daylight, it's almost pitch-black inside. It's clear that addicts of all stripes have been using the shack as a refuge. Tiny plastic heroin baggies with their ominous stamps—"Time Bomb," "The Recession," "Kiss of Death," and oddly, "Cookie Crisp"—litter the floor along with broken needles, dried used condoms, and fast-food wrappers. The floorboards in the bathroom, which were bowed deeply like the bump on a camel's back the last time I was here, have finally given way and snapped in two. Mamaw's collection of almost-finished deodorant sticks still sits on the bathroom shelf, her broken salt and pepper shakers are frozen on the windowsill, a lone can of Vienna wieners is perched on the kitchen counter. One of her old coffee cans is in the corner. The kitchen floor is a gaping hole.

But the white door is still tightly shut.

Among the litter on the floor of the main room are childhood report cards; postcards I sent back from New Zealand, Cambodia, Lithuania; and old bills from the phone company; long brass pins for making pin curls; and Ed's New Guinea pith helmet, cracked open like poor Yorick's skull.

I turn a Taco Bell bag into a provisional rubber glove and attempt to save the scattered papers. It's like the shack imploded. Who would know that this is the place where I had stayed up night after night, battling the mosquitos that swirled around the nightlight? That this is where I slept night after night with Mamaw, a loaded gun under our heads? In this imploded room, I discovered Maya Angelou. I learned how to sew, how to play solitaire, how to

string butter beans. In this imploded room, my mother was born, Ed's torso was re-embalmed, Mamaw and Granny wept.

And though the years dried everyone's tears, we kept on weeping inside.

This is my family, and I am unable to carry it on. I am unable to make it move into the future.

Some of these genes will die with me.

I wade through the detritus of our lives until I stand in front of the white door. I hold the brass knob in my hand and turn. I duck as the knob gives way and the door creaks on its hinges. I pause for a second and hold my breath.

Everything is white mold. Mold so thick it hangs like snow over every inch of the room, like the ice palace in *Doctor Zhivago*—stalagmites hanging from nails. There is the desk, the desk that likely holds evidence of my mother's childhood, only it's encased in mold so thick it looks like frosting on the wedding cake I never had.

All I can do is stare.

There is no revelation.

CHAPTER 63

I have not performed in a long time, and I have also not looked at myself in a mirror for a long time.

Everything seems to be an elegy for everything else.

I don't know if I will ever be able to stand unguarded, live, in front of an audience again.

But I have devised some temporary armor.

Tonight, I am performing from inside a twenty-dollar child's play tent. It's flimsy and flammable, and as the audience wanders into the gallery space, once a famous porn theater here in downtown LA, I crawl inside and zip myself up. Inside my little cocoon, I arrange my clip-on lights and shuffle my script. I slash some red lipstick across my mouth and flip my hair up and down so it doesn't look quite as thin. I test the microphone. The amps pop.

Over the past twelve years of performing, with one exception, I have never used my voice, deliberately. Everything has been silent, my body, particularly my face, standing in for spoken language. At heart, I'm shy, yes, but probably no more than the average person. It's just that any word that comes out of my mouth has always felt gone before I could really contemplate it. When an expression lives only in my body, I can hang on to it longer, stretch it out, toss it in the air and jump on it. My voice just can't do that.

Then I turn on the clip lights inside the tent; my performance begins. The nylon fabric creates a lantern, illuminates me in the vacuous space.

The video projector is turned on, and behind the tent my face appears, massive and melancholy on the wall behind me. I am broadcasting from my

laptop inside the tent. The tent, the computer, the light, the microphone: They mediate me.

The microphone is strange in my hand. Who knew that the better ones were so heavy? At first, the sounds I make are baby-bird twitters, the sounds of someone who doesn't know how to fly. But I find my way.

What I am reading is part of the first draft of what will eventually become this book.

And when I stop reading, I look into the camera and articulate the movements of my face wildly, comically—some Jerry Lewis, some Muppets, some butoh—an eruption of influences and heartache. I contort my face around and around itself until slowly, the audience can see the edge of something peeking out from my mouth, pressing up against the edges of my lips. Dripping with saliva and lost lipstick, a very tiny house emerges. It hits the floor and breaks into three pieces.

Other objects emerge from my mouth: little bottles of dish soap, miniature roasted turkeys, a teeny bottle of glue, mouth-sized pizzas, Bundt cake pans, candlesticks, a miniature copy of *War and Peace*, tiny Styrofoam cartons of eggs, a baby salmon, rotary telephones, rolls of toilet paper, cracked lobsters.

Finally, encased in a thicker blob of saliva, a plague of plastic ants spew from my lips. The audience cringes as the ants drip off my chin one by one, each bubble of spit writ large behind me.

I think of Ladybird, I think of Mamaw, I think of Ed.

Somewhere in the nest of insects comes the tiny plastic head of a baby girl.

She is a head; she is a torso.

She is split.

And she survives.

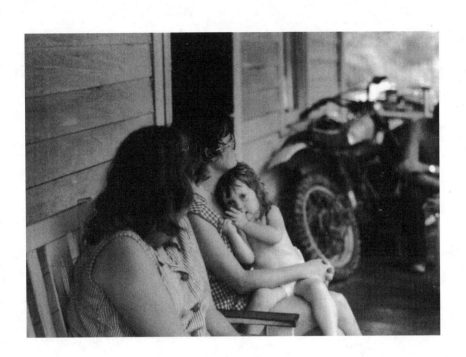

ACKNOWLEDGMENTS

This book is dedicated to the insights, patience, and devotion of many people. First, I'd like to thank my incredible editor, Abby Muller. She swooped in and guided me in a new direction at the perfect moment. It is a gift to be in the presence of her immense intelligence and instincts. I will always be grateful to Tracy Carns for seeing the potential in this book and taking a chance on me. Eleanor Jackson has been my steadfast champion since day one, and her reassurance in all matters has meant the world to me. To Betsy Lerner, I owe everything. Her belief in my writing kept me going through some difficult days. Her generosity and enthusiasm for this book convinced me that I had a voice that others might want to hear. I'd also like to thank Andrew Gibeley and Kristen Milford for being incredible advocates of my book in its crucial final stages. I think of Andrea Kleine as my artistic big sister. She has led me through the strange worlds of both experimental performance and publishing with patience and aplomb. Marcelle Soviero cradled this book at its ambivalent birth as a pile of grubby, disjointed pages. She helped it gain its training wheels and learner's permit, and nurtured it into book adulthood with love and tenderness at every moment.

I always thought that writers climbed into a garret with a cat and a cup of tea and emerged a year later with a book—that it was a strictly solitary pursuit. I have been proven wrong by the spirit and love of so many people who have supported me along the way. Deep curtsies of gratitude to Stephen O'Connor, Lauren Cho, Beasie Goddu, Alec Black, Swan Huntley, Claude Rawson,

Christen Clifford, Tom Cole, Yelena Gluzman, Esther Neff, Stephen Petronio, Nick Cipolla, Amitava Kumar, Greg Marshall, and the entire sixth floor of the Morse College Tower.

Extra special thanks to Elena Oxman, Theresa Lawson, and Nicole Austin for their constant encouragement and permission to bribe myself for various tasks with cookies.

Thanks also to the funniest person in all the universes, Ken Yee, for keeping me fed with unconditional friendship and daring, delicious food for so so many years.

As always, Danya Pincavage supplied crucial provisions of fire, plastic monkeys, and loving guidance.

Thanks to the Oxman, Sulaiman/Suleiman (both US and abroad), and Savitski families who have given me shelter from various storms.

To Patrick Meade. You once told me that I was meant to live a big life, not the small one I had convinced myself was all I deserved, thank you.

To Kristen Slesar, who was with me through every bump and curve and crash and spontaneous shift into full reverse, thank you.

Much gratitude to my early readers: C. Flanagan Flynn, Diane Lowman, Mary Ann Palmer, Adelma Lillston, Wendy Kann, Christine Pakkala, Sally Allen, Elizabeth Von Klemperer, Naomi Wolcott, Olivia Schiller, Alex Kvares, Doug Moser, and Shana Katz Ross.

Lynn Carnegie and everyone at Carnegie Prep have supported my artistic endeavors since day one. None of my work would be possible without their faith, flexibility, and friendship.

Much gratitude to the many institutions that gifted me time, space, and bottomless cups of coffee as I made this piece: The Corporation of Yaddo, Virginia Center for Creative Arts, Kimmel Harding Nelson Center for the Arts, and Atlantic Center for the Arts.

Very early parts of this book originated as an unrealized one-woman monologue work in progress titled *Jewbilly*. It was supported and developed by the Yale Hillel, New Haven, Connecticut; Eyedrum, Atlanta, Georgia; and the Conney Conference on Jewish Arts at the University of Wisconsin–Madison, Wisconsin.

I am deeply indebted to the amazing teachers I have had throughout my life: Joanne Gage, Trudy Kelly, Barbara Danielson, Carol Sumner, Peter Bennett, Lis Comm, Al Pia, Jerry Kuroghlian, Jim Wheeler, Dick Leonard, Dave Harrison, Tod Papageorge, Constance Thalken, John McWilliams, Cheryl Goldsleger, and Nancy Floyd just to name a few.

I would also like to thank the staff of Panera Bread in Westport, Connecticut. It took me six years to write this book, and I spent almost all of it in the far-left corner two-top, the one with the really good outlet. Thank you also for the extra butter! Life is better with extra butter!

Thank you to Mary and the entire WJM newsroom, and also to Chuckles the Clown (RIP).

Thank you also to J Mascis and Dinosaur Jr.

Long ago I promised Alison "One L" von Klemperer that I would write a book and that when I did, I would make sure to write that she was the coolest mom in Fairfield County. AvK, you are the coolest mom in Fairfield County.

Portions of this work were previously published in different forms in the following: *bioStories*, the *Chattahoochee Review*, *Kindred* magazine, and *Brain Teen*.

Other portions of this text were used in performance at: University Settlement/New Dance Alliance, New York, New York; Yale Hillel, New Haven, Connecticut; Movement Research at Judson Church, New York, New York; INVERSE Performance Art Festival, Fayetteville, Arkansas; Dixon Place, New York, New York; Rosekill, Kingston, New York; and Panoply Performance Lab, Brooklyn, New York.

The performances described in length in this text were performed at or with Exit Art, Surreal Estate, the Center for Performance Research, English Kills Gallery, Grace Exhibition Space, MoMA, and Art in Odd Places, all of which are in New York City. Other spaces where pieces in this text were performed include Human Resources, Los Angeles, California; Queer City Cinema, Regina, Saskatchewan; and The Contemporary, Atlanta, Georgia.

Nothing in my world would be possible without Dorothy, Francine, Alvin, Ladybird, and Sugi.

And most of all, Mom and Dad, thank you for letting me be me.